INSIDE ROME

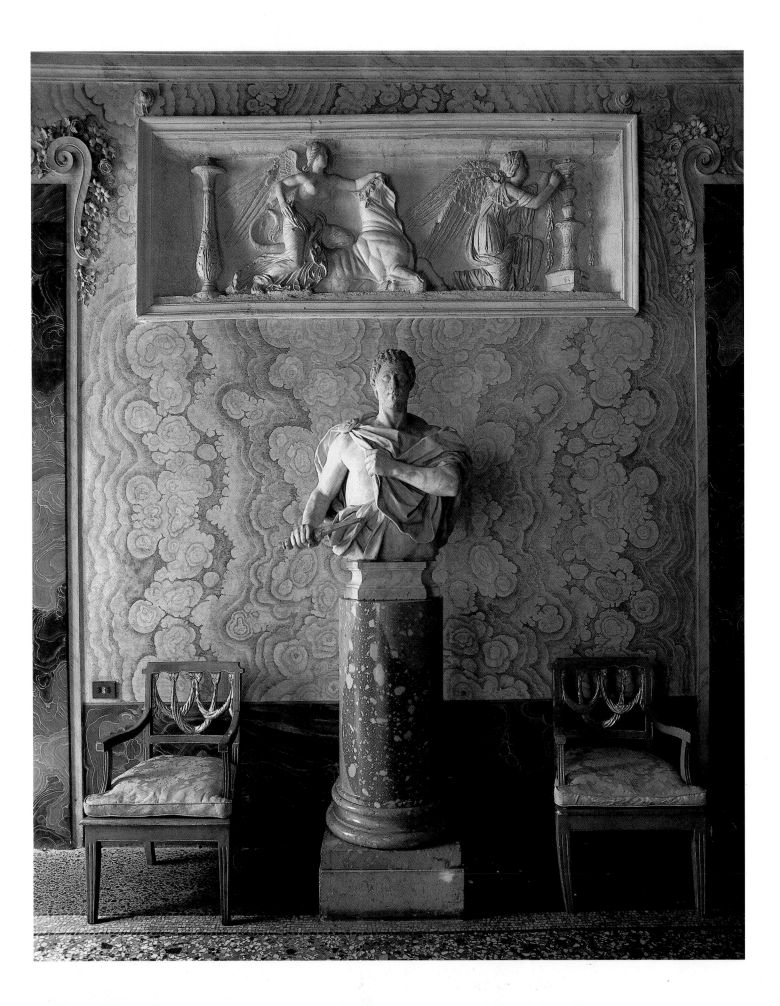

INSIDE
ROME

DISCOVERING·ROME'S
CLASSIC·INTERIORS
BY·JOE·FRIEDMAN·AND
MARELLA·CARACCIOLO
WITH·PHOTOGRAPHS·BY
FRANCESCO·VENTURI

Φ

Phaidon Press Ltd
140 Kensington Church Street
London W8 4BN

First published 1993

© 1993 Phaidon Press Limited
Photographs © 1993
Francesco Venturi

ISBN 0 7148 2892 0

A CIP catalogue record for
this book is available from
the British Library.

Typeset in Monotype Centaur

Printed in Singapore

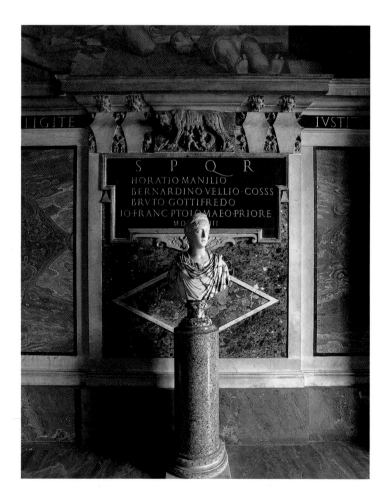

A love of marble, a fusion
of statuary and architecture
and a striking use of lapidary
inscriptions: the interior of
the Museo Capitolino follows
a Roman tradition as old as
the city itself (left).

FRONTISPIECE
The interior of the Palazzo
Rondinini marks the transition
from Baroque to neo-classicism.
The doorcase, with curvaceous
lugged architraves, looks back
to Borromini; and the wall,
faced in *scagliola*, in imitation of
marble, provides a resplendent
background to a classical relief
and bust flanked by a pair of late
eighteenth-century armchairs.

ENDPAPERS
Murals at the house of Livia
and Augustus.

Contents

Introduction

All cities are in one sense museums of architectural history; every street a gallery, every building an exhibit. But Rome is in this respect the greatest, for there is no other city whose built environment so fully encompasses the history of Western architecture. Whether standing or in ruins, there are buildings here of every period dating back to classical antiquity and even to the early Iron Age. The diversity and beauty of this architecture testifies to Rome's continued importance through some 3000 years of history. Founded in the eighth century BC, the city grew to become the hub of a vast territorial and commercial empire, a metropolis of temples, palaces, theatres and markets, linked by broad streets, squares and circuses. It was here that Christianity took root and the popes established the seat of the Catholic Church. By the end of the fifteenth century Rome had become the undisputed centre of Renaissance culture, remaining at the forefront of artistic activity for over 200 years. Great churches were built, no less splendid than the old pagan temples; new palaces, new streets and new squares were erected, often inspired by those of the antique past.

The city became a place of pilgrimage for artists and art-lovers from all parts of the world. Before the modern age, when it was held that a great artistic talent was formed as much through exposure to the artistic masterpieces of the past as through introspection, Rome fulfilled the function of a great academy, where architects, sculptors and painters came to complete their education. By the end of the eighteenth century anyone who had not visited Rome was in Johnson's phrase 'conscious of an inferiority'. Following the Risorgimento, Rome was created the capital of the newly united kingdom of Italy, the seat of government and sovereign, initiating a wave of expansion and redevelopment which again transformed the city, bringing purpose-built offices and apartment buildings, government ministries, large public theatres and department stores. In the 1920s and 1930s, as the focus of Mussolini's dreams of a new Roman Empire, the city was transformed once more into a giant construction site from which there arose a vast array of public buildings and monuments. With the collapse of Fascism and the abolition of the monarchy, Rome maintained its central role in national and international affairs as the capital of the new republic, and in the boom years of the post-war period saw the construction of a whole new generation of buildings which radically altered the city's skyline.

The days of the Grand Tour are long past. Through a steady process of cultural dispossession in our schools the post-war generation has been cut off from its classical roots. Yet Rome, visited by millions of people each year, remains as a reminder of the very real continuity between the modern world and antiquity.

Rome is a city built for display, a showcase in which successive rulers, whether emperors, popes or political parties, have sought to glorify themselves and their surroundings through the construction of conspicuous buildings and monuments. The plan of the city, with its wide open piazzas and broad axial roads, purposely heightens the visual drama. Even the topography seems designed to set off the architecture, the rise and fall of the landscape creating arresting scenic effects through an infinite series of shifting perspectives.

If Rome is one great outdoor museum, it also contains the earliest of all public art galleries, the Capitoline Museum, where from the fifteenth century antique statues from the papal collections were placed on permanent display. It was at the Capitoline also that the first modern museum administration was established in the eighteenth century, with a salaried curatorial staff, regular opening hours and illustrated catalogues. And yet this most open, visible city still has its secrets. If it were possible somehow to turn Rome's buildings inside out, people would see at once that the great architectural inheritance the city presents to the world is matched by another, no less spectacular, which it largely keeps to itself. In Rome, as in other cities, some of the greatest architecture is found on the inside of buildings, but for this very reason is generally hidden from view and little known. Even the interiors of the most celebrated buildings often remain a mystery.

The purpose of the present book is to open up this hidden world and so reveal an aspect of the city which is largely unexplored. Naturally there are gaps; it was never our intention to produce a comprehensive survey. Such a study would fill a dozen volumes and still fall short of its aim. Rather we have tried to evoke the great wealth and diversity of historic interiors which, no less than the façades of Rome's great buildings, are a vital part of the city's architectural heritage.

Faced with an almost infinite choice, it was necessary to establish some basic criteria for selection. In the first place we decided to limit ourselves to Rome proper. Frascati, Tivoli and other neighbouring towns have for thousands of years provided an important extension to Rome, a retreat where since the days of the Emperor Hadrian wealthy Romans have built magnificent villas. However, with so much to choose from in Rome itself we thought it best to resist the temptations of such outstanding interiors as those of the Villa Caprarola, the Villa Aldobrandini and numerous other architectural masterpieces. The only exception we made was the Vatican City. Although not strictly speaking a part of Rome, nor even of Italy, having seceded as an independent sovereign state in 1929, the Vatican City forms such an integral part of the history of Rome and is so close geographically to the historic centre, that we felt unable to exclude it.

Broadly speaking we have focused on privately owned interiors which are closed to public view and have never or only rarely been published. At the Vatican, for instance, we deliberately avoided those areas which form part of the public museum and chose instead the Casino di Pio IV, a garden pavilion designed for the Pope's personal use by the great Renaissance architect Pirro Ligorio (pages 16–17). From the ancient remains of the Palatine we selected the *Sala delle Maschere* at the House of Augustus, a brightly painted interior dating from the first century BC which has only recently been excavated and is not yet open to visitors (pages 64–65). At S. Trinità dei Monti we left aside the famous church and concentrated instead on the adjoining convent, a private institution which houses the remains of a remarkable frescoed bedchamber of the 1760s painted in *trompe-l'oeil* to represent the crumbling shell of an ancient Roman chamber (pages 98–99).

In particular we have given the broadest possible coverage to the *palazzi* of the old Roman nobility. It is not always understood that at one time these buildings fulfilled a semi-public role, not only as a focus of social and political life,

but as a setting for cultural events such as concerts and plays, a meeting-place for artists and writers, and a repository of fine works of art and furniture. In the days of the Grand Tour these buildings were open to accredited visitors; some still honour this tradition. Indeed the gallery of the Palazzo Doria Pamphili functions today as a public museum, as does the gallery of the Palazzo Colonna (pages 70–71). However, in an age of mass tourism the owners of the great *palazzi* have generally been forced to adopt a more restrictive policy with regard to admission. Nonetheless, as the photographs in this book will show, the palaces of Rome remain among the city's greatest artistic assets. In London the mansions of the nobility and gentry have largely been destroyed; most were demolished between the wars. In Paris, although the great *hôtels particuliers* of the *ancien régime* have generally been preserved, in most cases they have been converted to other uses, functioning today as offices, embassies, ministries and apartment buildings, stripped of their original contents and otherwise altered and dismantled. In Rome, by contrast, many of the old *palazzi* are still functioning as private houses, sometimes occupied by the families who built them. Of the examples featured in this book there is the Palazzo Massimo, residence of the Massimo family since its construction in the early sixteenth century (pages 14–15); the Sacchetti family continues to occupy the *piano nobile* of the palace it first acquired in the mid-seventeenth century (pages 12–13), while the Palazzo Pallavicini-Rospigliosi has been in family ownership for almost 300 years (pages 18–19). In some cases, palaces have passed into other hands and uses: the Palazzo Farnese is now an embassy, as are the Palazzo Caetani, the Palazzo Pamphili and the Palazzo di Spagna (page 36). The Palazzo Borghese is occupied in part by a club (pages 37, 96), as are the Palazzo Barberini and the Palazzo Rondinini (frontispiece and pages 94–95). The Palazzo Corsini has been occupied by an academy (pages 108–9), and government offices have been created in the old state apartments of the Palazzo Chigi, the Palazzo Spada and the Palazzo Madama (pages 40–41). In certain cases palaces have been remodelled, but most preserve their original architectural decoration, and where they continue to serve as private houses they often retain the nucleus of a great historic collection of works of art and furniture.

The old *palazzi* are a reminder of the importance of aristocratic patronage in the development of Rome. The city we see today arose largely from the rivalry which existed, and in some quarters still persists, between the great Roman families. In the Middle Ages there was open fighting in the streets between the Orsini, the Colonna and other competing patricians, but from the time of the Renaissance battles were fought through the more peaceful medium of architecture. The nobility not only built the city's palaces; it funded the construction and embellishment of churches; raised the sons who as popes laid out streets and raised great public buildings; and, while fostering local talent, gave employment and encouragement to eminent artists from all over Italy and other parts of Europe, creating a culture in which the arts and the city itself could flourish.

While focusing on the private side of Rome, we have also aimed to cover interiors which are open to the public. No photograph, however exciting, can match the experience of visiting a building, and about a third of the interiors we have

chosen are easily accessible. At the same time, however, we have deliberately avoided the more familiar sights of Rome.

One of the saddest aspects of modern tourism is that our cities have been simplified and repackaged in a way which betrays their very nature. A few stock sights come to represent a world of infinite complexity, so that Venice becomes St Mark's Square and the Rialto Bridge, London the Houses of Parliament and Buckingham Palace, whilst Rome, most complex of all, is gradually whittled down to the Sistine Chapel, the Forum and the Spanish Steps. In this book we have tried to broaden the picture. The interiors we feature are generally those which have somehow been neglected or overlooked. At the church of S. Maria in Trastevere we have chosen not the celebrated thirteenth-century mosaics but the Avila Chapel, a little-known masterpiece of Baroque design which occupies a tiny space off the nave (page 117). At the Vittoriano, the most conspicuous of all public buildings in Rome (and probably the most disparaged), we have highlighted the remarkable mosaic ceiling of the loggias at the summit, an area which generally goes unnoticed (page 70).

Rome has been the centre of the Catholic Church for over 1500 years and contains almost as many churches. Choosing between them has not been easy, but we have tried to include as broad a range as possible. The examples we feature extend from the dawn of Christianity almost to the present day; from the fourth-century interior of S. Costanza (pages 110–11) to the 1930s interior of the Tempio di Cristo Re (pages 118–19). There are the eighth-century frescoes of S. Maria Antiqua (page 110); the twelfth-century nave of S. Maria in Cosmedin (page 113); and outstanding examples of the Baroque, including

Borromini's S. Carlo alle Quattro Fontane (pages 116–17). Also included are the Rococo interior of S. Maria Maddalena (pages 112–13); the neo-classical tomb of the Princess Odescalchi in S. Maria del Popolo (page 114); and the exotic late nineteenth-century interior of the city's principal synagogue (pages 120–21).

Rome has always been a centre of learning, a rallying-point for scholars and a sorting-house for ideas which have shaped Western thought. Some of the finest and best-preserved interiors in the city are libraries and reading rooms, several of which are featured in these pages, among them the Biblioteca Casanatense, its towering walls lined with rare books and manuscripts (page 104–5), and the library of the Fondazione Marco Besso, a shrine to the poet Dante (pages 105–7).

Rome is likewise a city of shops and hotels, restaurants and cafés, office blocks and apartment buildings, train stations and sports complexes. Buildings of this kind are an integral part of Rome's architectural environment, as important in their way as the city's churches and palaces, but they rarely receive attention or consideration. Many of the best examples have been lost, sadly swept away in the wave of modernization which followed the Second World War, but this only increases the value of the few that survive. Among the city's shops there are the Farmacia della Scala, a magical eighteenth-century apothecary's (pages 78–79), and from a later period the gentleman's outfitters, Radiconcini, which boasts one of the most complete Art Deco interiors of its kind in the world (page 81). The Caffè Greco continues in business in the Via dei Condotti, its top-lit tearoom largely unchanged since the mid-nineteenth century (pages 80–81), while the restaurant Alfredo

all'Augusteo preserves its original Art-Nouveau style allegorical reliefs in stucco glorifying the virtues of *fettuccine al burro* (page 81). At the Stazione di Porta San Paolo where trains depart for the seaside resort of Ostia, the walls are still enlivened by unique 1920s panels in etched cement representing frolicking sea nymphs and marine animals (page 58). Although most of Rome's hotels have been spoilt by bland post-war decoration there remain such gems as the foyer of the Grand Hotel de Rome, with its dizzying cantilevered staircase enriched with stucco (pages 72–73); the Grand Hotel Plaza, with its main staircase terminating in a majestic full-size lion in marble (page 72); and most precious of all, the Albergo degli Ambasciatori, whose principal *salone* retains its original 1920s murals representing figures from the Roman *beau monde* (pages 74–75).

It is especially interesting to visit government ministries and discover that even here, at the heart of bureaucracy, there are beautiful and sometimes fantastical interiors. There can be few better examples of turn-of-the-century Italian interior design than the conference room of the Ministry of Agriculture, the walls and ceiling decorated with sheaves of grain in gilded stucco, as well as paintings representing allegories of farming and gilt-metal lights in the form of flowers swarming with bees (pages 60–61). In the basement of the Ministry of Aviation it is astonishing to discover a fresco of the 1920s representing a pilot's vision of paradise, with fallen heroes seated among the clouds, playing chess and drinking coffee (pages 46–47).

We tend to think of Rome as a city of antiquity and the Middle Ages, of the Renaissance and the Baroque, which to a large extent it is; but there is so much more. If by the middle of the eighteenth century Rome could no longer be considered the artistic capital of the world, the city continued to evolve, responding to the ideas which have shaped architectural design in Europe right up to the present day: to neo-classicism, of which it was the natural birth-place; to the historicist revivalism of the nineteenth century; to Art Nouveau and its Italian variant the *Stile Liberty*, which flourished around 1900; to Art Deco and the neo-classical revival of the 1920s and 1930s; and to the International style, which took root in the years following the Second World War. All too often the architecture of Rome after 1750 (or even 1700) is disregarded, but in the present book we have deliberately aimed to include as many examples as possible of interiors dating from the eighteenth, nineteenth, and even twentieth centuries.

If we ourselves began with a prejudice in favour of the architecture of an earlier age we were quickly swept up by a growing enthusiasm for modern Rome. In particular we were drawn to interiors of the interwar years. Architecturally, as well as politically, the Fascist period was a destructive phase in Rome's development. Projects like the construction of the Via dei Fori Imperiali, which cuts a swathe of asphalt through the old Roman Forum, would today be unthinkable, and it is fortunate that town-planners of the period did not proceed further with Mussolini's plans for wholesale redevelopment and modernization. But this was also a period of greatness, especially in the area of public architecture, and after an interval of more than half a century it is possible to take a more dispassionate view of the output of Piacentini, Libera and other leading designers patronized by the Fascist regime. Buildings of this era are sometimes bombastic, sinister, even

faintly ridiculous. It is hard to repress a smile when we consider the homo-erotic murals at the Foro Italico representing muscular athletes of the new Roman Empire (pages 90–93). But the same buildings sometimes show a surprising degree of humour and sensitivity, as in the children's pool at the Foro Italico, with its lively decoration of circus animals , or the beautiful stained-glass windows at the Ministry of Industry and Commerce (pages 48–49). Nor can one deny the skill with which the better designers of the period were able to manipulate the language of classical architecture without ever falling into the emptiness of pastiche.

From the moment this book was conceived we wrestled with the question of what constitutes a typical Roman interior. Needless to say the question remained unanswered. Every interior in this book is in some sense unique. Indeed, we deliberately sought out the rare and the unusual and were constantly surprised by the seemingly infinite variety we encountered in the course of our researches. If there is any consistency it stems from the city's constant preoccupation with its own architectural past and from the use of certain materials and techniques which run like a thread through the whole of its history: marble and bronze, mosaic and stucco, fresco painting, carved and gilded wood, and trompe-l'oeil.

To work on this project has been a privilege. If we have any regrets it is that for reasons beyond our control we were not always able to photograph interiors which we had hoped to include. As anyone who has visited Rome will be aware, this is a city constantly under repair. The blessings of a rich artistic heritage are matched by the demands of a conservation programme which grows longer and more onerous each year. At the time of writing many of the city's great buildings are closed for restoration; some have been in this condition for several years. One such example is the Villa Torlonia, a neo-classical mansion by Valadier, administered today by the Comune di Roma. Restoration has been delayed so long that the building is now in a state of near-collapse. Ceilings have fallen in and a once outstanding suite of early nineteenth-century interiors is rapidly perishing. Similar delays have dogged the restoration of the Villa Borghese, likewise administered by the city authorities. Some seven years after work began, the magnificent Renaissance façades are still obscured by scaffolding, while the interior, though finally reopened, is illuminated by workmen's arc-lamps.

The Museum of Rome, which ought by definition to provide a gateway to the city, has been firmly shut since the late 1980s. Housed in an eighteenth-century palace, the museum is famous for its majestic colonnaded staircase, but also contains a series of interiors salvaged from the old Palazzo Torlonia (itself sadly demolished) which are among the most precious of their kind in the city. Let us hope that these are safe and that it will not be long before they are once more open to public view. It would be a bitter irony if, having escaped destruction at the hands of demolition contractors, they suffered damage through the negligence of salaried museum curators, especially in Rome where, as the interiors of this book bear witness, a love of the modern has always been balanced by a deep respect for tradition and a sense of responsibility towards the city's unique artistic inheritance.

Private Houses and Apartments

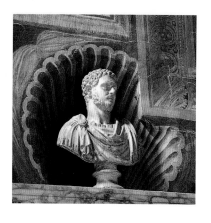

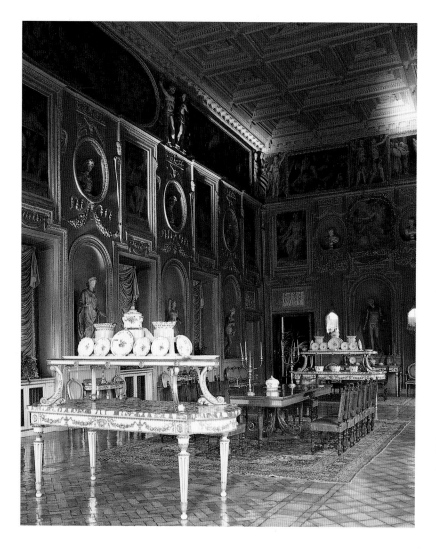

Palazzo Sacchetti

The Palazzo Sacchetti was begun in 1542 as the private residence of the architect Antonio da Sangallo; it clearly reflects the wealth and social prominence enjoyed by leading artists of the Renaissance. Unfinished at the time of Sangallo's death in 1546, the building was acquired in 1552 by Cardinal Giovanni Ricci and completed to the designs of Nanni di Baccio Bigio, later passing into the possession of the Sacchetti family, who still occupy the *piano nobile*. The *Sala dei Mappamondi* (right), which served as Cardinal Ricci's audience chamber, is decorated with frescoes of 1553–54 by Francesco Salviati illustrating the story of King David. The *Galleria* (left), decorated by Giacomo Rocca, is used today as a dining room but originally provided a setting for the Cardinal's collection of antique statuary.

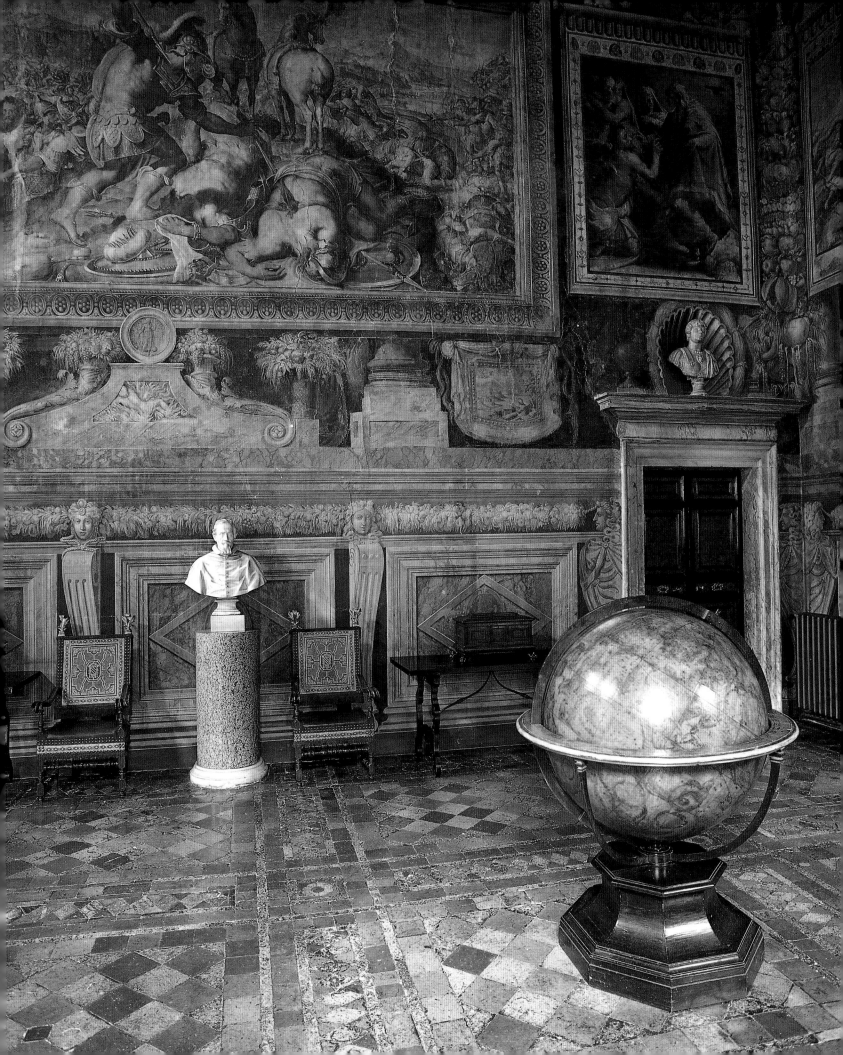

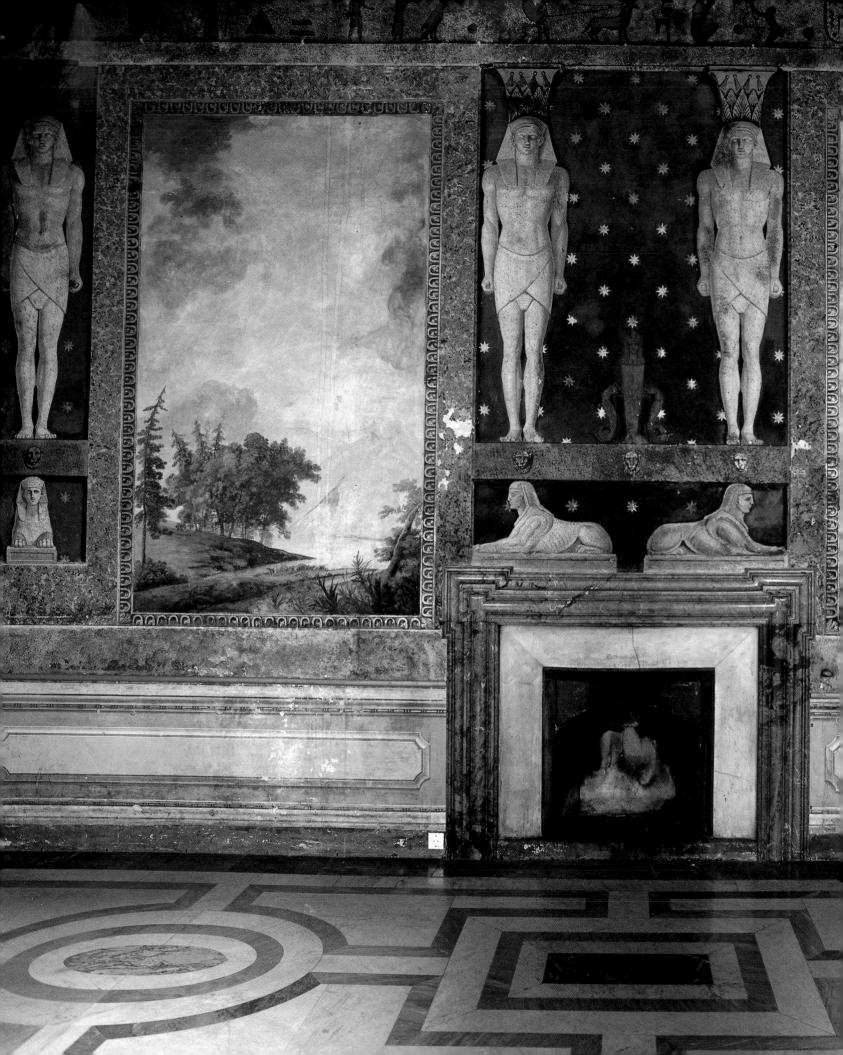

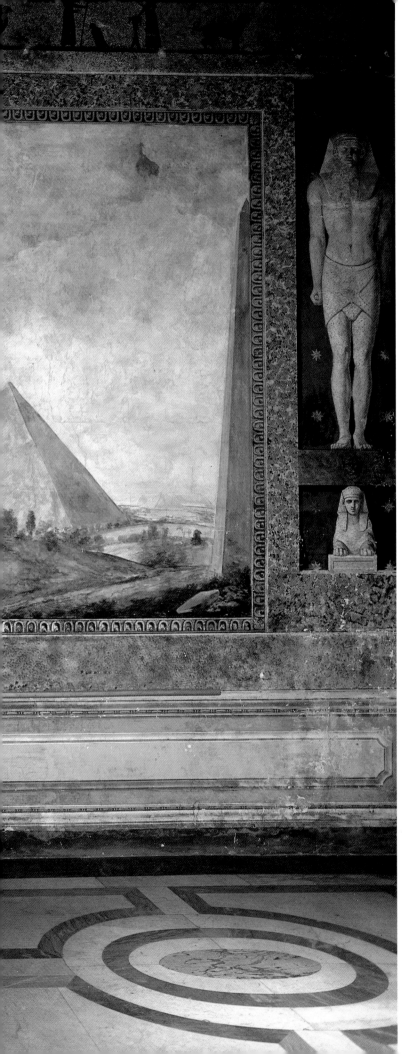

Palazzo Massimo alle Colonne

The *Sala Egiziana* is a rare surviving example of a painted interior in the Egyptian style, predating the Egyptomania which followed in the wake of Napoleon's famous campaign. The room is decorated with Pharaonic figures, crocodiles, recumbent lions, hieroglyphics and desert landscapes dotted with pyramids and palm trees. There could be no greater contrast with the exterior of the building with its celebrated bowed façade by the sixteenth-century architect Baldassare Peruzzi. The palace was commissioned by the brothers Angelo, Pietro and Luca Massimo, and is still in family ownership. Indeed there has been a Massimo palace on this site almost since records began. According to tradition, the family descends from Fabius Maximus. When asked by the Emperor Napoleon whether this was true, the then marchese Massimo modestly replied, 'I cannot prove it. The story has been told in the family for only twelve hundred years.'

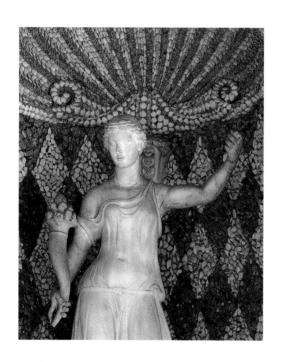

Casino di Pio IV

The Casino di Pio IV offers a fascinating insight into the private world of the papacy. In the secluded setting of the Vatican gardens the architect Pirro Ligorio created an enchanting retreat for his patron, Pope Pius IV, composed of twin pavilions facing each other across an elliptical forecourt. Known respectively as the *Grande* and *Piccolo Casino*, the pavilions are modest in size yet sumptuously decorated, evoking the atmosphere of luxury and refinement which characterized the life of the senior clergy and aristocracy during the Renaissance. One of the interiors (opposite) takes the form of a nymphaeum, lined from floor to ceiling with coloured shells, modelled in relief to represent the marriage of nature and classical mythology.

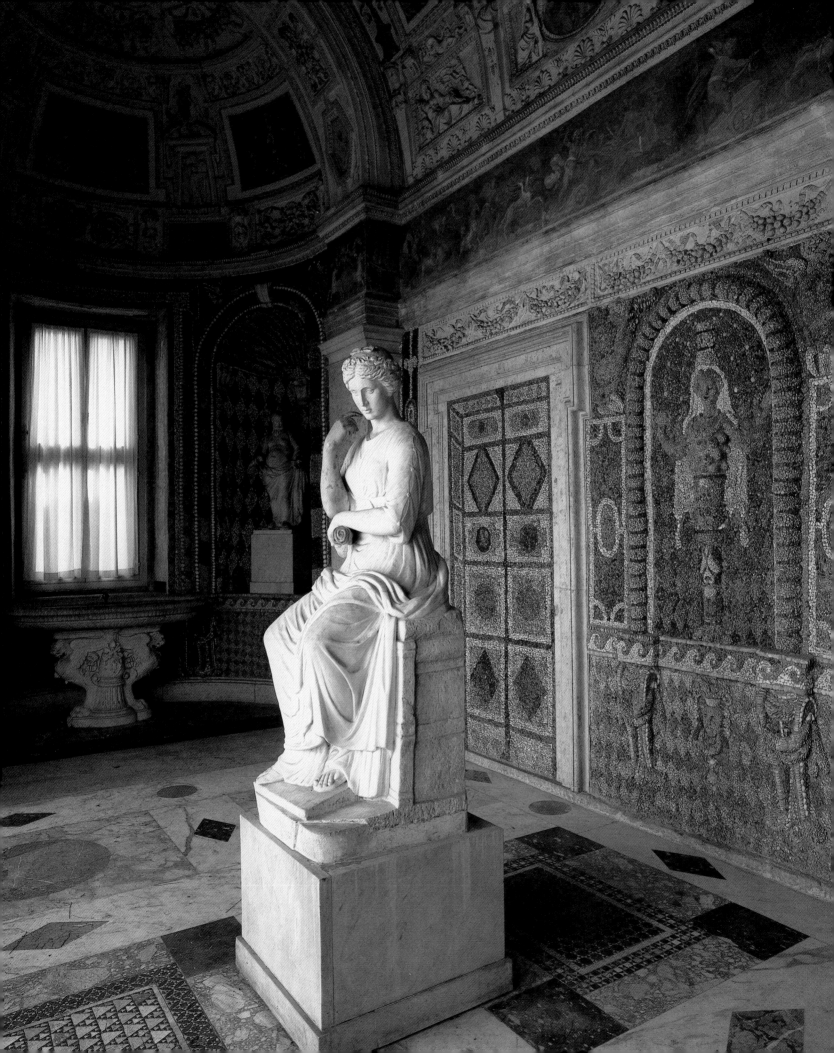

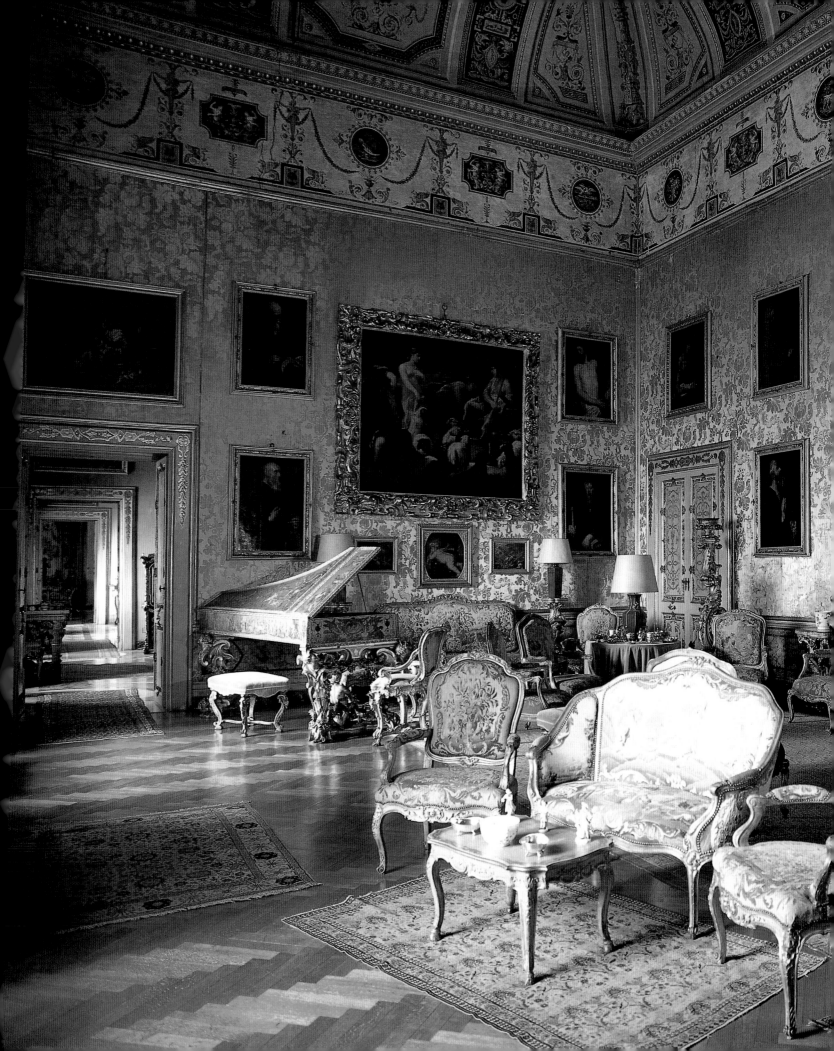

Palazzo Pallavicini-Rospigliosi

Nothing gives a better idea of the scale of the old aristocratic way of life in Rome than the interior of the Palazzo Pallavicini-Rospigliosi, the grandest surviving example of its kind in the city. The palace has an illustrious past, having been occupied at various times by the Borghese and Lante families, as well as Cardinal Mazarin. The interiors range from formal rooms of state to intimate private apartments. The *Sala degli Apostoli* (left) is hung with magnificent paintings of the Apostles by Rubens, complemented by an outstanding collection of eighteenth-century French furniture. The Rococo anteroom (right) is a rare and beautiful example of the use of silver-gilding.

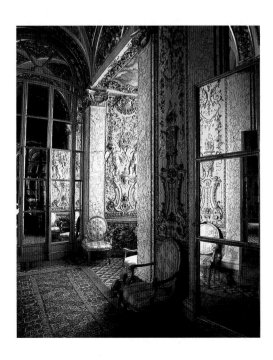

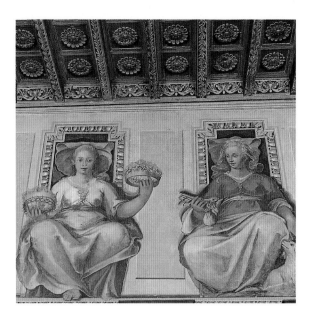

Palazzo Ricci

The Palazzo Ricci is an elegant Renaissance palace situated on the fabled Via Giulia. When owners marchesi Giuseppe Gustavo and Eleonora Ricci took possession of the *piano nobile* in the mid-1960s they had to undo the work and taste of more than a century. The most exciting discovery was a cycle of frescoes (left) with allegorical female figures representing the human virtues, believed to have been painted towards the end of the sixteenth century by Giovanni Guerra, a pupil of Salviati.

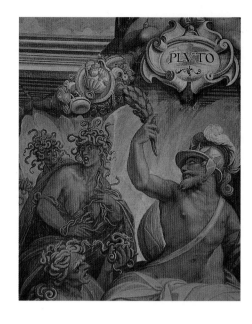

Palazzo Ruspoli

The Palazzo Ruspoli is a Florentine palace set down in the heart of Rome. The architect, Bartolomeo Ammanati, was from Florence, as were his patrons the Rucellai family. Even the Gallery (above and right) was decorated by a Florentine, Jacopo Zucchi, who worked for four years, from 1586 to 1590, on the remarkable cycle of frescoes representing mythological and biblical scenes. Quite apart from its artistic merits, the huge dimensions make this one of the largest and most impressive interiors of its kind in Rome. The Gallery remains in private ownership and continues to serve its original purpose as a formal reception room, providing a spectacular finale to the enfilade on the *piano nobile*.

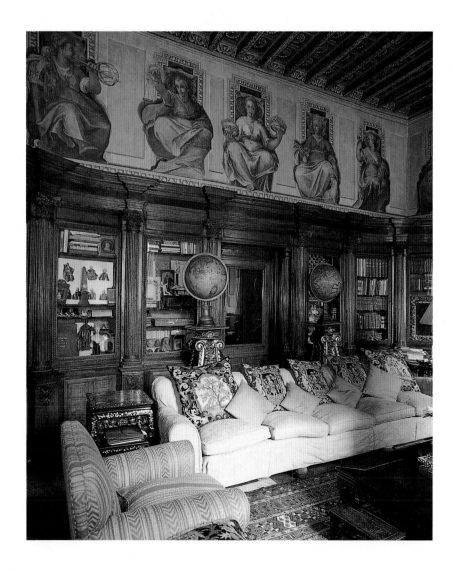

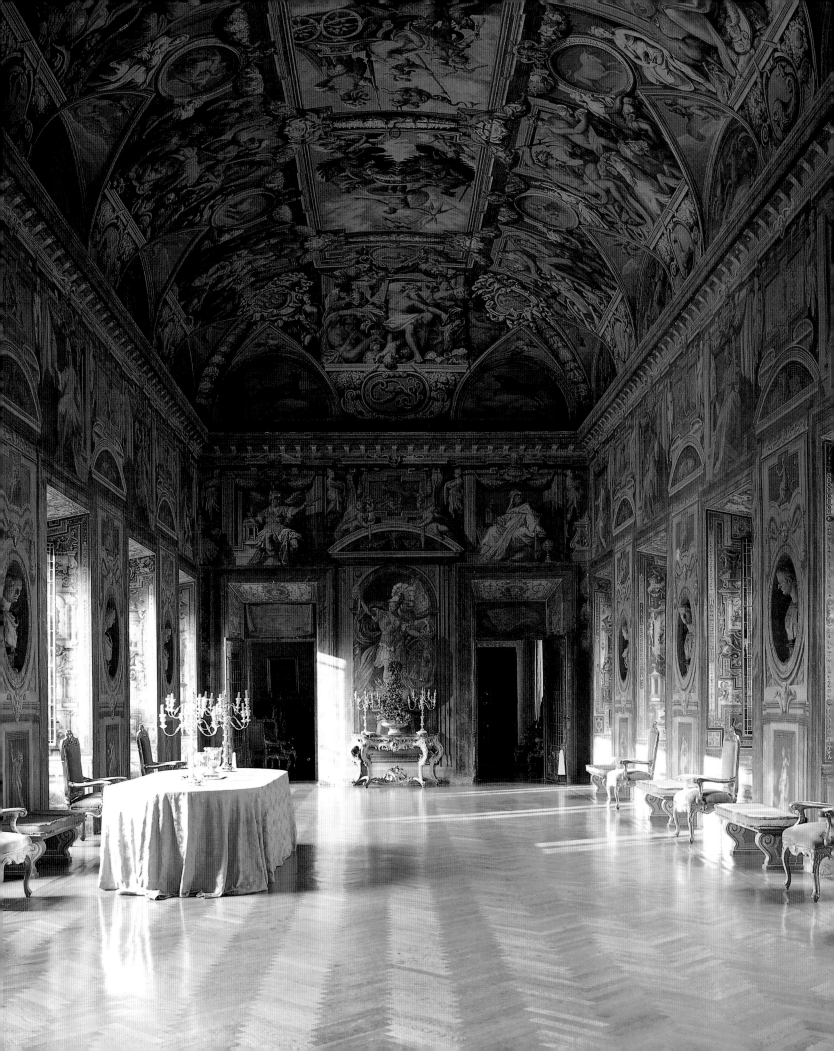

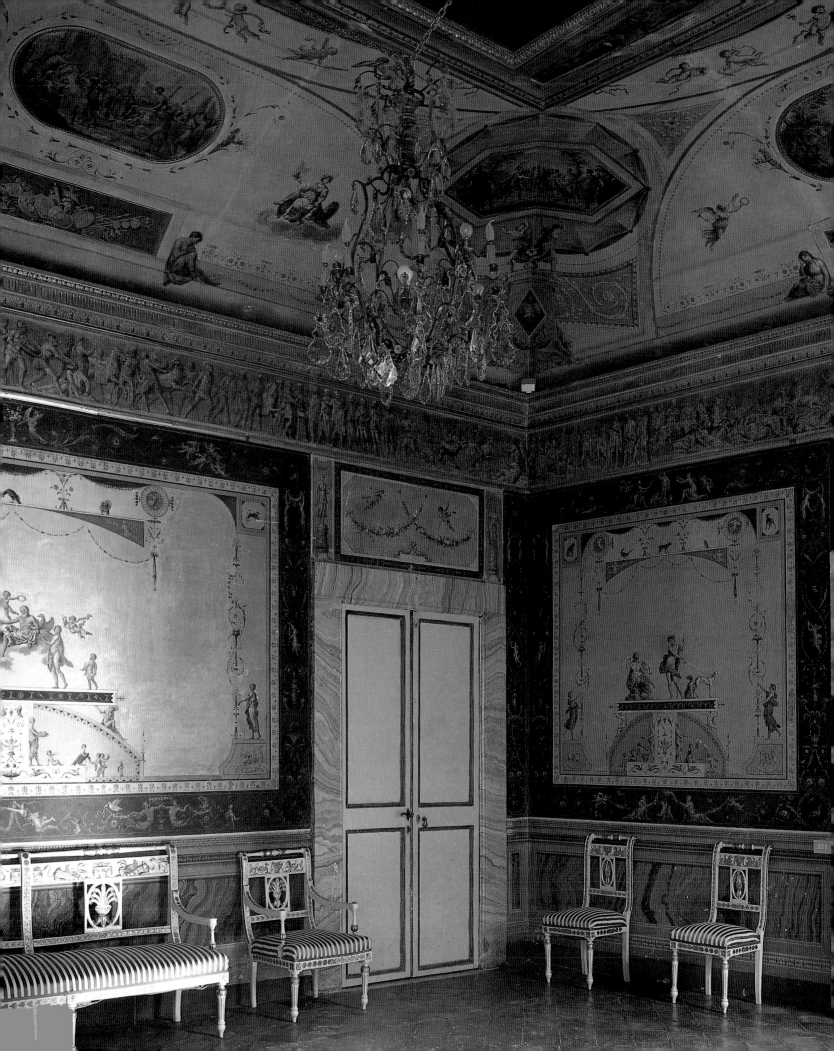

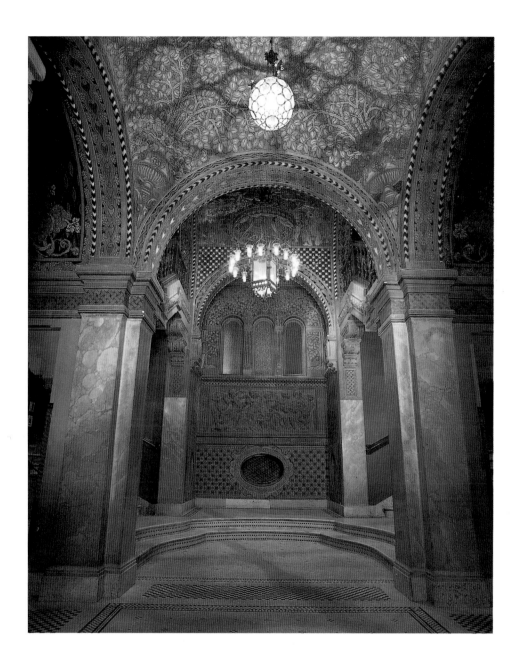

Palazzo Taverna

From the street the palace is entered by way of a ramp, an indication of its great antiquity; indeed there was a fortress on the site as early as the twelfth century, occupied at that time by the Orsini family. Over the centuries the building has been repeatedly remodelled in accordance with changing fashion. In the early nineteenth century, with the arrival of the French under Napoleon, a wing of the palace was redecorated in the First Empire style (left and below). The neo-classical murals are some of the finest of their kind in the world, rivalling those of Napoleonic Paris.

Quartiere Coppedè

Coppedè is a unique suburban development of luxury apartments and villas, built in 1919-23. The architect, Gino Coppedè, turned his back on the austerity of the modern movement, continuing the rich historicist tradition of the nineteenth century. Through a daring combination of diverse elements derived from the architecture of the past, he developed his own highly idiosyncratic and eclectic style, of which the Quartiere Coppedè represents the ultimate fulfilment.

Embassies

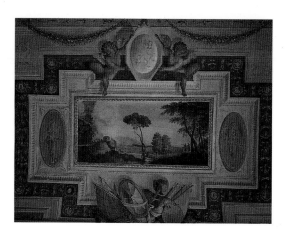

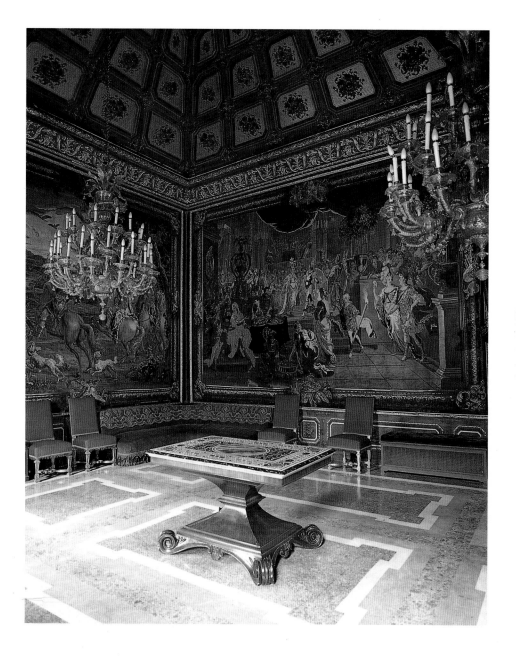

Palazzo Caetani
The Residence of the
Brazilian Ambassador to
the Holy See

Situated on the *piano nobile*
of the sixteenth-century
Palazzo Caetani, the
residence of the Brazilian
ambassador is one of the
most sumptuous of its
kind in the city and an early
example of the neo-classical
style in interior decoration.
The walls and ceiling of the
dining room (above and
right) are decorated in a
manner which consciously
evokes the interiors of
ancient Rome and the
grotesques of Raphael and
his followers. The principal
anteroom (left) has a ceiling
with *trompe-l'oeil* coffering
and precious Flemish
tapestries.

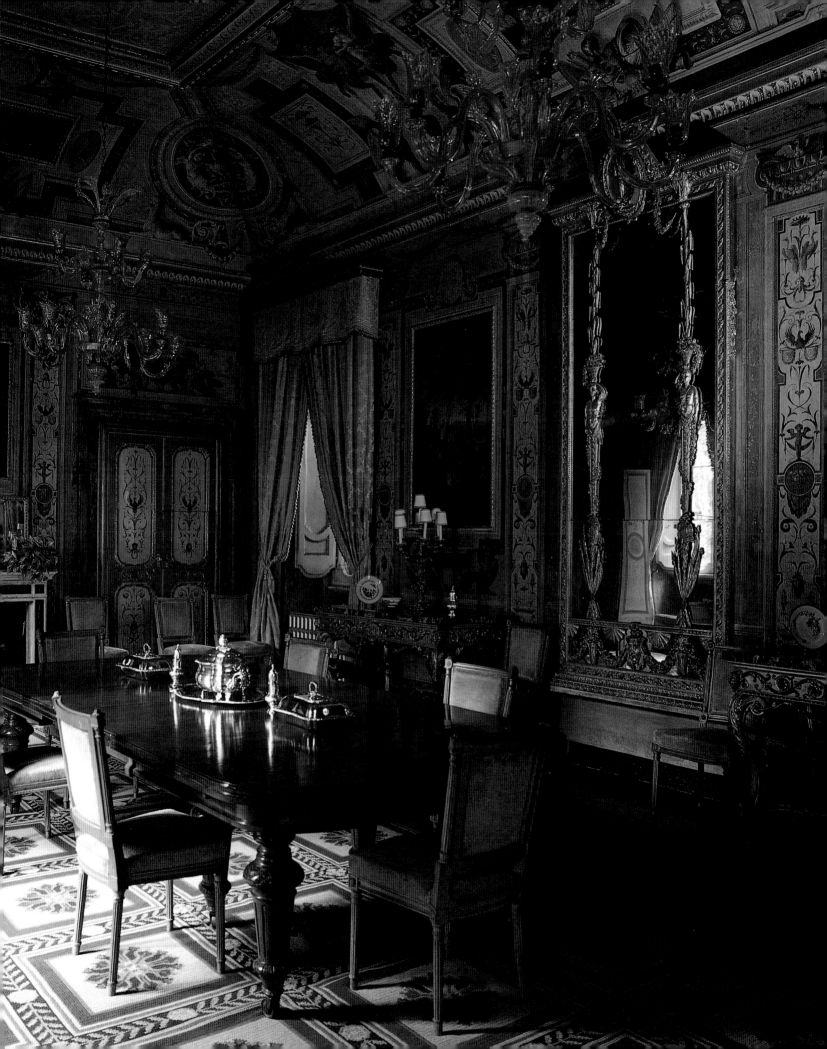

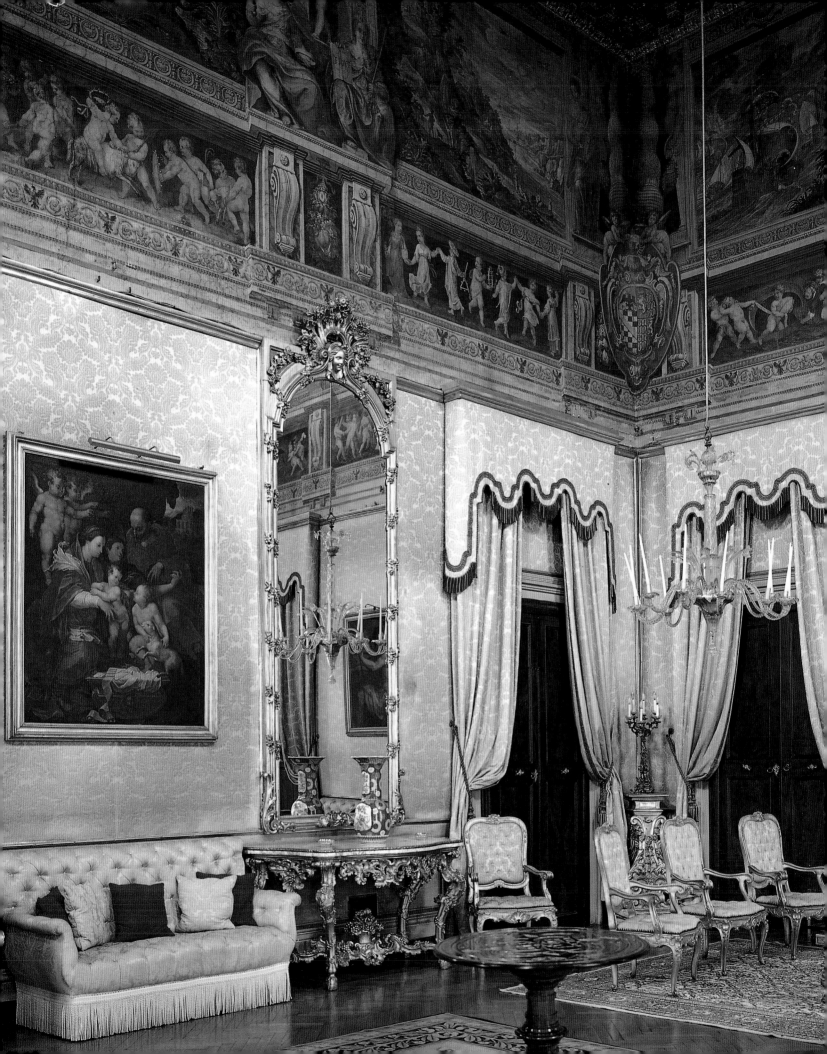

Palazzo Caetani

continued

Most impressive of all is the *Salone* (left) which retains an original cycle of sixteenth-century frescoes by Taddeo Zuccari, together with a priceless collection of eighteenth-century furniture.

Palazzo Borghese
Chancery of the Spanish Embassy to the Italian Republic

The *Sala Rossa* at the Palazzo Borghese is a mid-nineteenth-century meditation on the early nineteenth-century past, recalling the period when Rome was occupied by the French and the marriage was celebrated between the head of the Borghese family and Pauline Bonaparte, sister of the Emperor Napoleon. The marriage was anything but successful; even in dynastic terms it proved a disaster. But the Empire Revival decoration of the *Sala Rossa* is evidence that in subsequent generations the Borghese family looked back with fondness and even pride on this famous episode. The room may have served originally as a setting for musical entertainments, as the ceiling is decorated with paintings representing Orpheus and the Muses. Here, as in other parts of the *palazzo*, the dragon of the Borghese arms is prominently displayed.

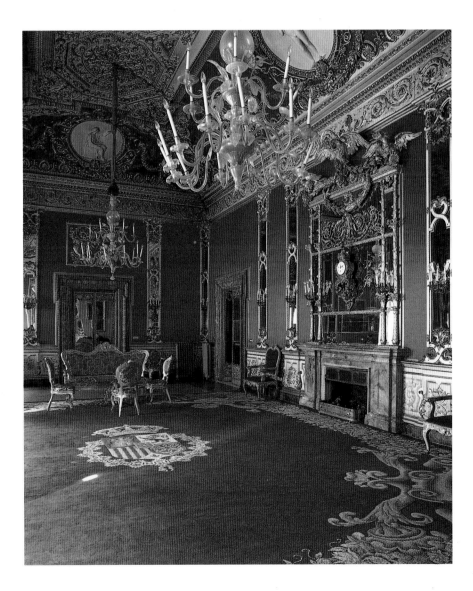

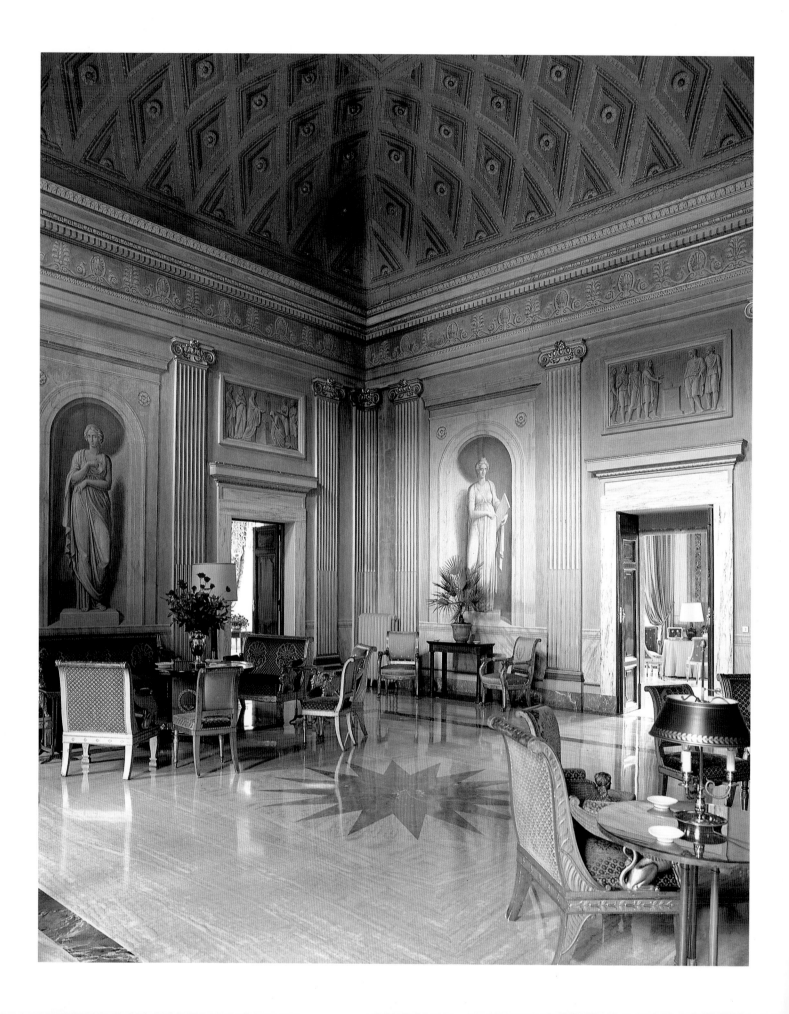

Villa Bonaparte
Residence of the French
Ambassador to the Holy See

Originally built for a
cardinal, this mid-
eighteenth-century villa
was occupied for a time
by the notorious Pauline
Bonaparte, younger sister
of the Emperor Napoleon,
who had settled in Rome
following her marriage to
Prince Camillo Borghese.
Parts of the building are
little changed since Pauline's
day. From a sunny entrance
hall, furnished with Louis
XV armchairs (right), the
visitor ascends to a
magnificent neo-classical
salon (left), the walls lined
with Ionic pilasters flanking
illusionistic murals of
antique statues in niches,
and overdoors painted in
grisaille in imitation of
ancient Roman bas-reliefs.
The classical theme is
continued by the anthemion
frieze and *trompe-l'oeil*
coffering on the ceiling,
together with a magnificent
suite of giltwood First
Empire seating furniture,
carved with winged chimerae
after the fashion of antique
thrones.

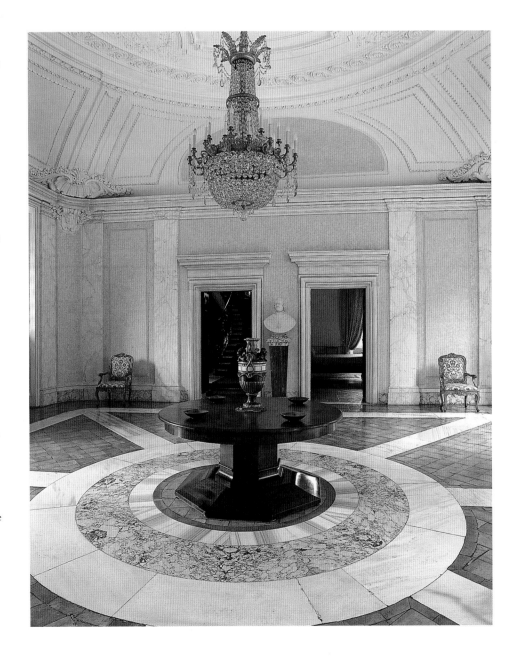

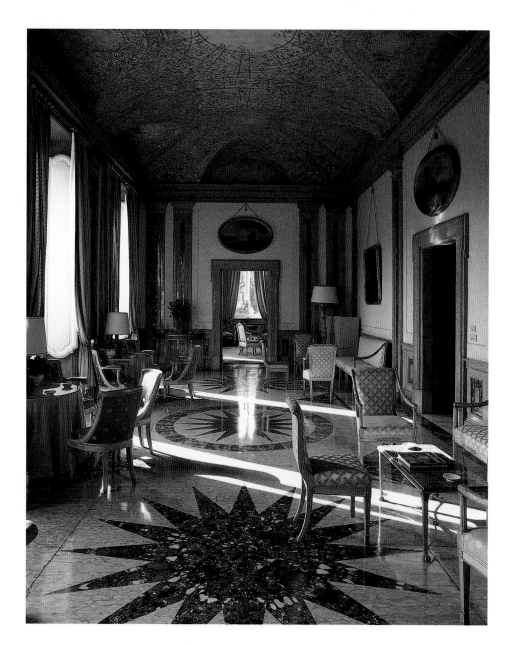

Villa Bonaparte

continued

The *Galleria* (left and above) has a remarkable inlaid marble floor and a vaulted ceiling painted in *trompe-l'oeil* with trellis work and foliage, inspired by the celebrated murals at the Villa Giulia. An interior on the ground floor (right) retains its original Egyptian-style ceiling dating from the early nineteenth century.

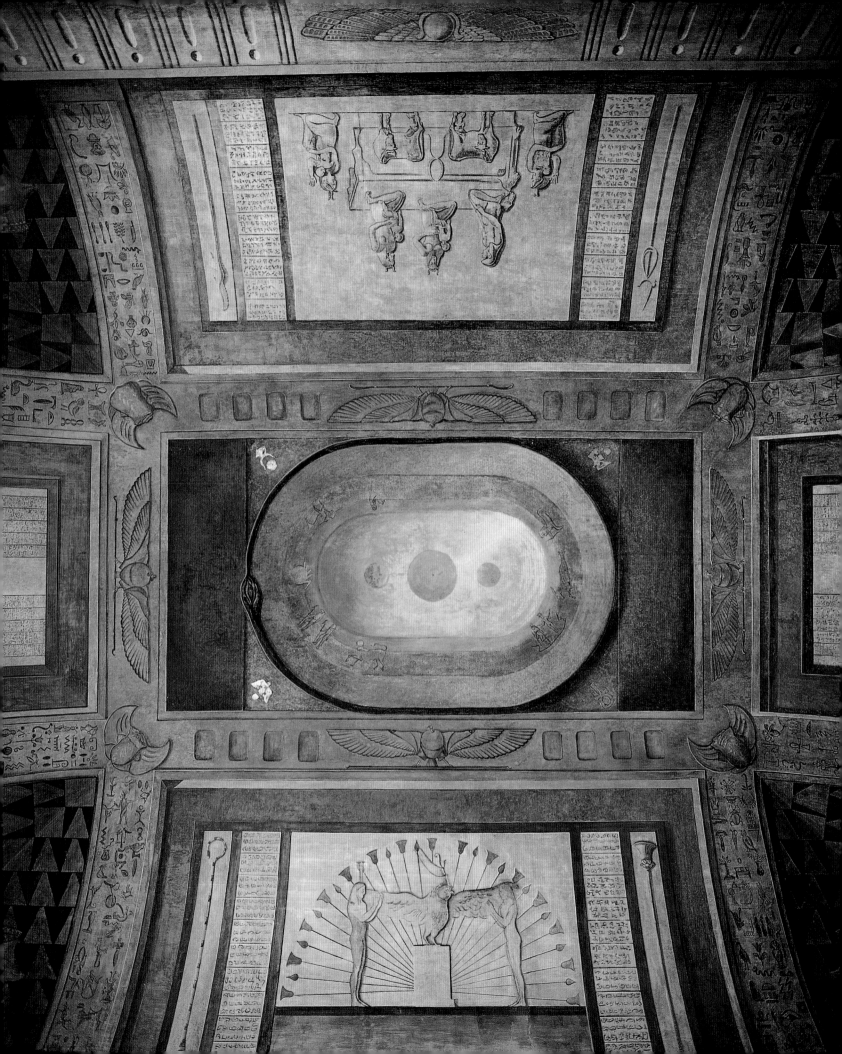

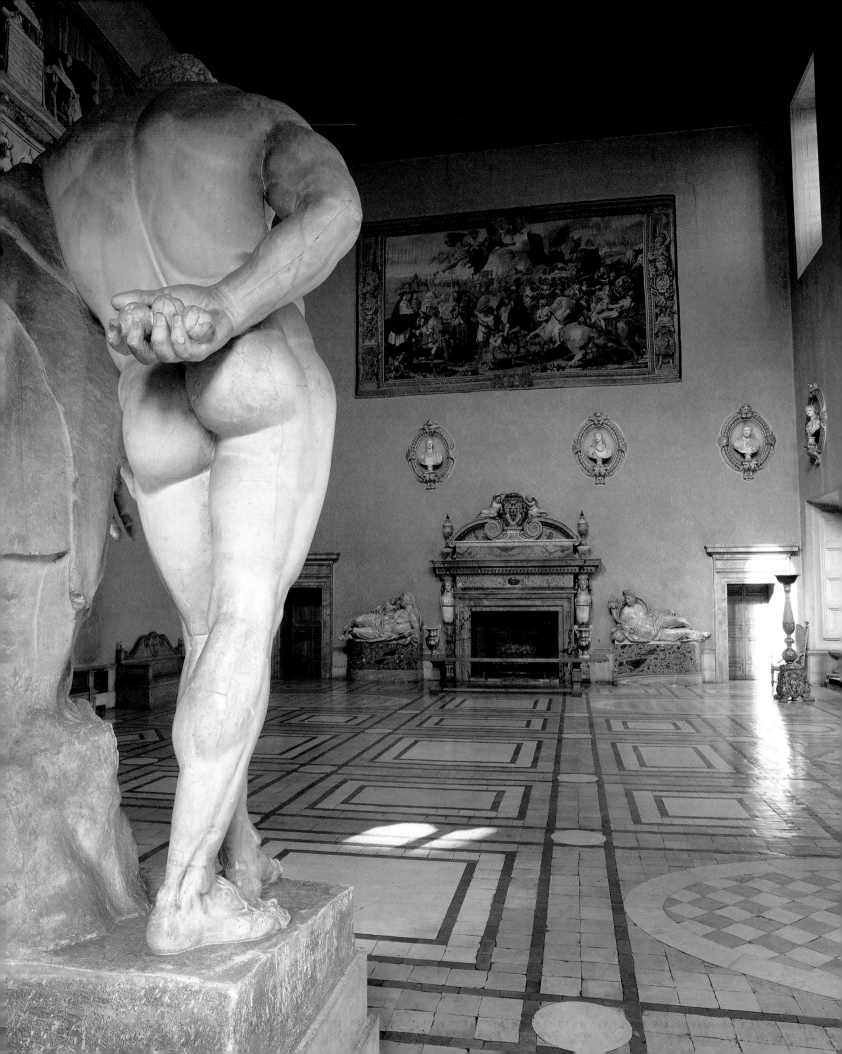

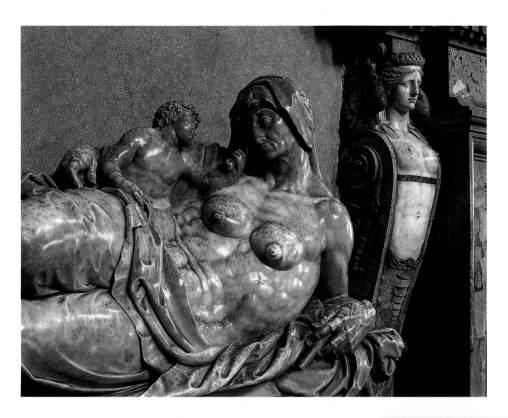

Palazzo Farnese
Residence of the French Ambassador to the Italian Republic

The Palazzo Farnese is a monument to the ideals of the High Renaissance. Begun to the designs of Antonio da Sangallo, the building was continued by Michelangelo and completed by Giacomo della Porta, although decoration of the interior went on into the seventeenth century. The palace bears witness to the personal and dynastic ambitions of the man for whom it was originally built, Cardinal Alessandro Farnese, who in 1534 was elected Pope Paul III. The *Salone d'Ercole* takes its name from a celebrated antique statue of Hercules installed here after its discovery in the ruins of the Baths of Caracalla in 1540. It was later transferred to the National Museum in Naples, but has since been replaced by a copy. The chimneypiece, by Vignola, is flanked by Guglielmo della Porta's *Abundance* and *Piety*. These originally stood on the tomb of Pope Paul III in St Peter's.

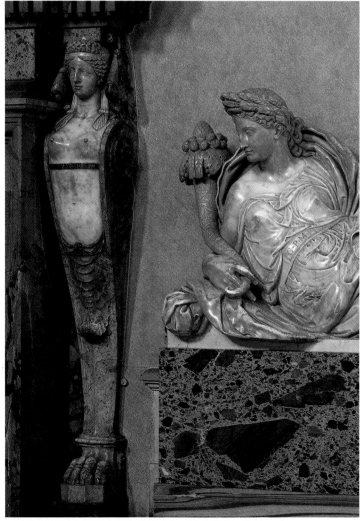

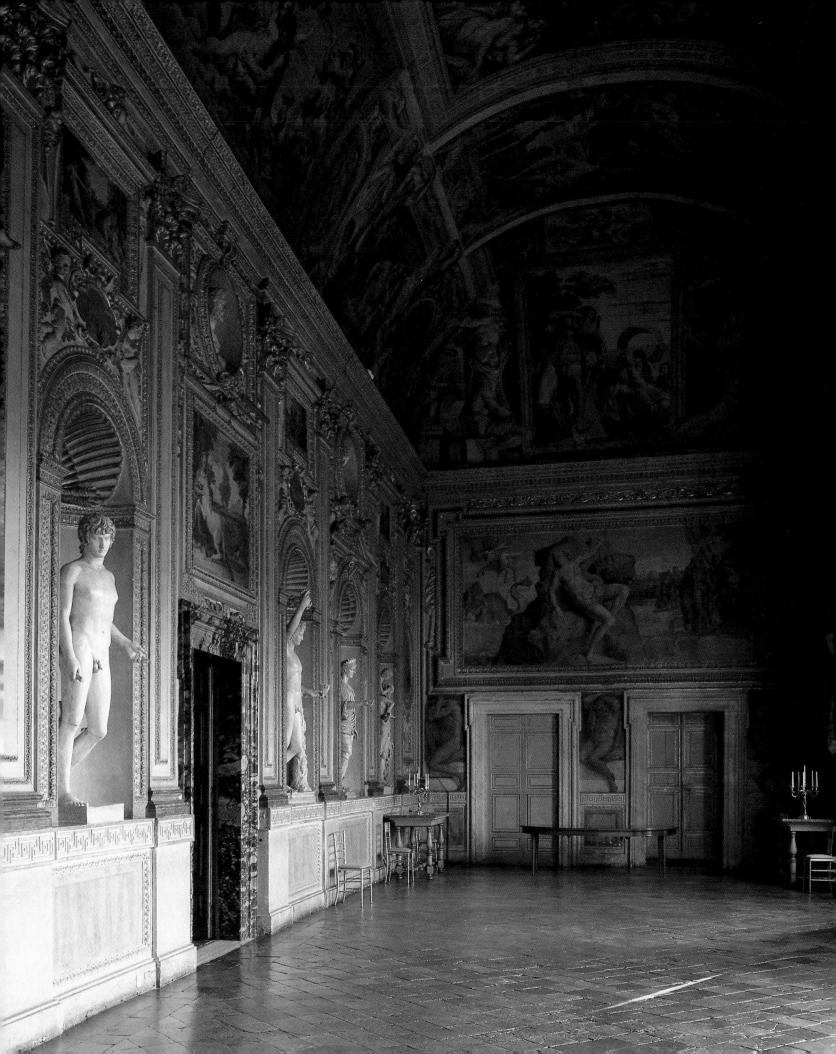

Palazzo Farnese

continued

The famous Gallery (left) was decorated by the Bolognese master, Annibale Carracci, assisted by his brother Agostino, and by Domenichino and Lanfranco. The principal theme is the loves of the gods of antiquity as related by Ovid in the *Metamorphoses*.

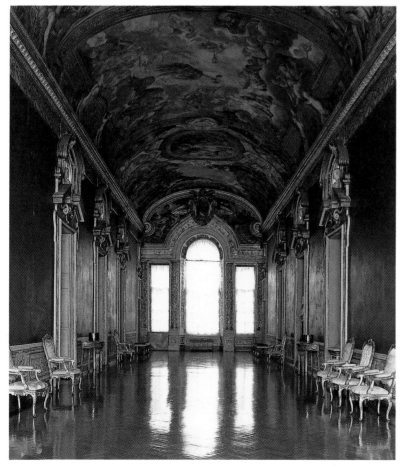

Palazzo Pamphili
Residence of the Brazilian Ambassador to the Italian Republic

The Pamphili family claimed descent from Aeneas and, as a reminder of these genealogical pretensions, the vault of the Gallery of their *palazzo* in Piazza Navona was painted with scenes from the *Aeneid*. The Gallery (left and above) runs the full length of the building and was designed by Borromini around 1647 for Giovanni Battista Pamphili who in 1644 had been elected to the papacy as Pope Innocent X. The size of the Gallery and the opulence of its decoration, by Pietro da Cortona, give the measure of the new Pope's wealth, taste and ambition.

Palazzo di Spagna
Residence of the Spanish
Ambassador to the Holy See

The Palazzo di Spagna,
which gives its name to the
famous piazza, was acquired
by the Spanish government
in 1655. One of the most
extraordinary interiors
is the *Sala Rotonda* (right and
below), a circular salon with
painted decoration by Felice
Giani dating from the first
decade of the nineteenth
century. The walls are
frescoed in *trompe-l'oeil* with
tasselled drapery, while the
ceiling forms an illusionistic
coffered vault ornamented
with birds and *amorini*.

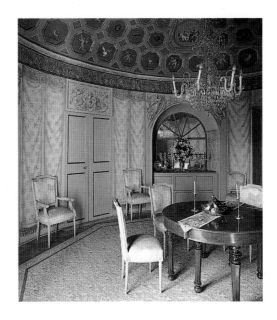

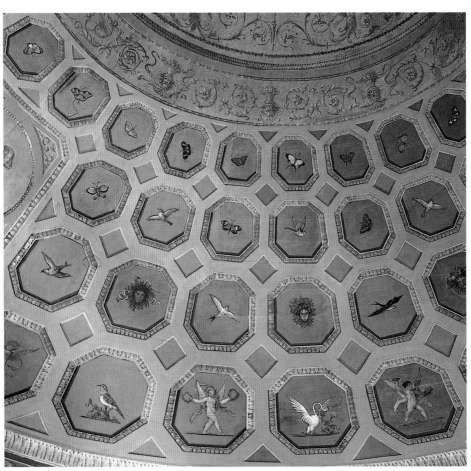

Villa Berlingieri
Residence of the Saudi
Arabian Ambassador
to the Italian Republic

Begun in 1912, the Villa
Berlingieri (right) provides
a reminder of the wealth
and optimism which
immediately preceded the
debacle of the First World
War. Grandiose, extravagant
and exotic, it represents
a fascinating fusion of the
Baroque and Art Nouveau.
The central hall rises
through three storeys from
an inlaid marble floor to
a glass and wrought-iron
skylight framed by frescoes
representing pastoral scenes
by the Venetian painter
Ettore Tito.

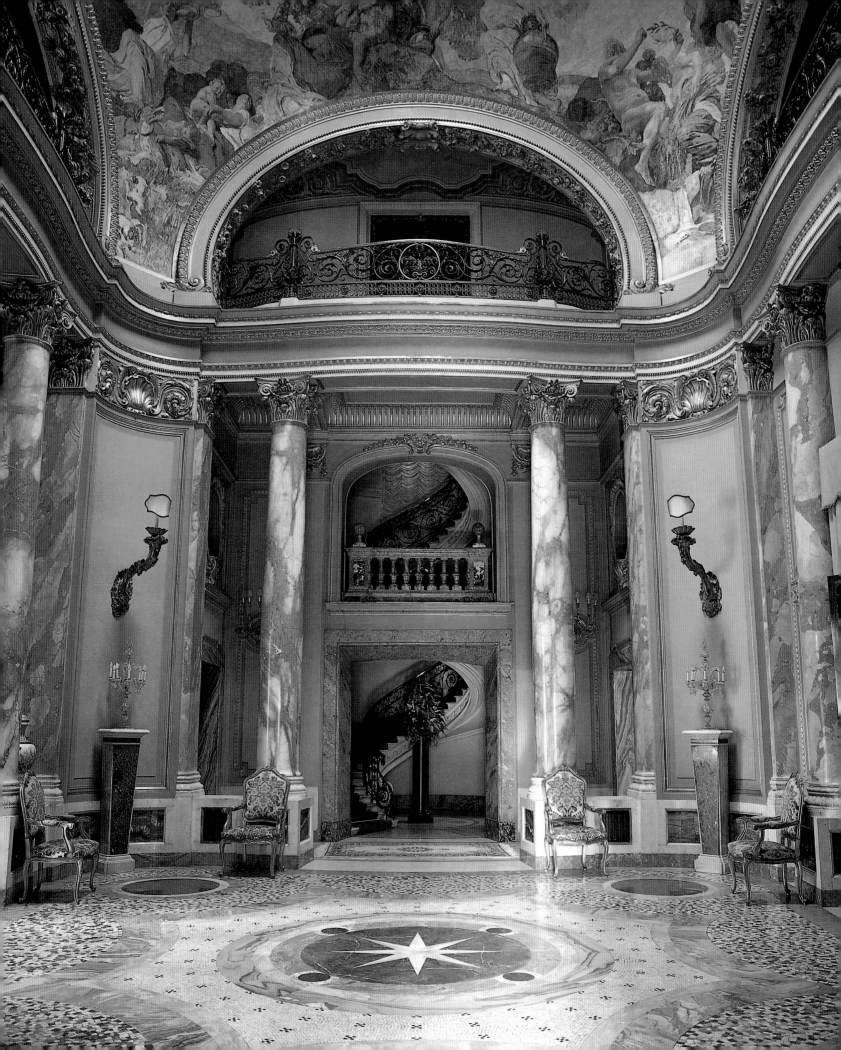

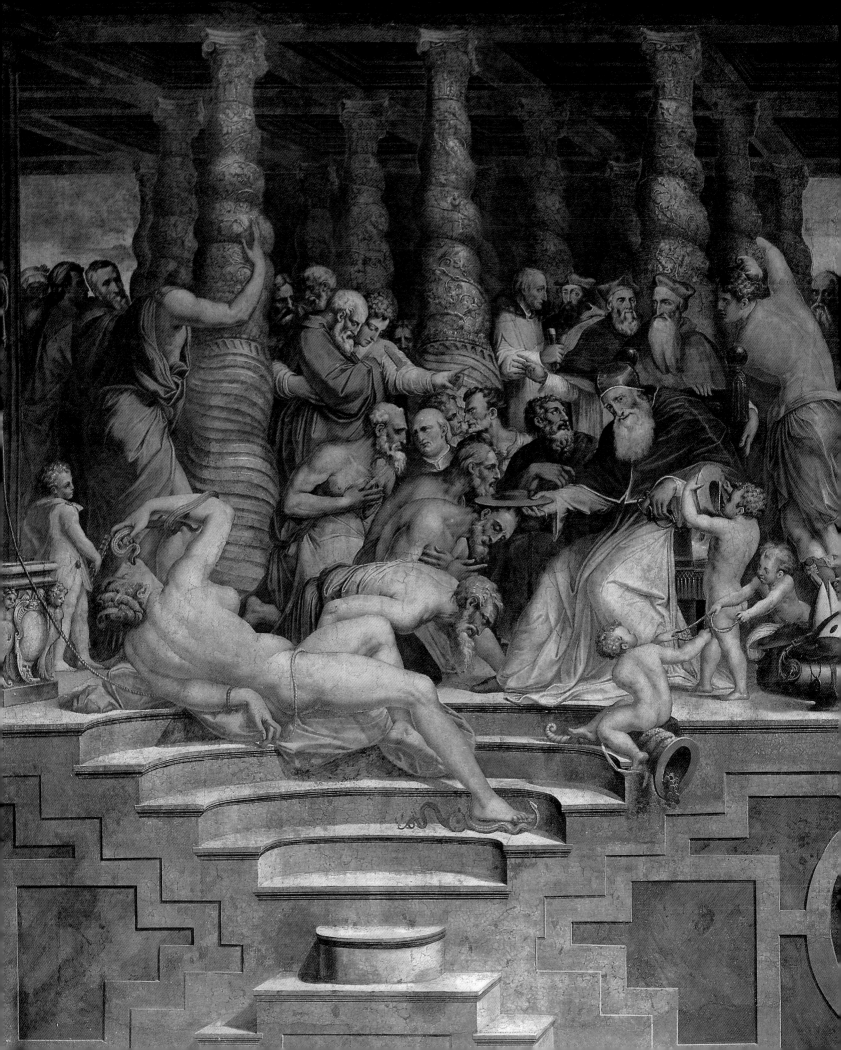

Palazzo della Cancelleria

This imposing Renaissance palace was begun in 1485 as the private residence of Cardinal Raffaele Riario, nephew of Pope Sixtus IV, and is said to have been built with the winnings of a single night's gambling. Under the Medici Pope, Leo X (1513–21), the building was expropriated by the Church and afterwards became the headquarters of the papal chancellery. Even today it remains the property of the Vatican, although situated in the heart of Rome. The principal interior is the *Sala dei Cento Giorni*, so called because the frescoes, by Vasari, were completed in a hundred days. Vasari's subject was the life of his patron Pope Paul III, but most remarkable are the criss-crossing staircases, painted in *trompe-l'oeil*, which demonstrate the artist's technical mastery and his fascination with perspective.

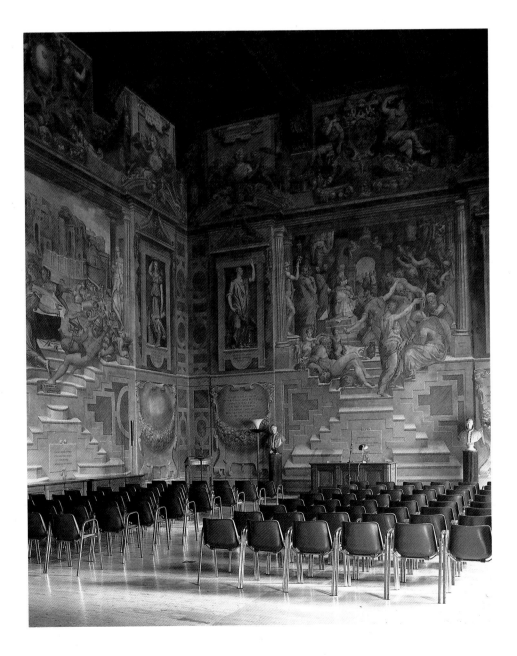

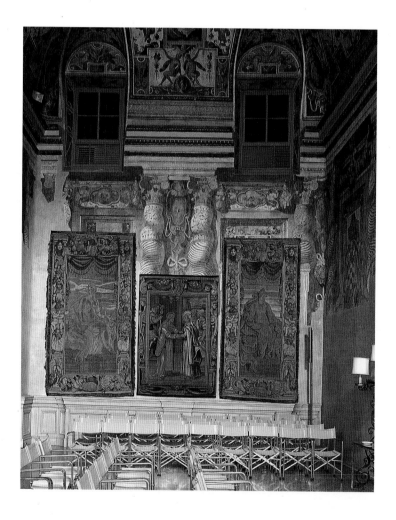

Palazzo Madama
Senato della Repubblica

Home to the Italian Senate since 1871, the old Palazzo Madama contains a magnificent painted interior of the 1880s with murals by Cesare Maccari representing edifying scenes from the history of the ancient Roman Senate (right). Particularly striking is a scene of the blind Appio Claudio being led towards the Senate to exhort the Romans not to accept the humiliating conditions for peace imposed by Pyrrhus. Set into the gilded stucco ceiling are painted panels depicting allegories of a young and innocent Italy in the form of naked children (above). Another building occupied by the Senate is the Palazzo Giustiniani (left), where recent restoration work has uncovered the remains of a remarkable cycle of illusionistic architectural frescoes and grotesque ceiling paintings dating from the sixteenth century.

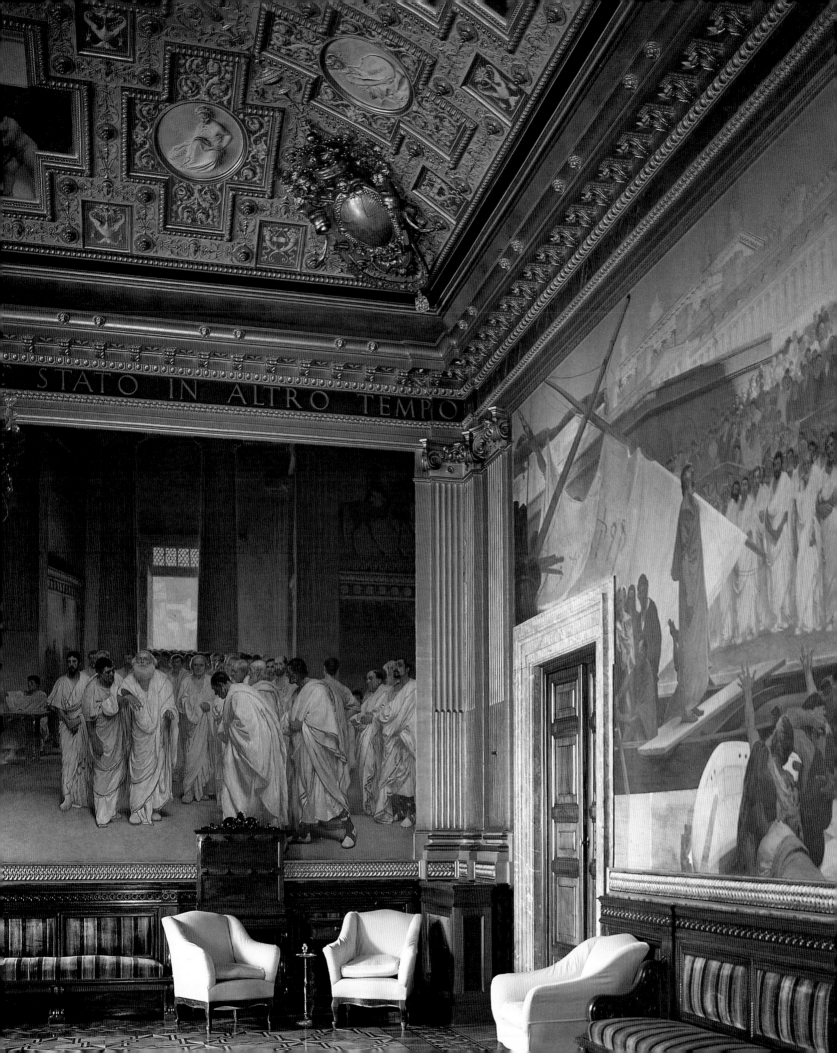

Palazzo Spada
Consiglio di Stato

With interiors ranging in date from the mid-sixteenth to the mid-seventeenth centuries, Palazzo Spada illustrates the transition from the Renaissance to the Baroque. The palace was built for Cardinal Girolamo Capodiferro, who had lived for many years at the Court of François Ier, and the *Galleria degli Stucchi* (right) clearly shows the influence of the celebrated *Galerie François Ier* at Fontainebleau. The interior is the earliest of its kind in Rome and features elaborate plaster decoration by a master *stuccatore* from Modena, Giulio Mazzoni. In 1632 the palace was acquired by Cardinal Bernardino Spada, for whom the interior was substantially remodelled. The *Sala Grande* (below left) was decorated between 1633 and 1635 by Agostino Mitelli and Angelo Michele Colonna, Bolognese painters who frescoed the walls with illusionistic architectural perspectives peopled by playful, colourfully dressed figures. The interior was designed around a famous antique statue, still *in situ*, which, having veins of red running through the marble of the legs, was generally believed to be the statue of Pompey on which Julius Caesar fell bleeding at the moment of his assassination.

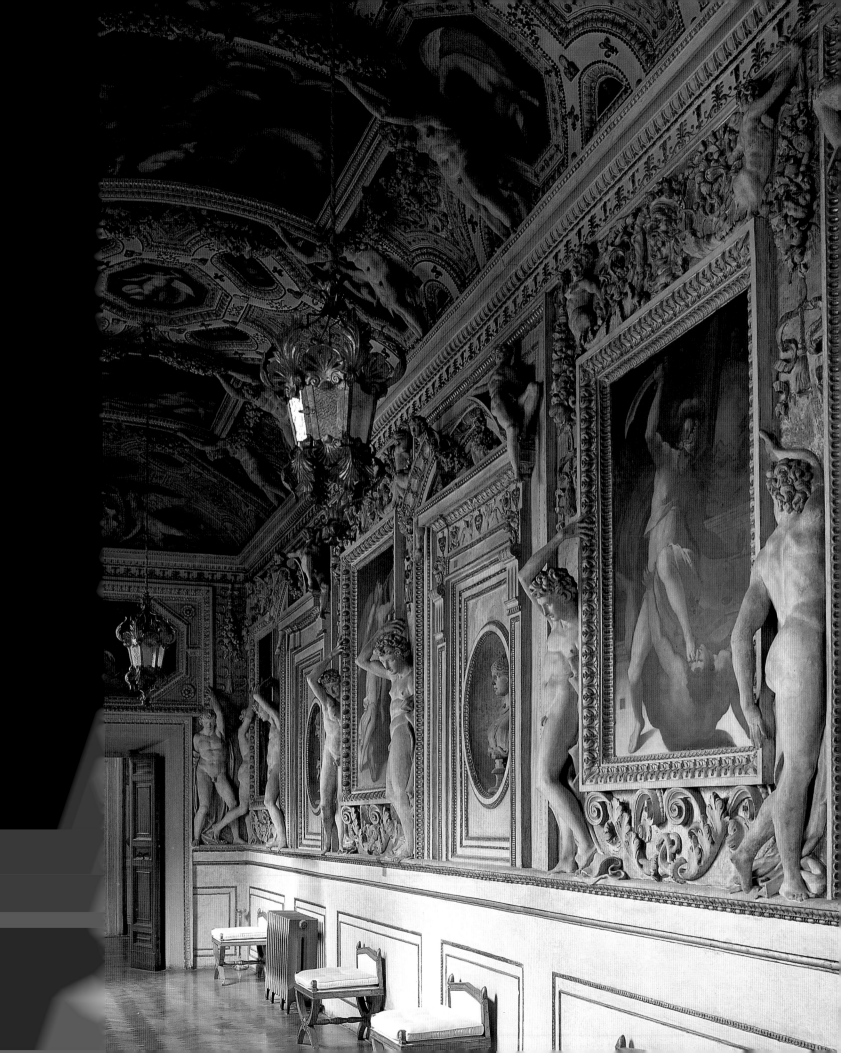

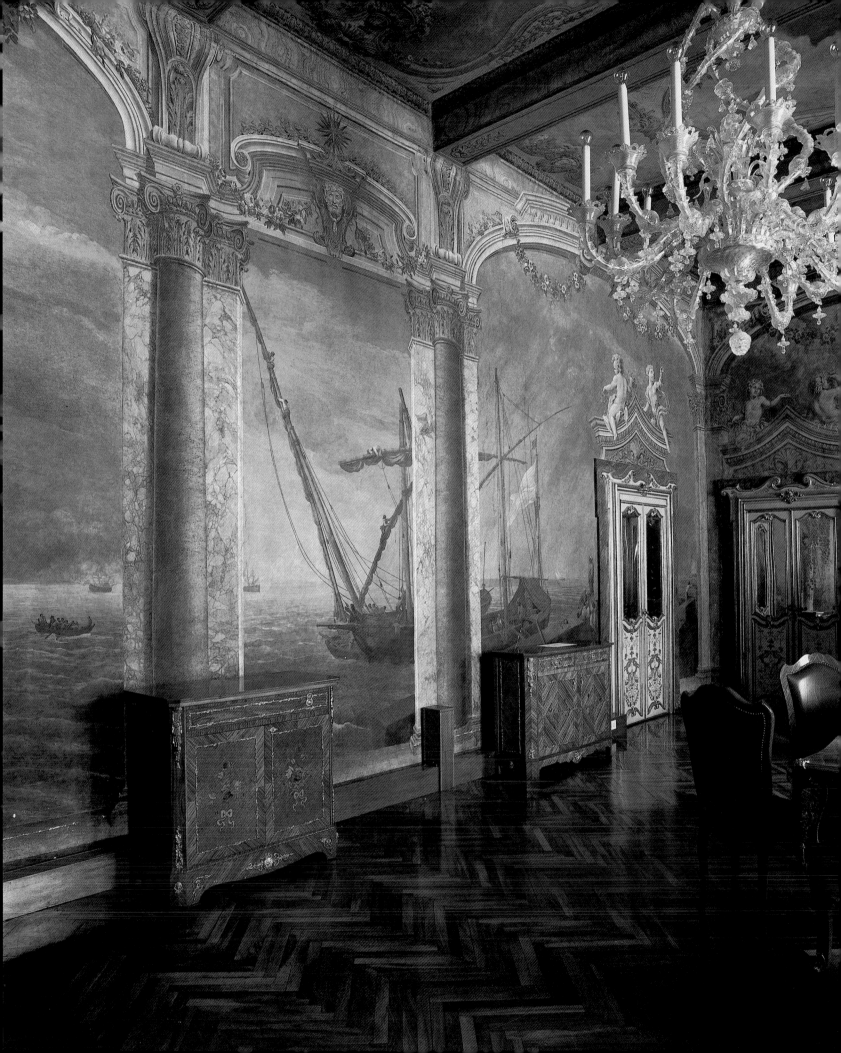

Palazzo Chigi
Presidenza del Consiglio

The *Sala delle Marine* at the old Palazzo Chigi (left) is unique among Roman interiors, with eighteenth-century murals representing atmospheric seascapes glimpsed through *trompe-l'oeil* colonnades. The *Salone d'Oro* (right and below), is an early example of the neo-classical style, and was designed to celebrate the recent marriage of the Chigi heir to the daughter of Prince Odescalchi. The ceiling, with *trompe-l'oeil* coffering, is decorated with figures of Cupid, god of love, and Hymen, god of marriage. Above the cornice are *monti*, lions and other elements derived from the Chigi and Odescalchi arms, while in an angle below (right) is a painting of Cupid and a relief representing a group of *amorini*, agents of love.

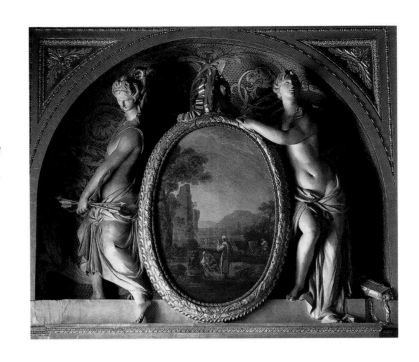

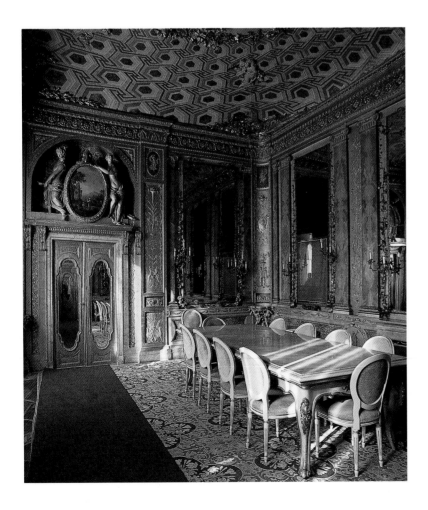

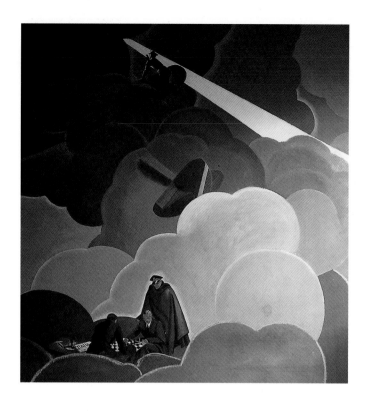

Palazzo Aereonautica
Ministero dell'Aereonautica

Inaugurated in 1930, the
Ministry of Aviation is a
monument to the ideology
and aesthetics of Italian
Fascism. The building was
commissioned by the then
Aviation Minister Italo
Balbo, war hero and close
friend of Mussolini, and
was completed in less than
20 months by engineer
Roberto Marino. The
severe masculine character
of the exterior is offset by
the colourful, sometimes
whimsical decoration of
the interior, governed by the
theme of flight. Italo Balbo's
private study has tempera
murals representing aerial
views of London, New York
and Rio de Janeiro: the three
main stages of his famous
1931 transatlantic crossing.
Other interiors feature
chevron-patterned panelling,
door handles in the form
of aeroplane wings, and
propellor-style ceiling lights,
together with wall paintings
depicting the stars and
planets. Most curious of
all is a mural by Marcello
Dudovich (above left)
representing an aviator's
vision of paradise, with
fallen heroes seated amid
the clouds playing chess
and drinking coffee.

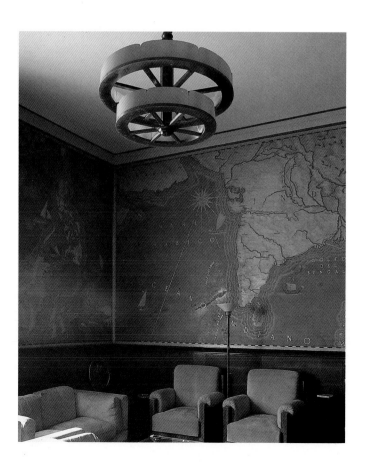

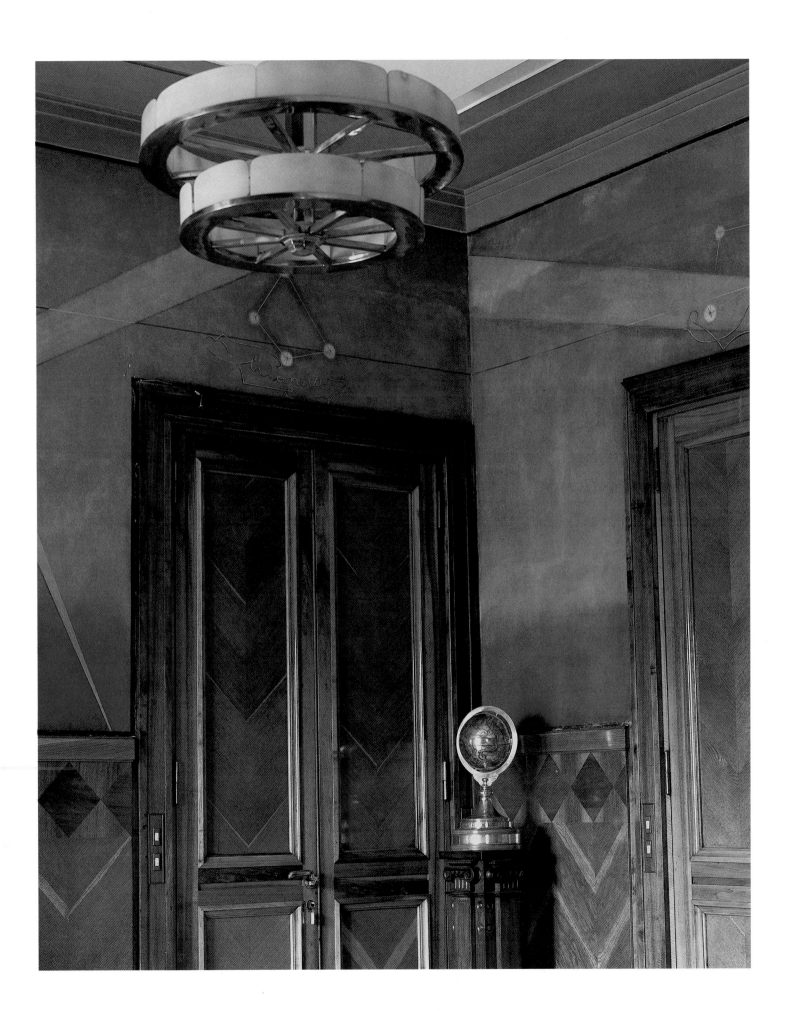

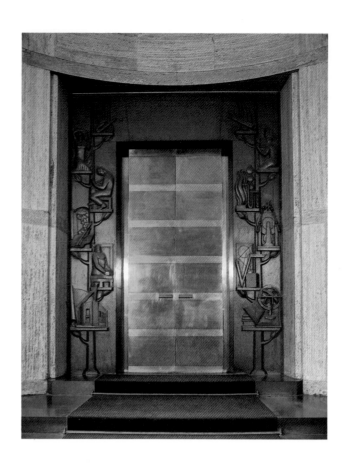

Palazzo dell'Industria
Ministero dell'Industria, Commercio e Artigianato

Much of the original decoration has been lost – destroyed or covered over after the fall of Mussolini in 1943 – but there are areas of the building which are virtually unchanged since its construction by architect Marcello Piacentini in the late 1920s. Mario Sironi, a leading interwar artist, designed the magnificent stained-glass windows (right) above the main staircase (below) with powerful male and female figures set against a modern industrial landscape, symbolizing the regeneration of Italy through mechanization, commerce and craft. In the lobby are green *roia* marble doorcases carved with further allegories of industry by artist Carlo Pini (left).

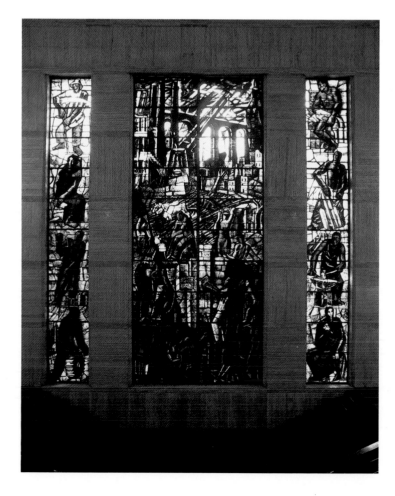

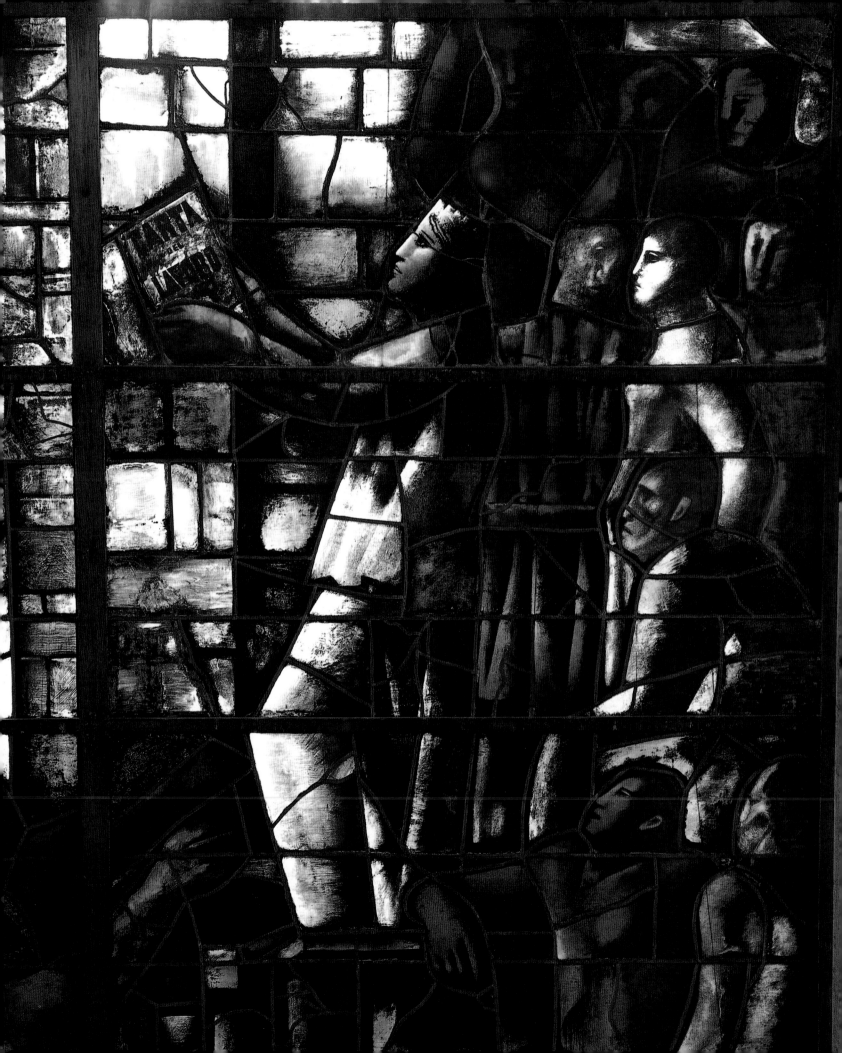

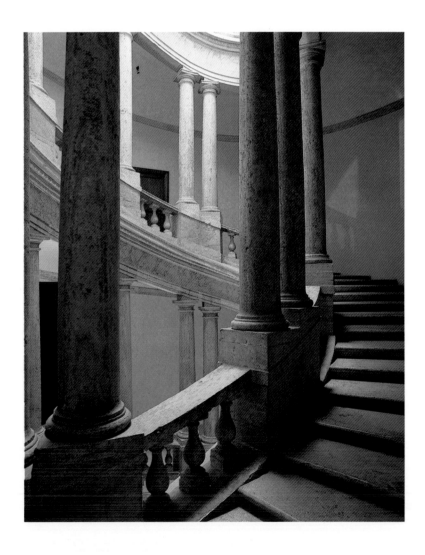

Palazzo del Quirinale
Presidential Palace

The history of the Palazzo del Quirinale is in a sense a microcosm of the history of Rome. The building was begun in the sixteenth century as a papal residence, serving as such until the early nineteenth century, when it was occupied by the French. Although it later reverted to papal ownership, in 1870, following the unification of Italy, it was occupied by the King and has served since the end of the Second World War as the residence of the President of the Italian Republic. The architecture is correspondingly diverse. The earliest surviving feature is an elliptical spiral staircase with coupled Doric columns, designed in *c.*1583 for Pope Gregory XIII by Mascherino (left and right) and clearly inspired by Bramante's celebrated staircase in the Belvedere tower at the Vatican.

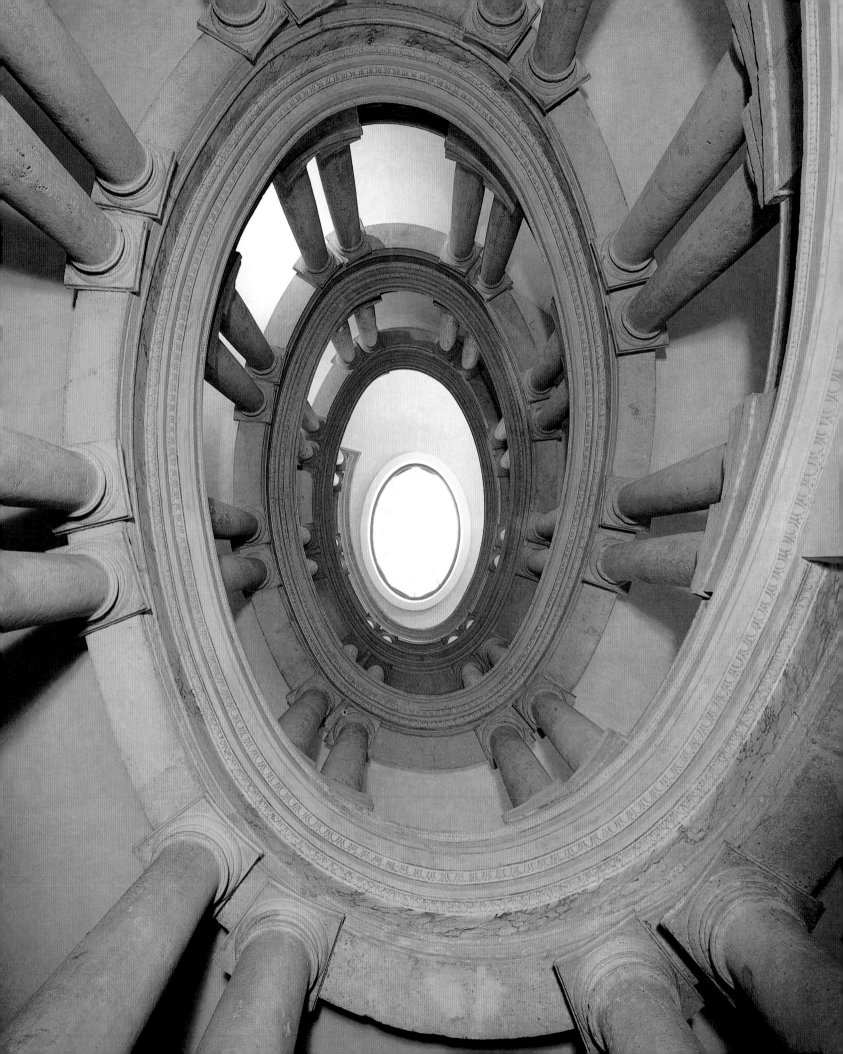

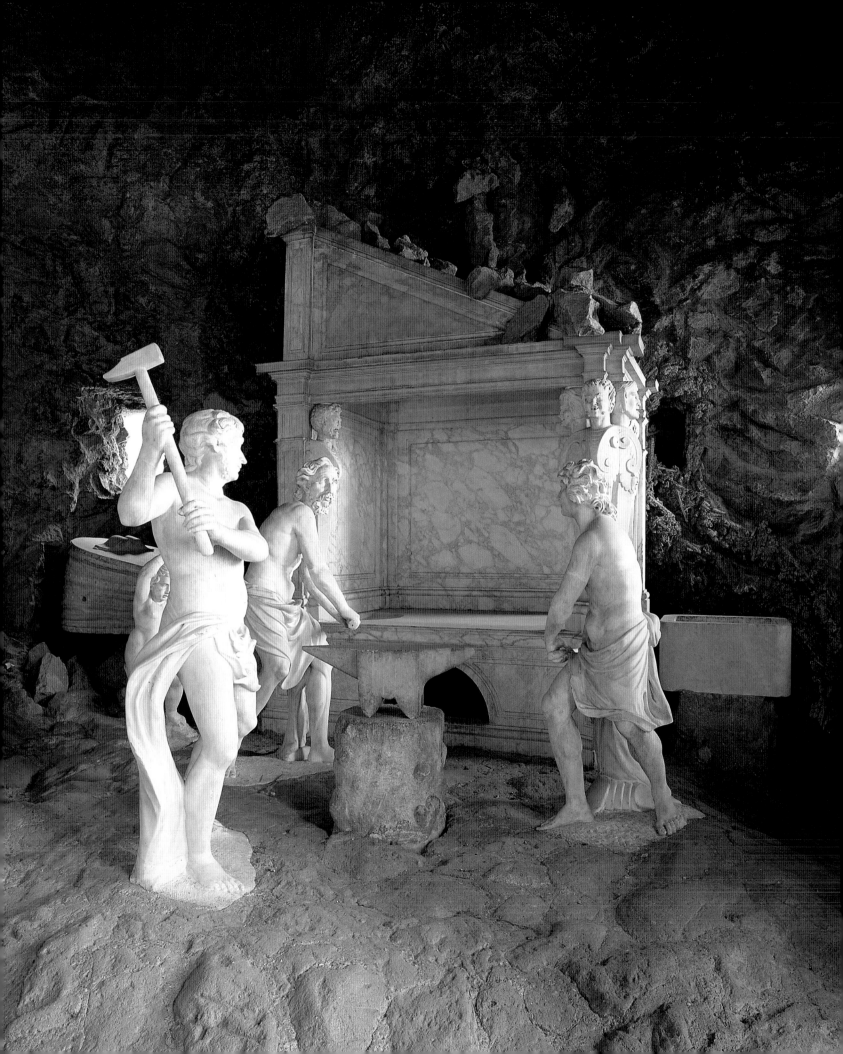

Palazzo del Quirinale

continued

The *Fontana dell'Organo* (above and right) dates from the late sixteenth century and was built at the initiative of Pope Clement VIII. Set into the centre of the apse is an ingenious water-powered organ, framed by artificial stalactites and radiating panels in stucco and mosaic representing scenes from nature and the Bible. An adjoining screen leads through to the Forge of Vulcan (left), a nineteenth-century *tableau vivant* with life-size human figures representing the old Roman god of fire and his followers.

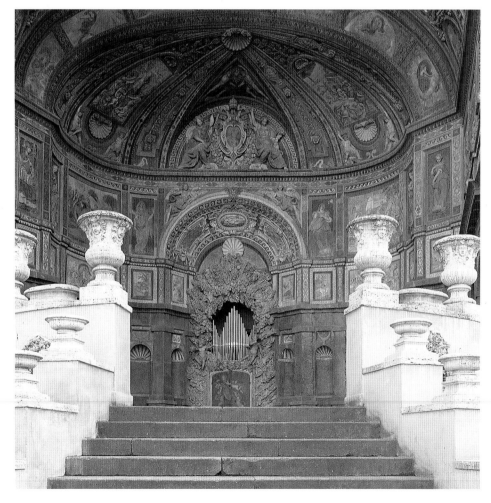

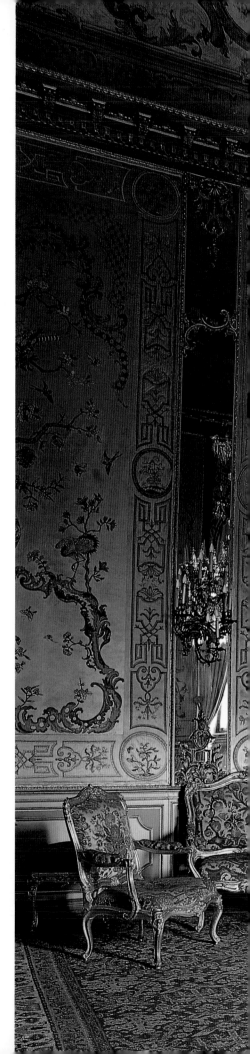

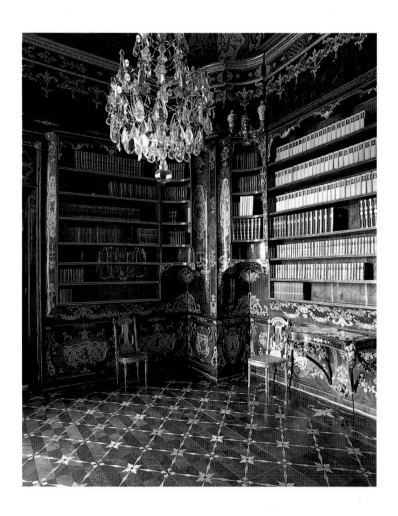

Palazzo del Quirinale
continued

Within the palace itself the period of the monarchy is recalled by the *Sala degli Specchi* and the *Sala degli Arazzi Piemontesi* (right). Although decorated around 1870, the interiors look back to the first half of the eighteenth century, recalling a particularly glorious period in the history of European royalty. Stylistically they provide the ideal setting for a magnificent collection of Louis XV furniture brought to the Quirinale by the Italian royal family from their palaces in Piedmont and elsewhere. The *Biblioteca del Piffetti* (left) likewise dates from the occupation of the Savoia, although it was assembled much earlier, having originally been created in the 1730s for Carlo Emanuele II di Savoia by the celebrated cabinet-maker Pietro Piffetti. Formerly part of the Castello di Moncalieri, near Turin, the whole interior was dismantled and transferred to the Quirinale in 1888. The decoration is a masterpiece of the art of marquetry; the floor, the panelling, the shelves and even the ceiling are of inlaid wood.

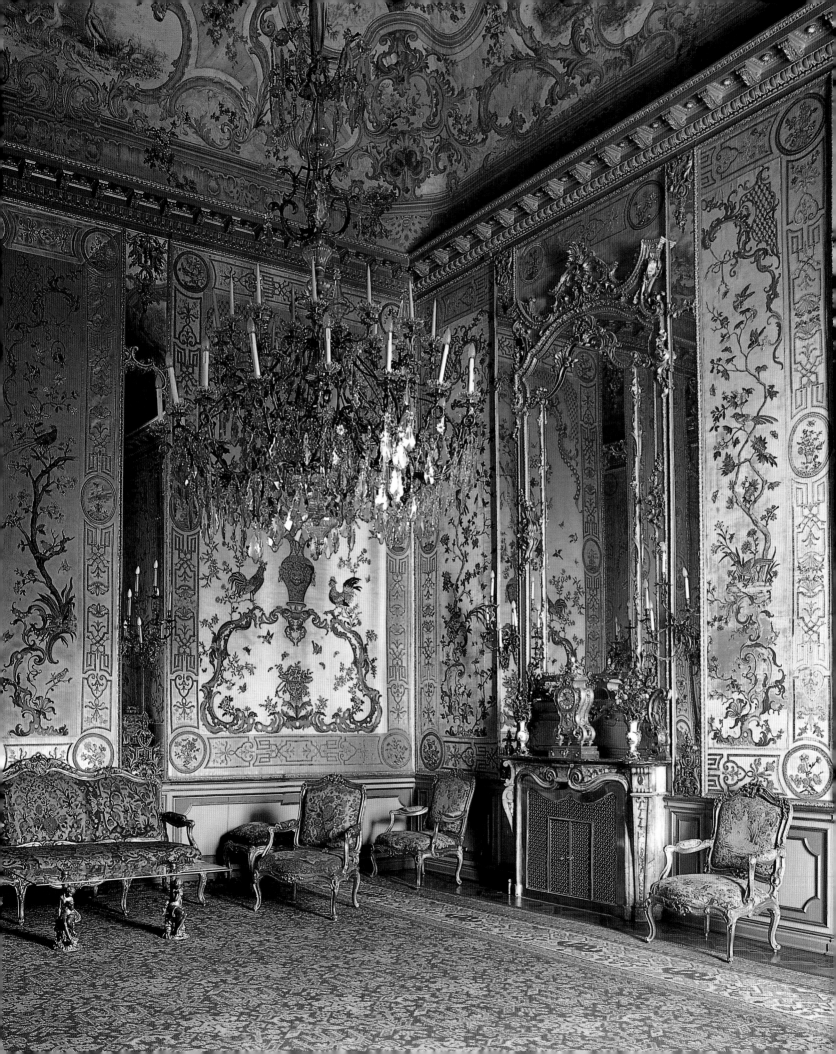

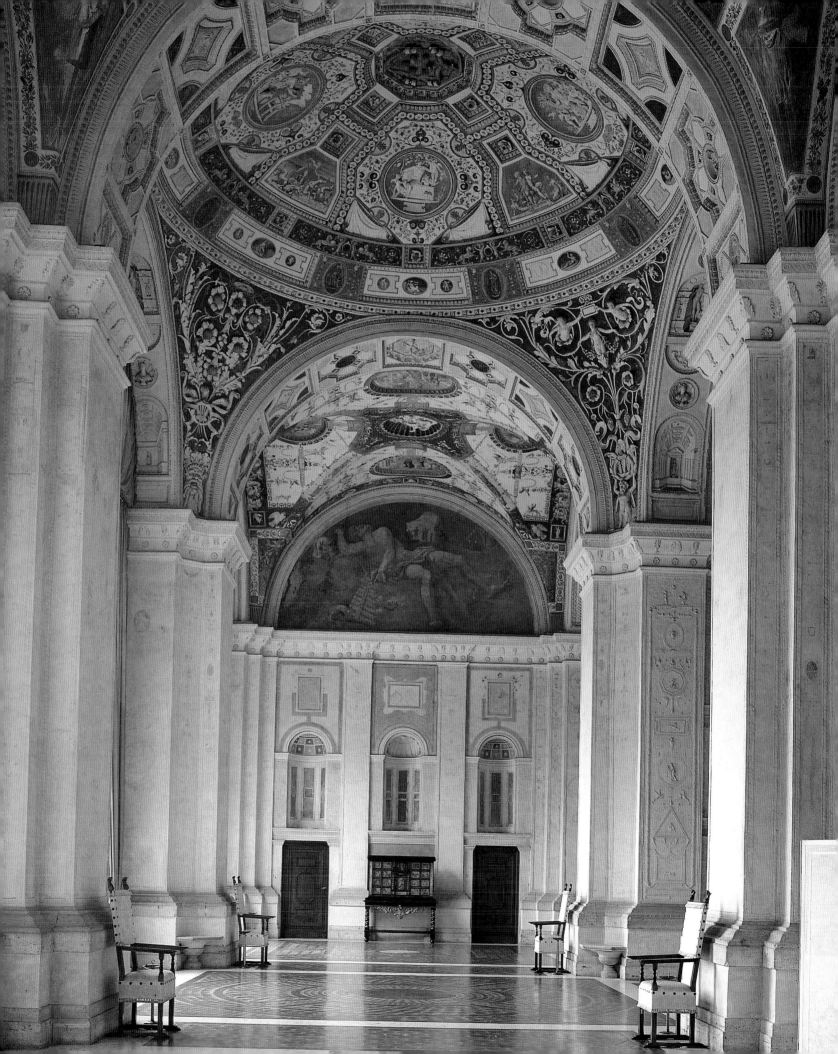

Villa Madama
Ministero degli Affari Esteri

The Villa Madama is
the earliest of the great
Renaissance villas, its
planning and decoration
consciously recalling the
architecture of classical
antiquity. Begun in *c.*1515, the
building was commissioned
by Cardinal Giuliano
de' Medici, afterwards Pope
Clement VII, but it takes
its name the *Madama* from
Margaret of Austria, who
married into the Medici
family and likewise gave her
name to the headquarters
of the Italian Senate. The
architect was Raphael,
although the building
remained unfinished at the
time of his death in 1520
and the decoration was
completed by his pupils
Giulio Romano and
Giovanni da Udine. The
paintings and stucco work
in the Loggia (opposite)
were directly inspired by the
recently discovered remains
of Nero's Palace, the *Domus
Aurea*. Over the entrance
is a double-sided mask
of Janus, the Roman god
of doors and gateways
(above). The chimneypiece
in the *Salone* (left) takes
the form of a giant
Ionic capital.

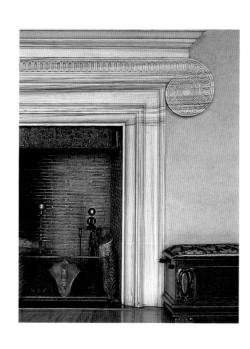

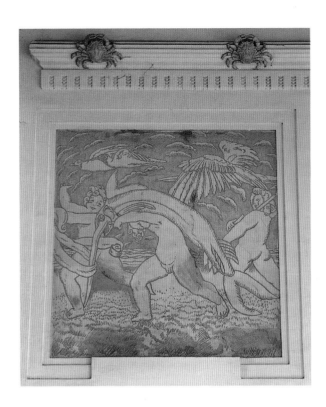

Stazione di Porta San Paolo

It is from this station that trains depart for the seaside resort of Ostia and, as a foretaste of the pleasures that lie ahead, the walls are decorated with crabs, scallop shells and a unique series of panels (left) in etched cement representing sea gods, mermaids, frolicking putti and marine animals. Designed by architect Pio Piacentini, the decoration dates from the early 1920s, typifying the light, fantastical style that immediately preceded the rigour of the Fascist period.

Palazzo di Montecitorio
Camera dei Deputati

The *Aula Magna* (principal debating chamber) of the Palazzo Montecitorio (right) is the masterpiece of Sicilian architect Ernesto Basile, who laboured on its design and construction for almost 20 years, from 1908 until 1925. Such was the delay that, by the time the interior was completed, the Liberty-style decoration had long gone out of fashion, displaced by the rationalist aesthetic of the 1920s. The oak-panelled walls are carved with floral swags, lightening the solemn atmosphere of this steep semi-circular room, which occupies the old central courtyard of the palace. The painted frieze by Aristide Sartorio shows a multitude of semi-naked figures, symbolic of the glory of Italy.

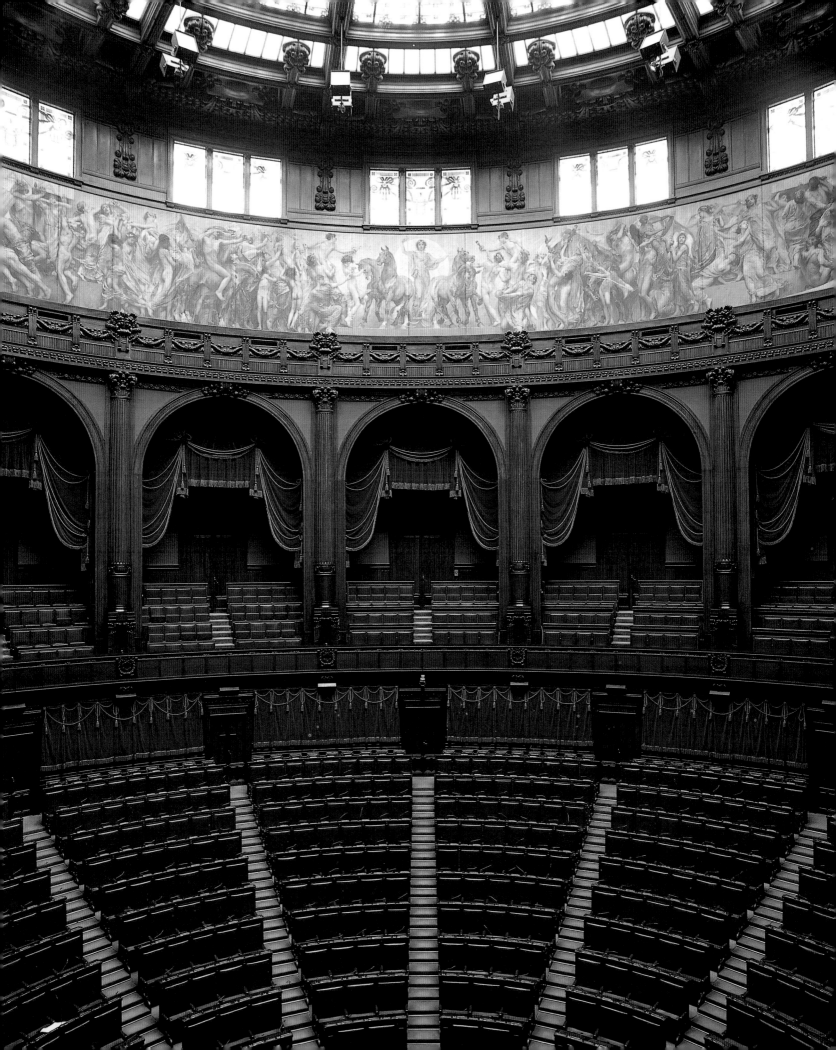

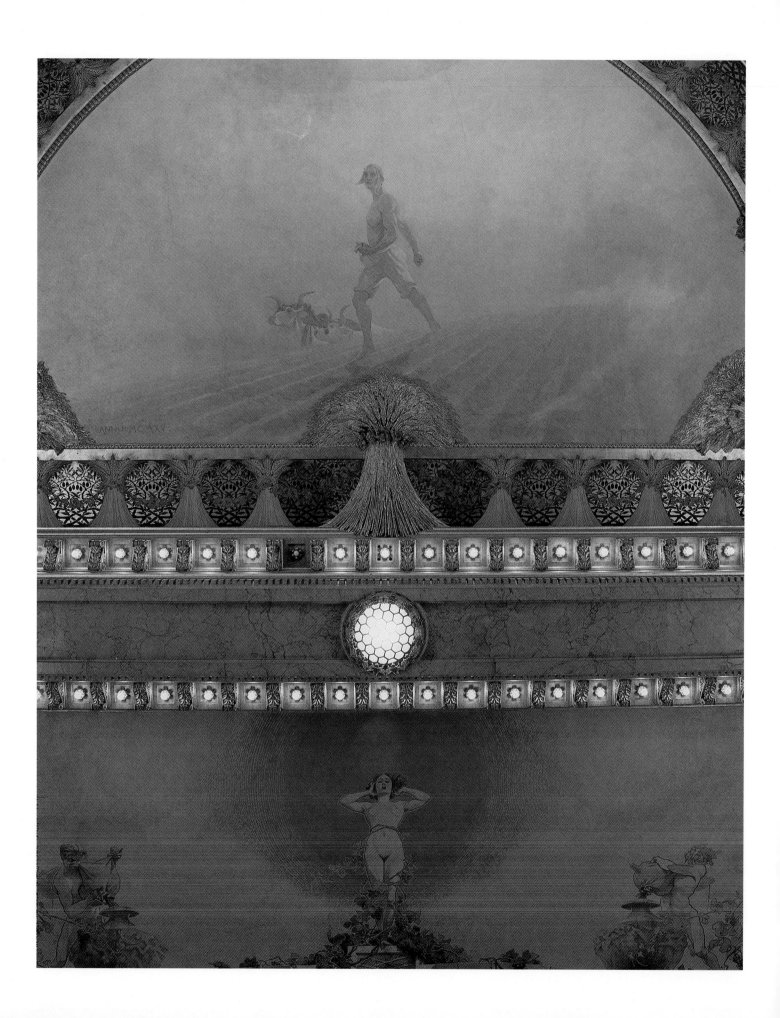

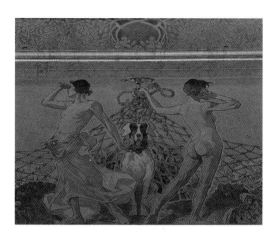 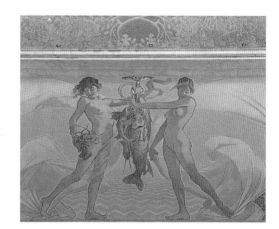

Palazzo dell'Agricoltura
Ministero dell'Agricoltura
e Foreste

Concealed within this solemn, somewhat forgotten building is a remarkable Art Nouveau interior, the *parlamentino* or conference hall, decorated with vibrant murals (above, left and right) and ceiling paintings on the theme of agriculture and fishing. The strong flat colours and heavy outlines are typical of the work of Andrea Petroni, a graphic artist who specialized in poster design. The paintings are accompanied by sheaves of grain in gilded stucco and gilt-metal lights in the form of flowers swarming with bees. The main hall has an inlaid marble floor designed by another graphic artist, G. M. Mataloni, with a floral border entwined with objects of modern industry and technology, such as cameras and sewing machines (below right).

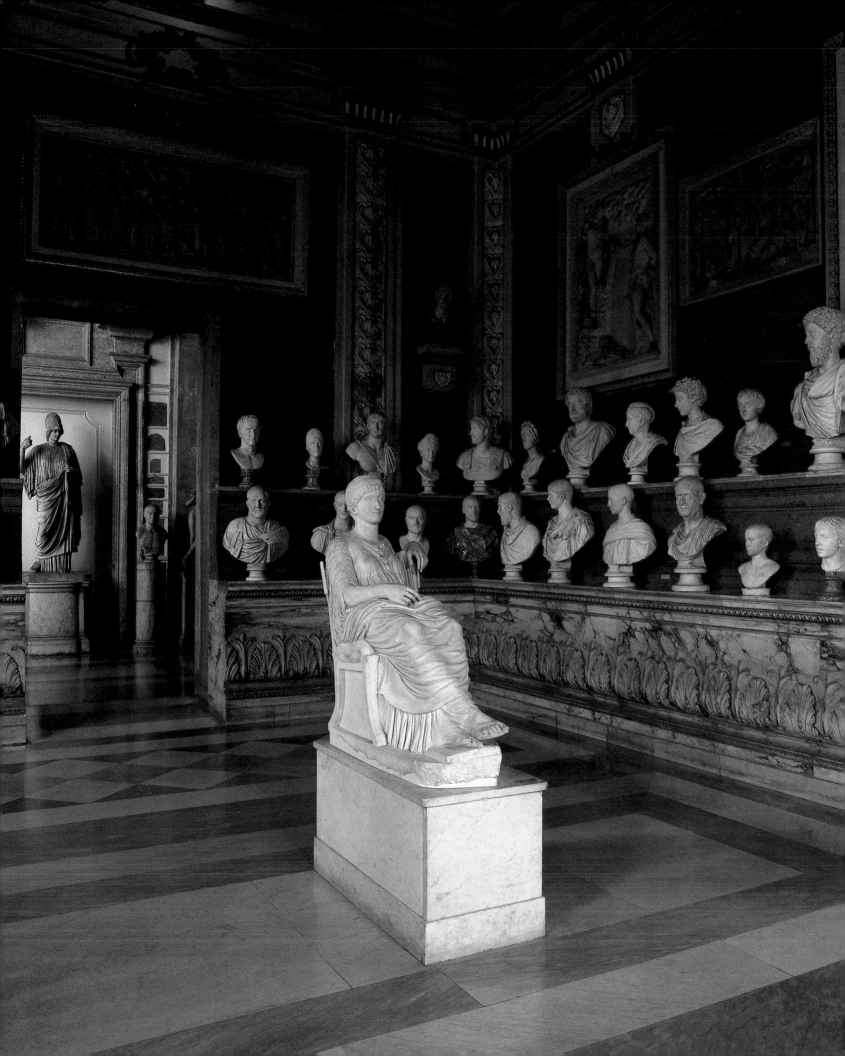

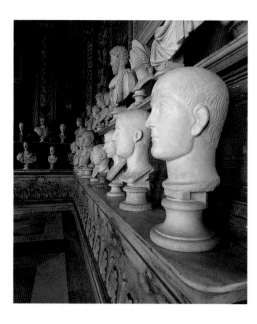

Museo Capitolino

The Museo Capitolino
is the world's first public
museum; treasures of ancient
art have been displayed
here since the late fifteenth
century. The *Sala degli
Imperatori* (left and above)
takes its name from the 66
busts of Roman emperors
lining the walls, arranged in
chronological order and
accompanied by a centrally
placed statue of Helena,
mother of Constantine.
The display is virtually
undisturbed since the
eighteenth century,
providing a fascinating
lesson in the history of
museology.

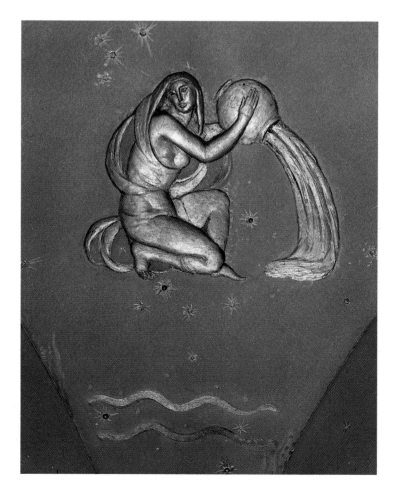

Palazzo Venezia

Mussolini understood
the connection between
architecture and power,
choosing as his headquarters
one of the largest and most
conspicuously sited palaces
in Rome, the Palazzo
Venezia, originally built
for Pietro Barbo, a Venetian
cardinal who in 1464 was
elected to the papacy
as Pope Paul II. Mussolini's
mistress, Claretta Petacci,
had her own set of rooms
in the palace, decorated
under her direction in the
1920s. One interior retains
its original azure ceiling with
gilded signs of the Zodiac
symbolizing the heavens
(left). The vault itself is
of Renaissance date, but
the reliefs typify the neo-
classical revival of the
interwar period.

Castel S. Angelo

Within the shell of this gruff, forbidding fortress, originally built as a mausoleum for the Emperor Hadrian, is a diminutive early sixteenth-century bathroom (below). The interior was created for Pope Clement VII, who was forced to take refuge here during the sack of Rome. Clement was a Medici, a man of refined sensibilities who was wise enough to put the resources of the Church behind the leading artists of the day. The decoration of the bathroom is traditionally ascribed to Raphael's pupil Giovanni da Udine and, although intended for the use of the pontiff, features erotic scenes involving the pagan gods of antiquity.

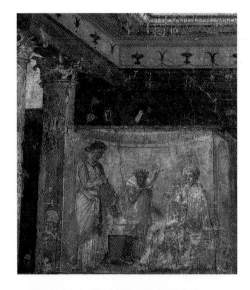

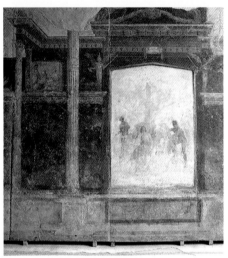

Casa di Livia e di Augusto

Two thousand years have passed, the building is now a ruin, but the decoration of the House of Livia, wife of the Emperor Augustus, is still remarkably fresh (above). The structure is believed to have formed part of a much larger complex of buildings which together made up the Palace of Augustus. In recent years the Emperor's private apartments have been excavated and are currently being restored. Although work continues, the intricacy and beauty of the decoration is already apparent, especially in the *Sala delle Maschere* (Room of the Masks), dating from *c.* 25 BC (right).

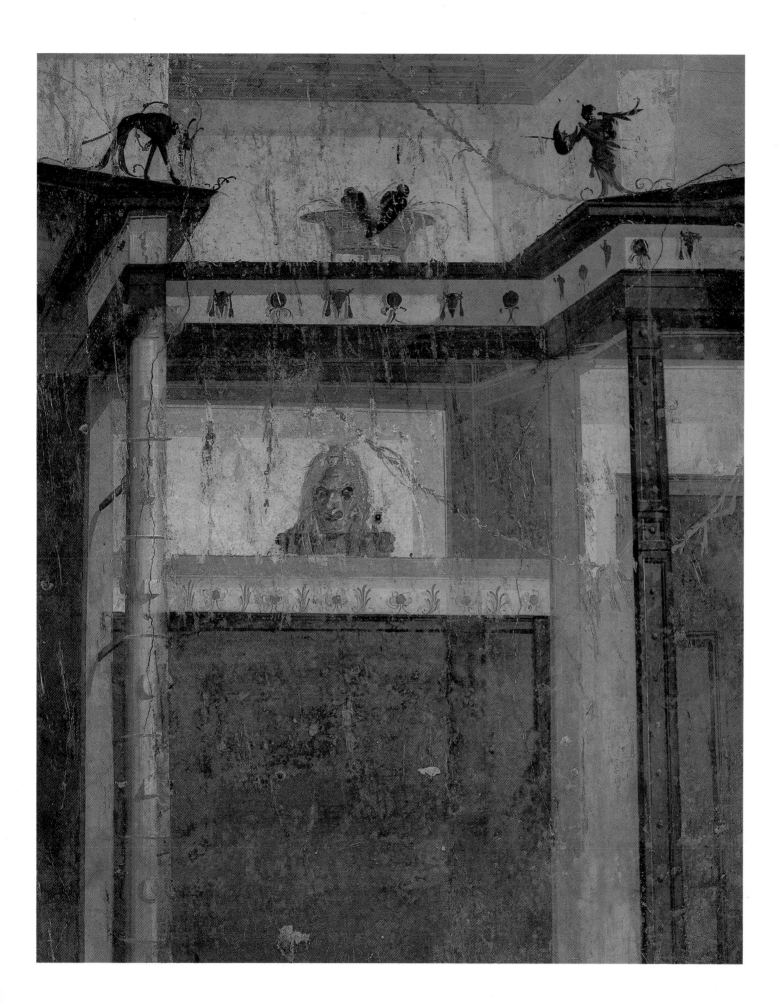

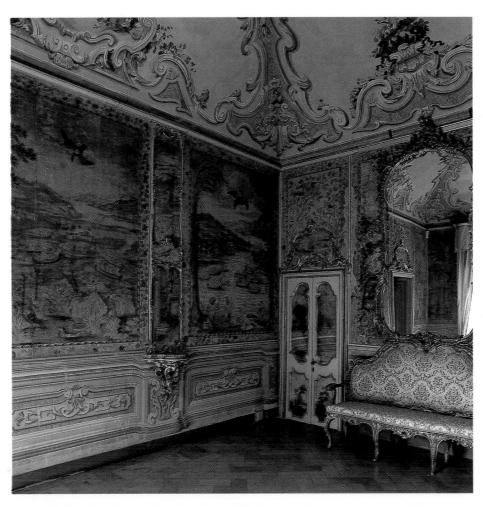

Palazzo Barberini

The Palazzo Barberini is famous throughout the world for the outstanding collection of paintings displayed on the *piano nobile*. Less well known is the old family apartment on the second floor, created in the eighteenth century for the Barberini heiress and her husband Prince Giulio Cesare Colonna di Sciarra following their wedding in 1728. Intimate in size yet richly decorated, these colourful, fantastical interiors are far removed from the pomp and grandeur of the apartments on the floors below, marking the transition from the Baroque to the Rococo. Curvaceous pier glasses and foliated carving offset the rectilinear architecture of the anteroom (above and right), which leads through to an equally ornate interior with silk wall hangings representing American Indians, based on illustrations by Jesuit missionaries (left).

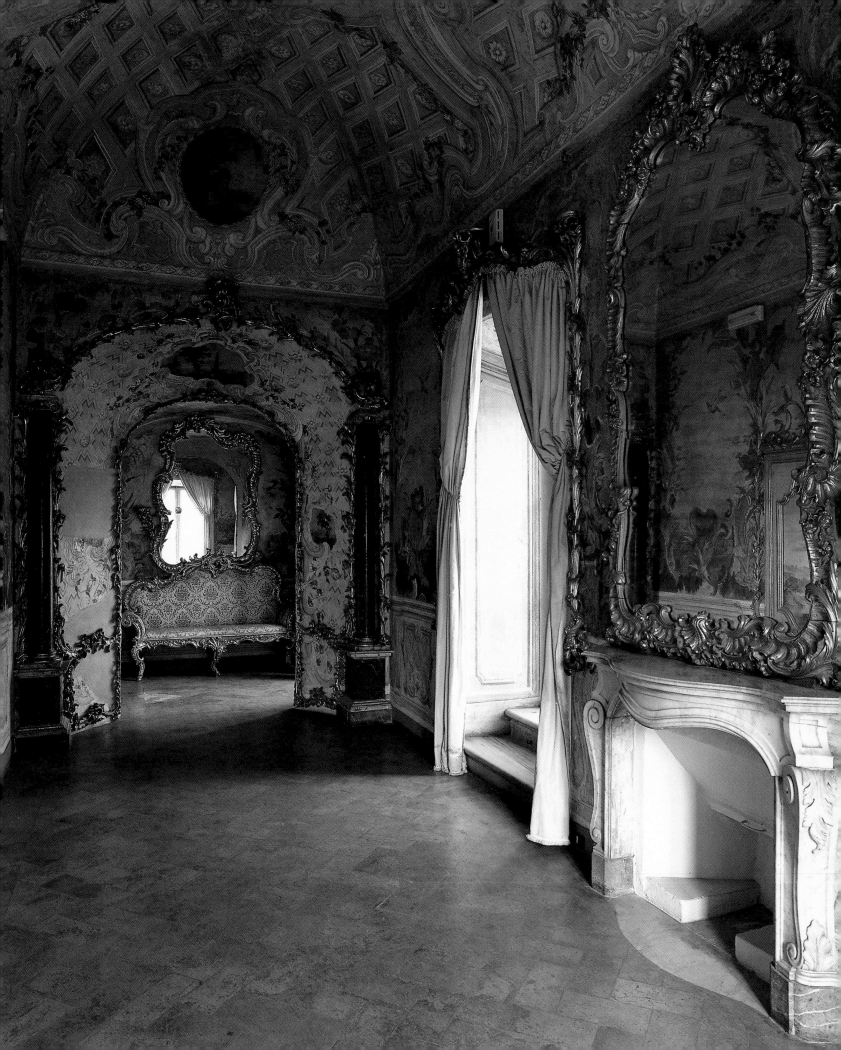

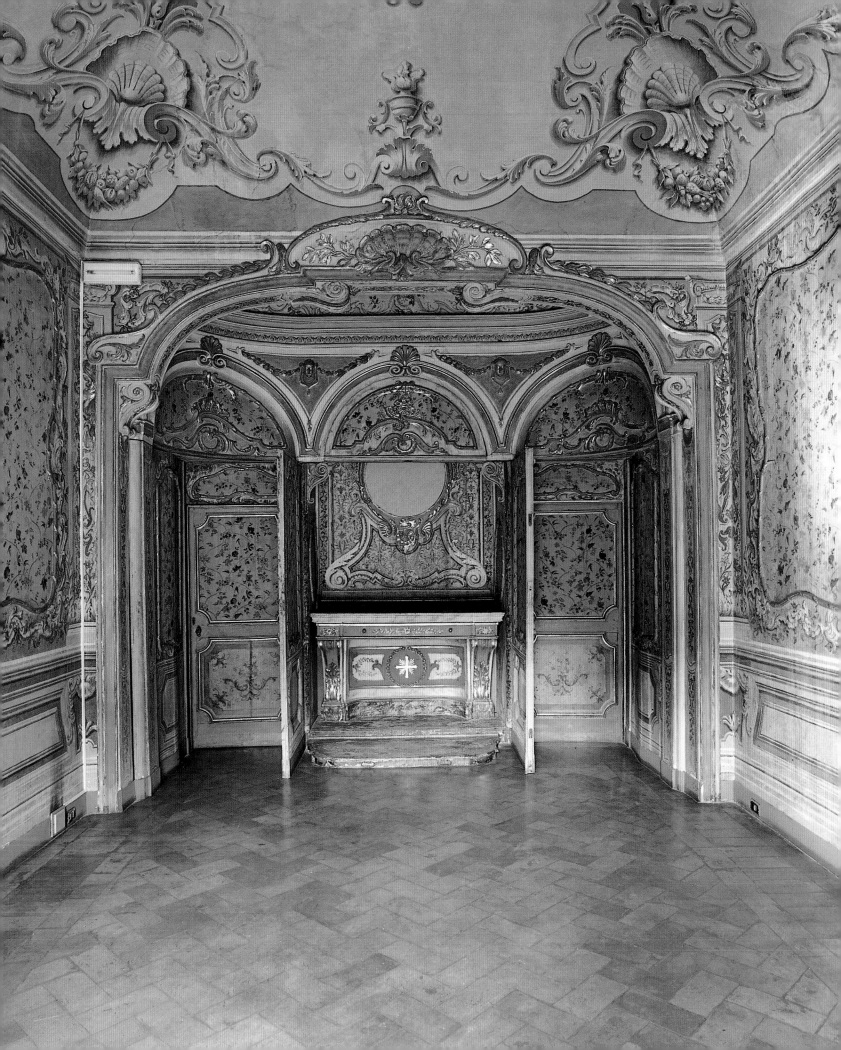

Palazzo Barberini

continued

Another of the interiors (left) originally doubled as a drawing room and private chapel, the blue and gilt panelling opening at one end to reveal a hidden altar. Portraits of the original occupants appear in the tiny closet (above and right) whose antique-style decoration heralds the advent of neo-classicism.

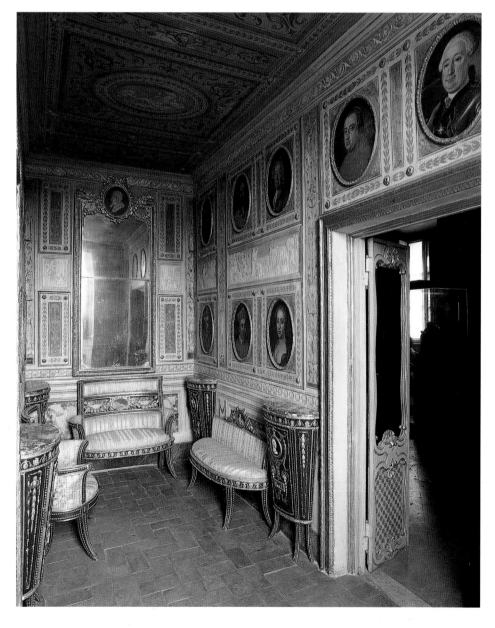

Vittoriano

Dubbed the 'Wedding Cake' by American soldiers in the Second World War, the Vittoriano has been for decades the most denigrated monument in Rome. Conceived as a monument to King Victor Emmanuel II, the towering marble structure took 26 years to build, construction lasting from 1885 to 1911. The architect, Giuseppe Sacconi, directed a team of over 50 artists, including Giulio Bargellini and Antonio Rizzi, who produced the beautiful mosaic decoration of the colonnade at the summit (right and below). The style of the monument is typical of the academic classicism of the late nineteenth century, but the mosaics break free of this tradition, clearly reflecting the influence of Secessionist Vienna.

Palazzo Colonna
Galleria Colonna

The Gallery of the Palazzo Colonna (right), with its precious marble floors and its sumptuously decorated ceilings, provides a tangible reminder of the former power and wealth of the old papal nobility. Begun around 1654 for Cardinal Girolamo Colonna, the Gallery is decorated with ceiling paintings depicting glorious moments from the life of Marcantonio II Colonna. The walls are lined with Siena marble pilasters framing large Venetian mirrors with painted cupids and flowers by Mario de' Fiori and Carlo Maratta.

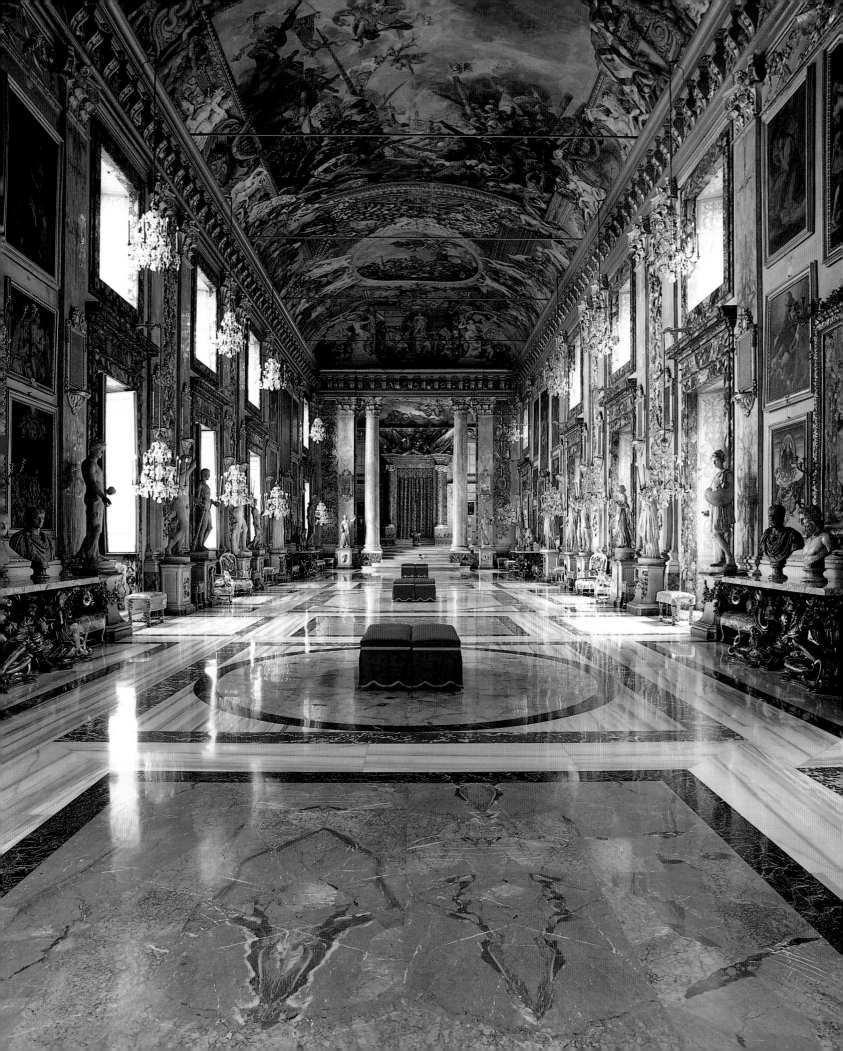

Hotels, Shops and Restaurants

The Grand was built in the last years of the nineteenth century by the legendary Swiss hotelier César Ritz, and although his architect, Podesti, was an Italian, the interior decoration was entrusted to Madame Ritz, the hotelier's wife. The building has since been extensively remodelled, but the magnificent cantilevered staircase (right) survives intact, a dizzying succession of flights and landings leading the eye towards an allegorical ceiling painting high above the stairwell.

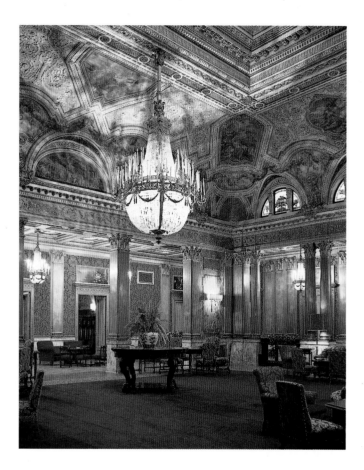

Grand Hotel Plaza

The decoration of the Plaza captures exactly the mood of optimism and extravagance which followed in the wake of the Risorgimento. Parts of the building are little changed in over a century, including an extraordinary marble staircase terminating in a life-size figure of a lion (right). The colonnaded central lobby is of French inspiration (above).

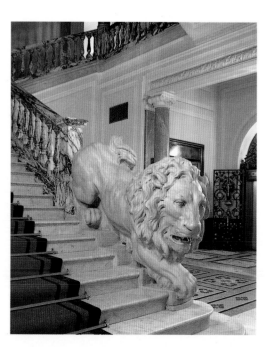

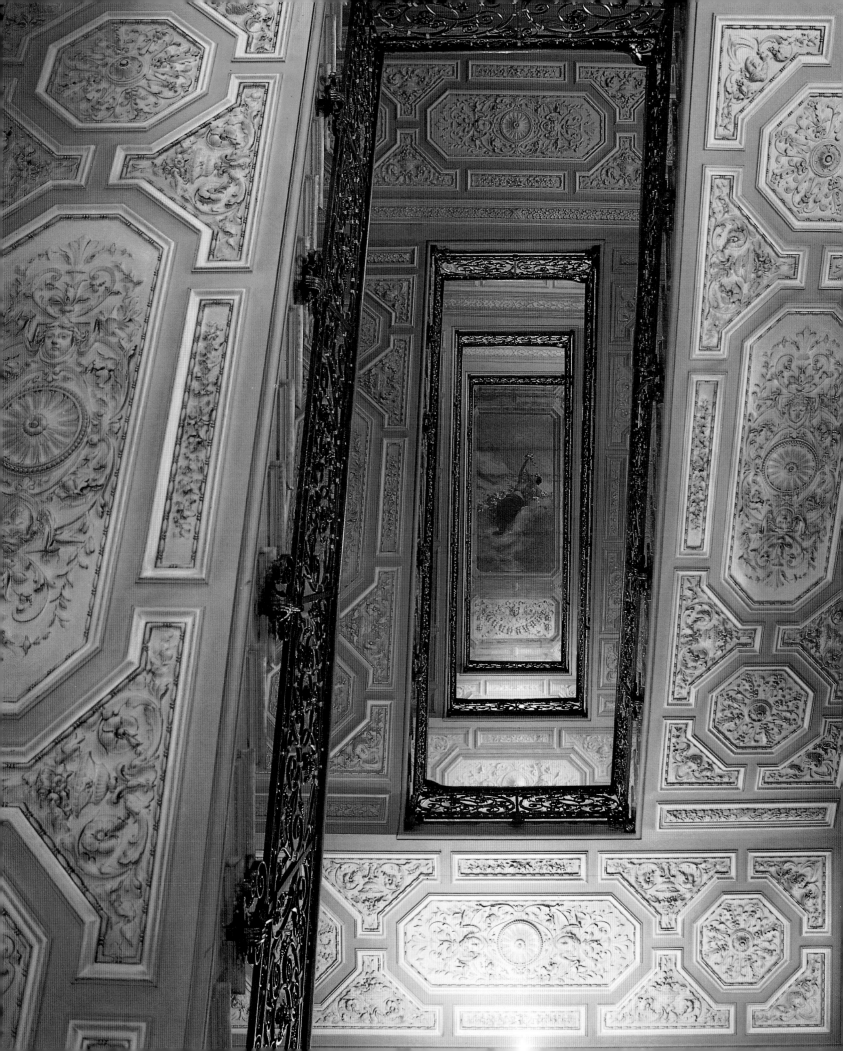

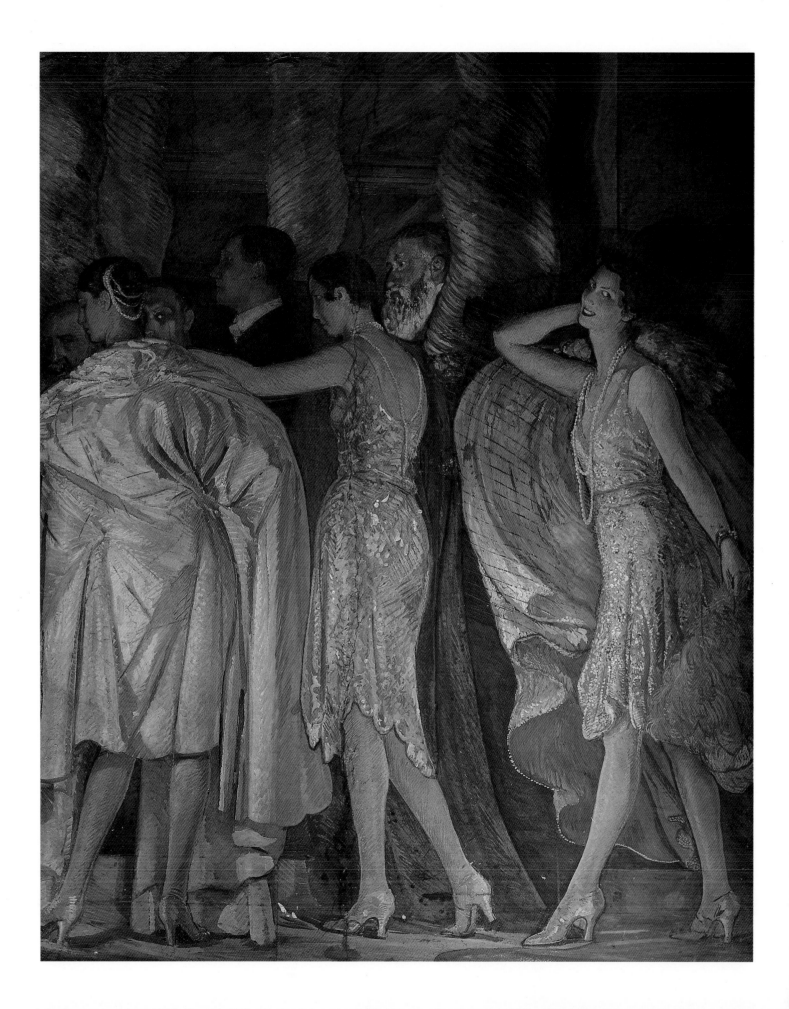

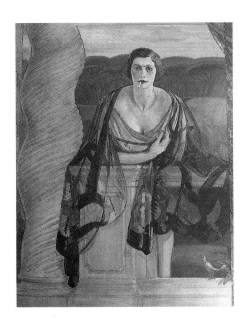

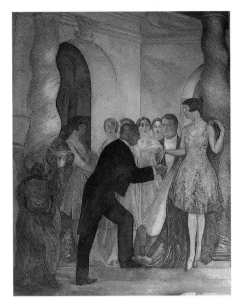

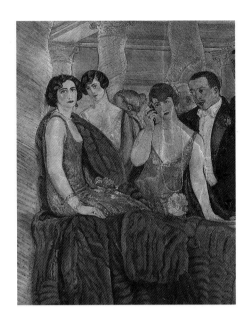

Albergo degli Ambasciatori

Like so many great buildings of the interwar period, the Albergo degli Ambasciatori was designed by the architect Marcello Piacentini, but the principal focus of interest is a remarkable cycle of frescoes by the Venetian painter Guido Cadorin, which decorate the walls of the *salone*. In a style inspired by the great illusionistic murals of Veronese and Tiepolo, Cadorin created a dramatic *tableau vivant* composed of all the most prominent figures from fashionable Roman society in the 1920s, illuminated from below as if by theatrical footlights. Little realizing the trouble it would cause him, the painter included a likeness of Mussolini's then mistress Margherita Sarfatti. When the Fascist leader got wind of the matter he ordered the frescoes to be draped and, although Cadorin took action against the hotel management, his work was covered over until after the war.

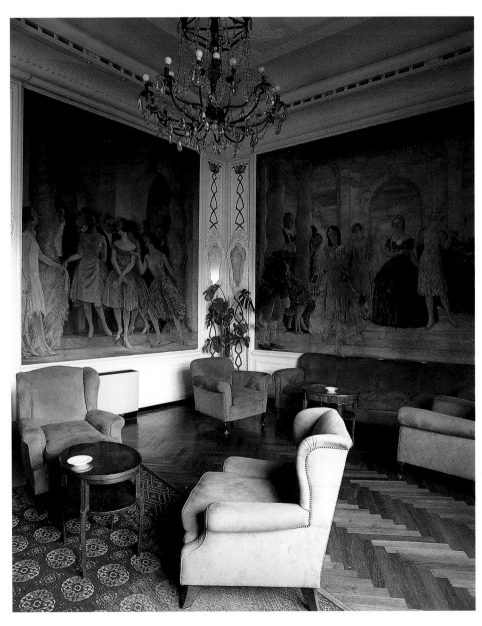

Galleria Sciarra

This superb nineteenth-century arcade is one of the great sights of Rome, yet little known to visitors. Built by Prince Maffeo Sciarra, newspaper publisher and owner of the adjoining Palazzo Sciarra (pages 86–87), the arcade is generally recognized as the first building in Rome in which the principal structural elements are of metal rather than traditional masonry. Working under the direction of architect Giulio De Angelis, the painter Giuseppe Cellini frescoed the walls with scenes from contemporary Roman life, interspersed with female figures symbolizing such virtues as Prudence, Chastity and Loyalty. Ironically the models for these figures were mostly friends of the artist and members of fashionable society.

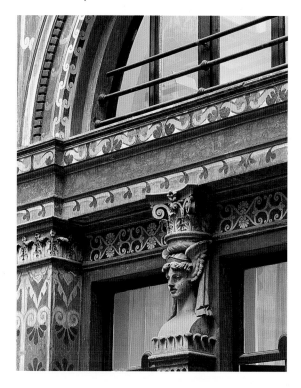

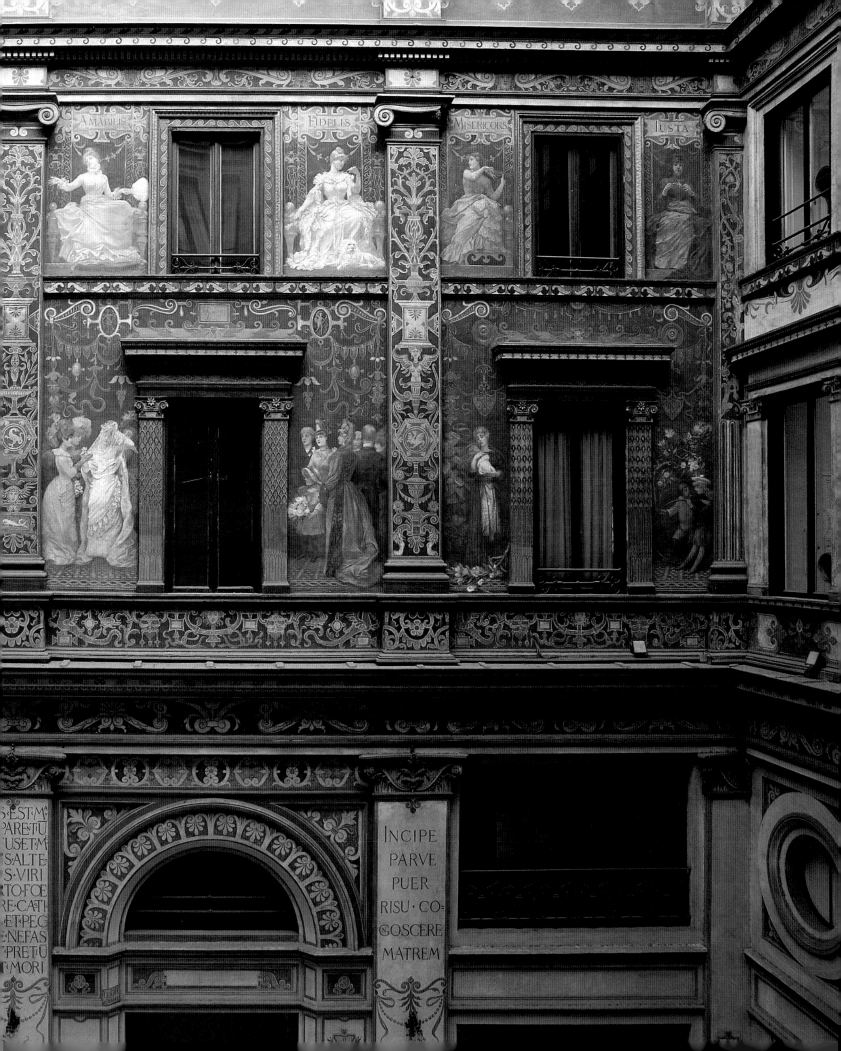

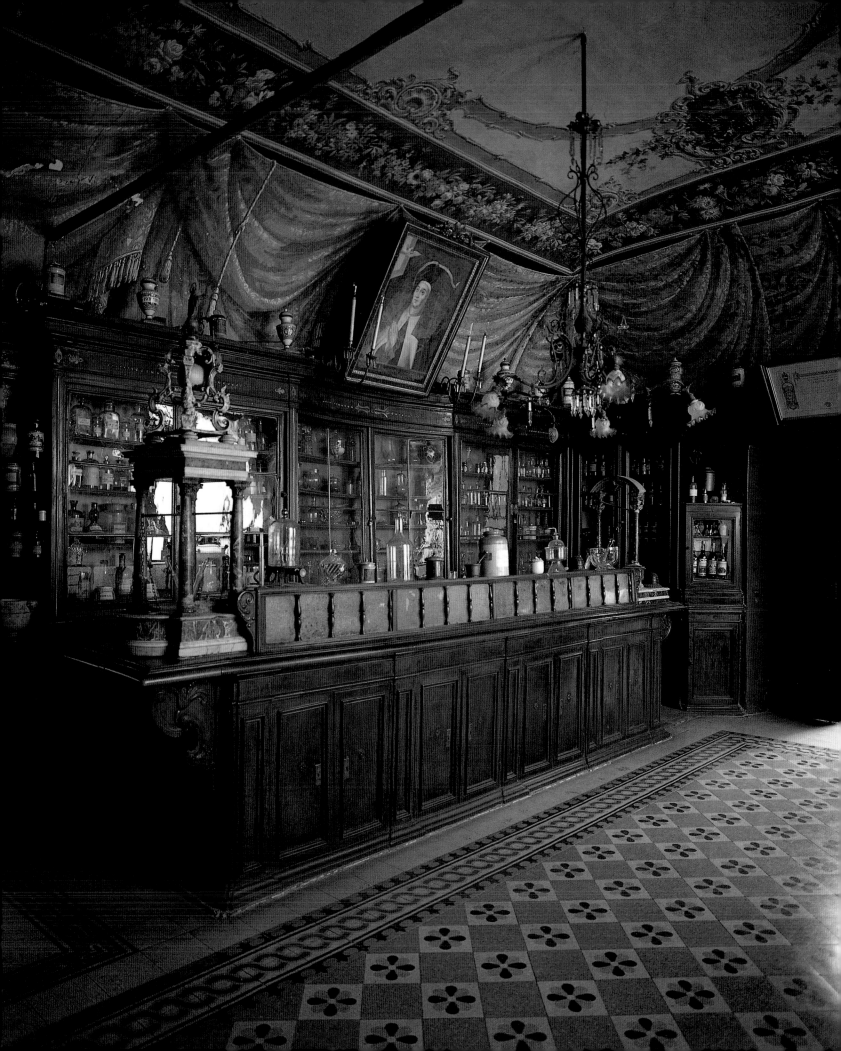

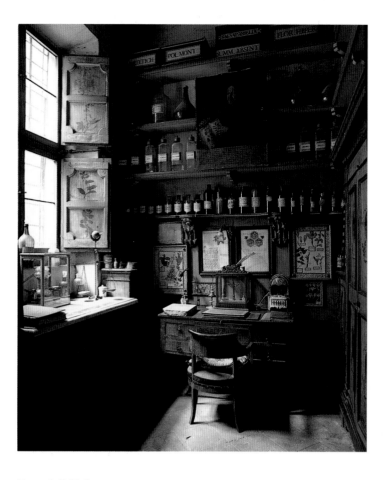

Farmacia Capranica

Completed in 1912, the tiled and panelled interior of the Farmacia Capranica (below) contains an elegant water fountain, composed of a seventeenth-century marble basin and a mirror etched with alchemical symbols.

Farmacia S. Maria della Scala

Still in operation as a dispensary, this late eighteenth-century pharmacy is one of the oldest in Europe to have survived intact (left). In the principal room the walls are decorated with *trompe-l'oeil* frescoes representing heavy velvet drapes. The floor is laid with brightly coloured early nineteenth-century tiles, while the counter is surmounted by a late eighteenth-century clock with marble colonettes. The room is adjoined by the *speziario* (above), a laboratory where specimen herbs were previously catalogued and stored in painted boxes. The window shutters are decorated with paintings of medicinal plants and the doors to the cupboards feature portraits of the founding fathers of medicine, such as Avicenna and Hippocrates.

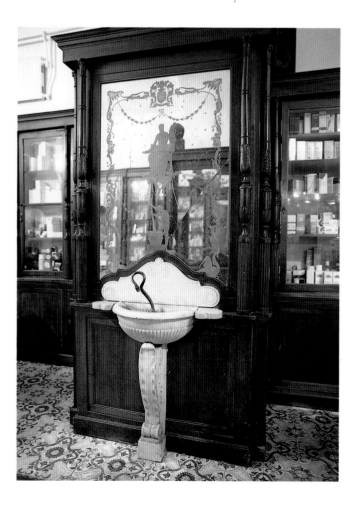

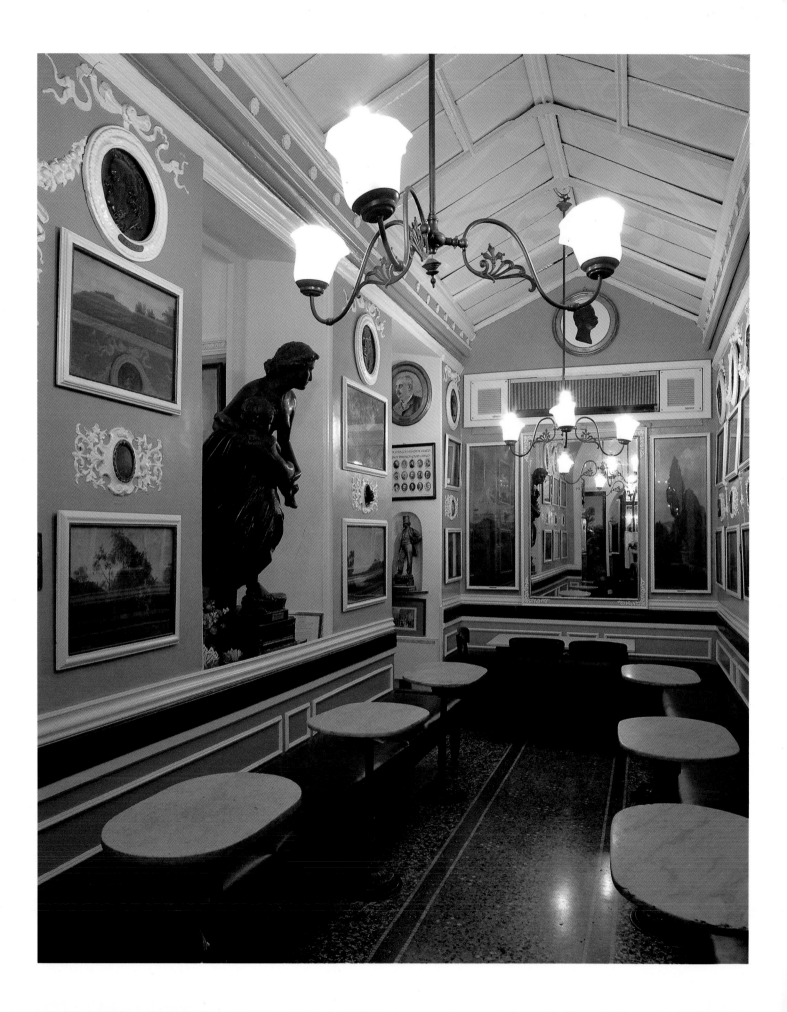

Antica Macelleria Annibale

The interior of this late nineteenth-century butcher's shop is the earliest surviving example of its kind in the city, the original Liberty-style decoration almost wholly intact. Especially striking is the marble-panelled entrance with meat hooks in the form of bull heads.

Macelleria Angelo Feroci

On a site near the Pantheon, where animals were once offered up in pagan sacrifice, this aptly named butcher's shop retains its original 1920s interior, with a spirited relief of fighting bulls, modelled in a mixture of cement and sawdust.

Caffè Greco

For more than 200 years the Caffè Greco has been a meeting-place for artists and writers from all over Europe and America. Founded by a Greek expatriot in 1740, it is the only coffee house in Rome predating the Risorgimento, and the famous Omnibus Room (left), so called on account of its narrow, elongated shape, retains an original collection of nineteenth-century stucco medallions, accompanied by landscape paintings by the German artist, Edward Hottenroth.

Da Alfredo all'Augusteo

A plaster relief pays tribute to the original founder, Alfredo I, known in his day as the 'King of Fettuccine', whose grandson, Alfredo III, still owns this world-famous restaurant. Carried in triumph on a Roman chariot drawn by four magnificent horses, a gleeful Alfredo holds aloft an overflowing plate of his celebrated *fettuccine al burro*.

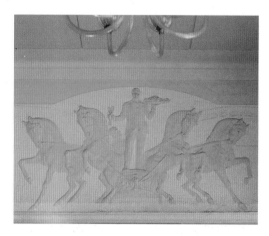

Ditta Radiconcini

The interior of the Radiconcini hat shop is virtually unchanged since the 1930s, a remarkably complete example of the Art Deco style. Above the principal display case are etched glass panels illustrating the five main stages of hat-making – from unsuspecting rabbit to finished topper.

Banks and Offices

Villa Chigi

Although hemmed in today by modern blocks of flats and offices, Villa Chigi still retains the atmosphere of an eighteenth-century country retreat. The main drawing room (left and right) is conceived as a colonnaded pavilion open to the landscape, with theatrical *trompe-l'oeil* marbling and a startlingly vivid use of colour. A tiny closet, originally intended for private worship, is decorated with illusionistic murals representing hermits and monks at prayer in a forest (below).

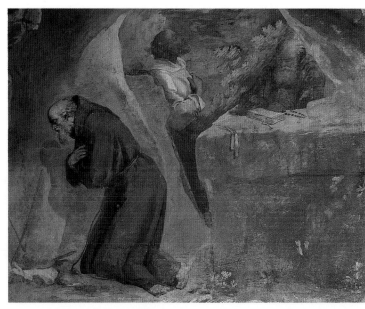

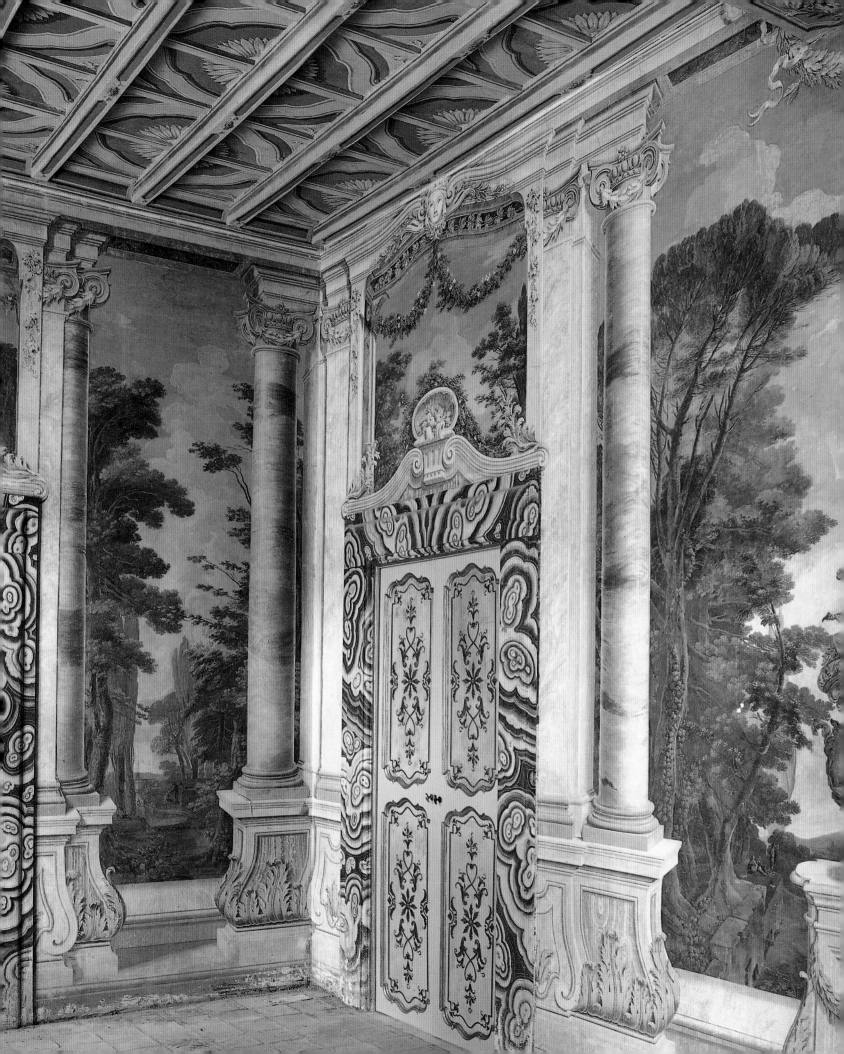

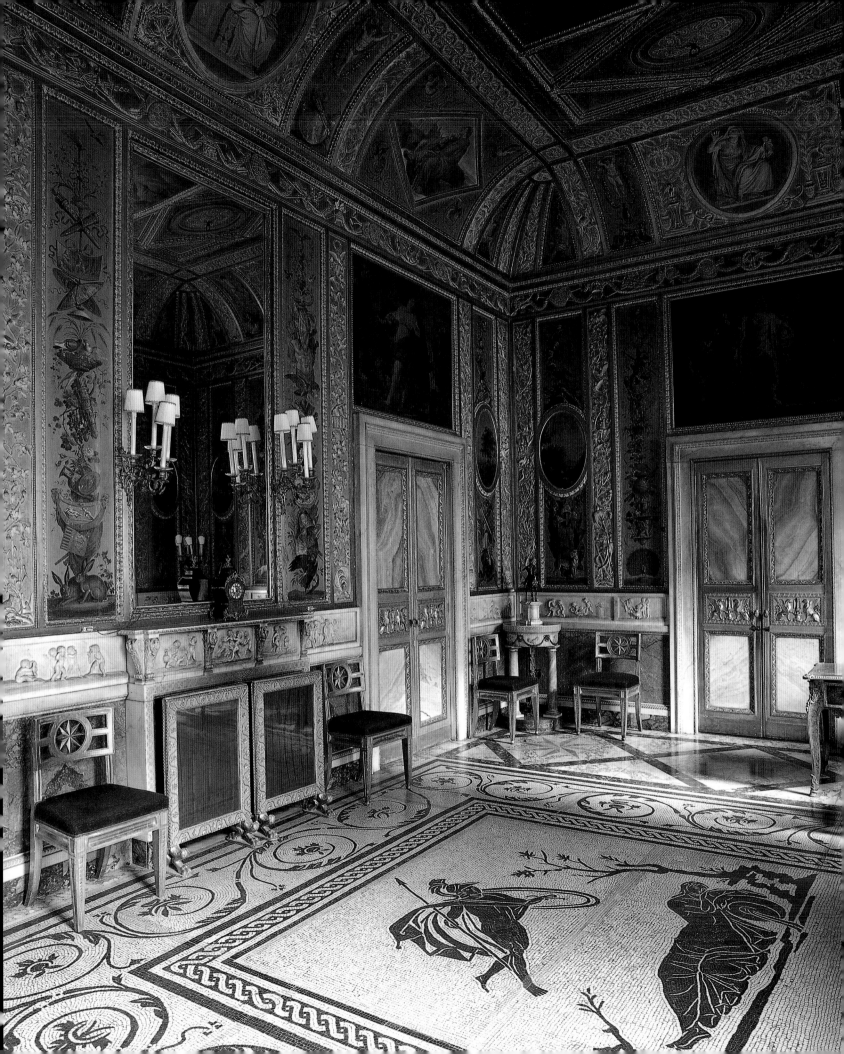

Palazzo Altieri
Associazione Bancaria Italiana

Although the palace itself was built in the seventeenth century, the *Sala del Mosaico* (left) dates from the neo-classical period and takes its name from the ancient Roman mosaic in the centre of the floor. The mosaic represents the legend of Mars and Rhea Silvia, parents of Romulus and Remus, and was discovered during excavations at Ostia in 1783. The interior retains its original panelling and stucco work, together with a set of four alabaster tripods specifically designed to complement and enhance the architectural decoration. The Altieri heraldry is recalled by the stars on the backs of the chairs. Equally striking are the *Gabinetto da Toeletta* (right), a Rococo dressing room of the 1730s, and the former Gallery (below) decorated with ruin paintings and classical and Oriental statuary.

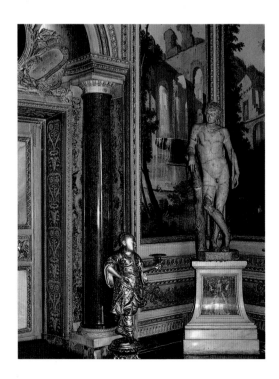

Palazzo Sciarra
Banca di Roma

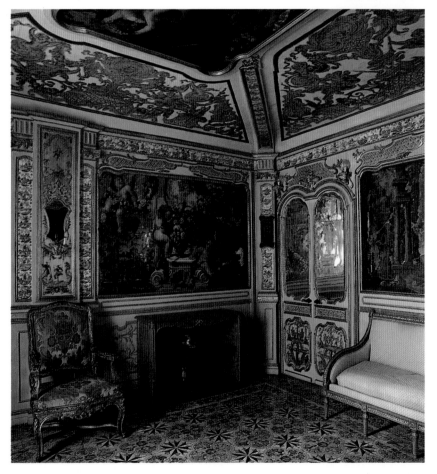

On the *piano nobile* of the
old Palazzo Sciarra, an early
seventeenth-century palace
now occupied by the Banca
di Roma, are two perfectly
preserved interiors of the
1750s designed by Luigi
Vanvitelli for Cardinal
Prospero Colonna di
Sciarra. The walls and
ceiling of the *Sala degli
Specchi* (left and above), the
Cardinal's private study,
are lined with Delft tiles and
parcel-gilt panelling framing
painted mirrors. One of
the most interesting features
is the use of seventeenth-
century Neapolitan ceramic
floor tiles, with eighteenth-
century Delft tiles on the
walls and ceiling. In the
adjoining library (right) the
floor is of pale and dark
woods inlaid on a radial
pattern.

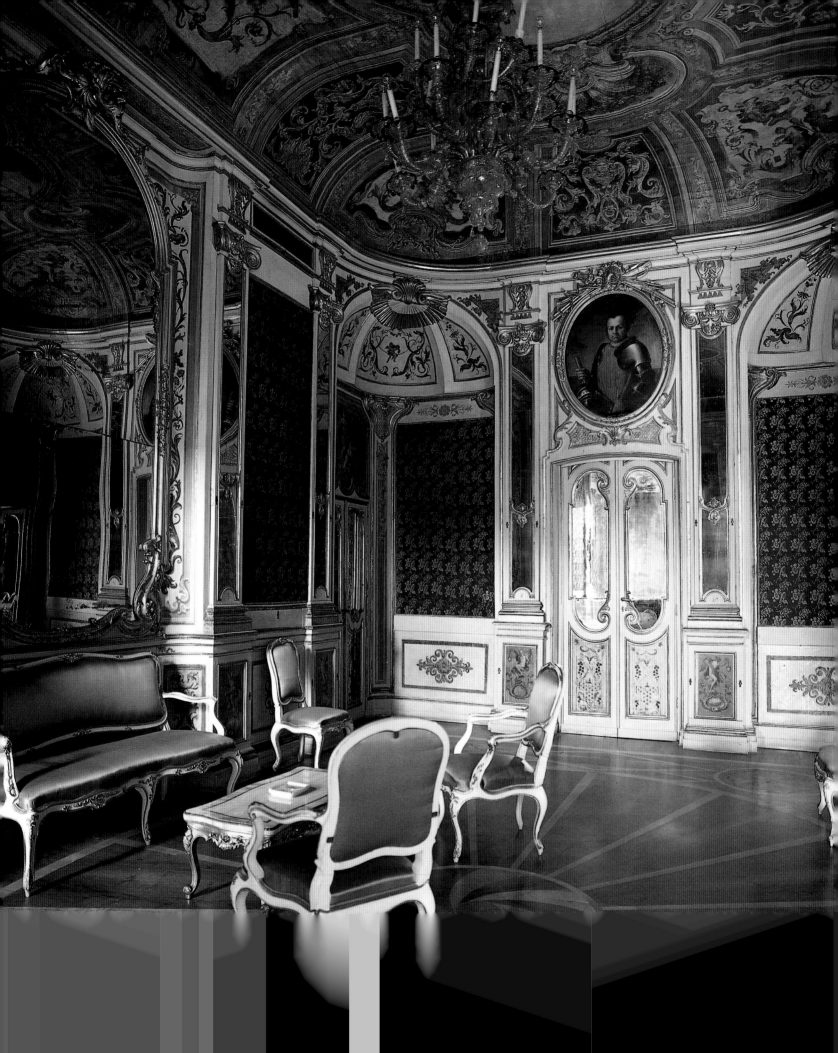

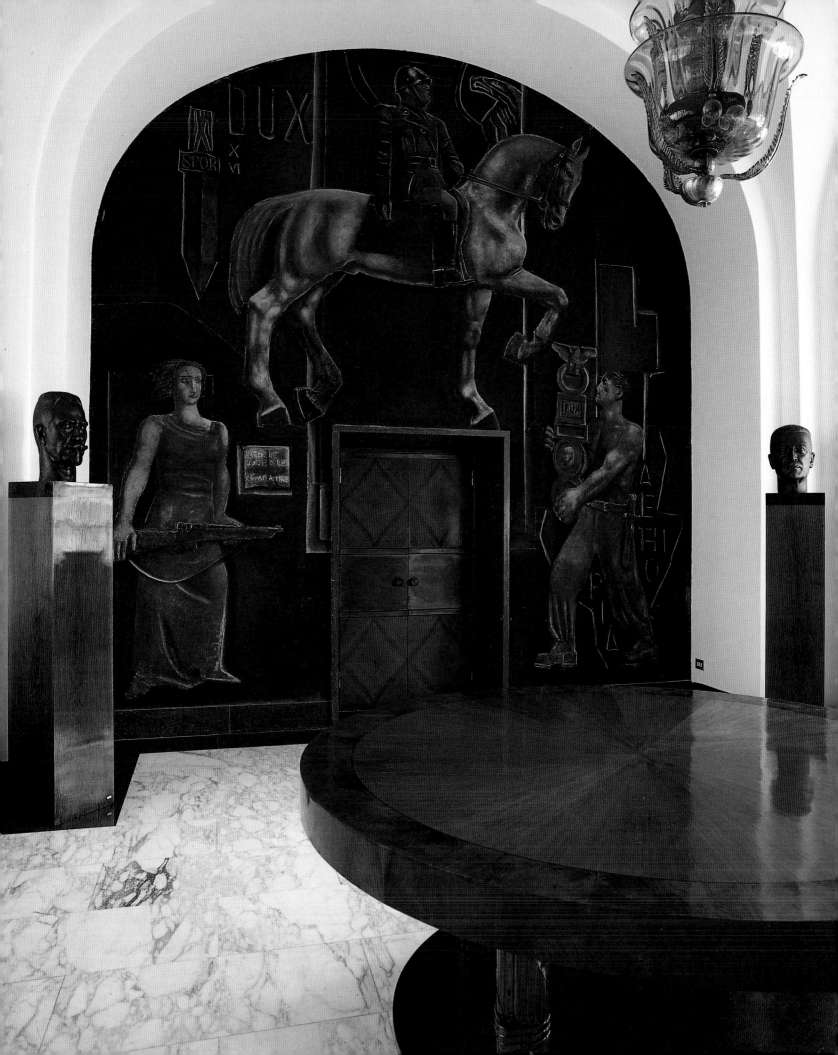

Casa Madre dei Mutilati

Designed by Marcello Piacentini, the building, which dates from the late 1920s, was commissioned by Mussolini as the headquarters of the War Invalids' Association. An interior on the first floor (opposite) has a mural by Mario Sironi depicting the *Duce* on horseback and a large round table with legs in the form of the *fascio*, or fasces, symbol of the Fascist movement. The *Parlamentino*, or conference room (right), features marquetry panelling (left) by Eduardo Del Neri with allegories of war and heroism.

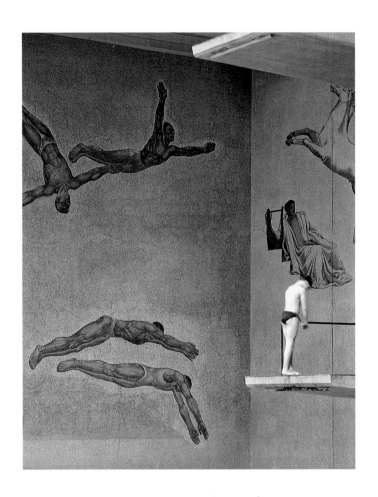

Foro Italico

Originally known as the Foro Mussolini, this giant sports complex of the 1930s was conceived as a temple to the Fascist cult of athleticism. The walls of the principal swimming pool are decorated with homo-erotic mosaics by Angelo Canevari representing virile sportsmen in various states of undress, as well as mythical sea monsters and figures from classical antiquity .

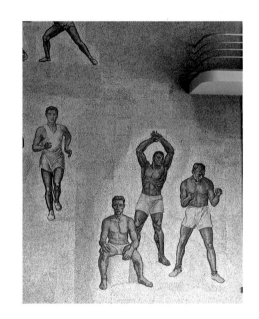

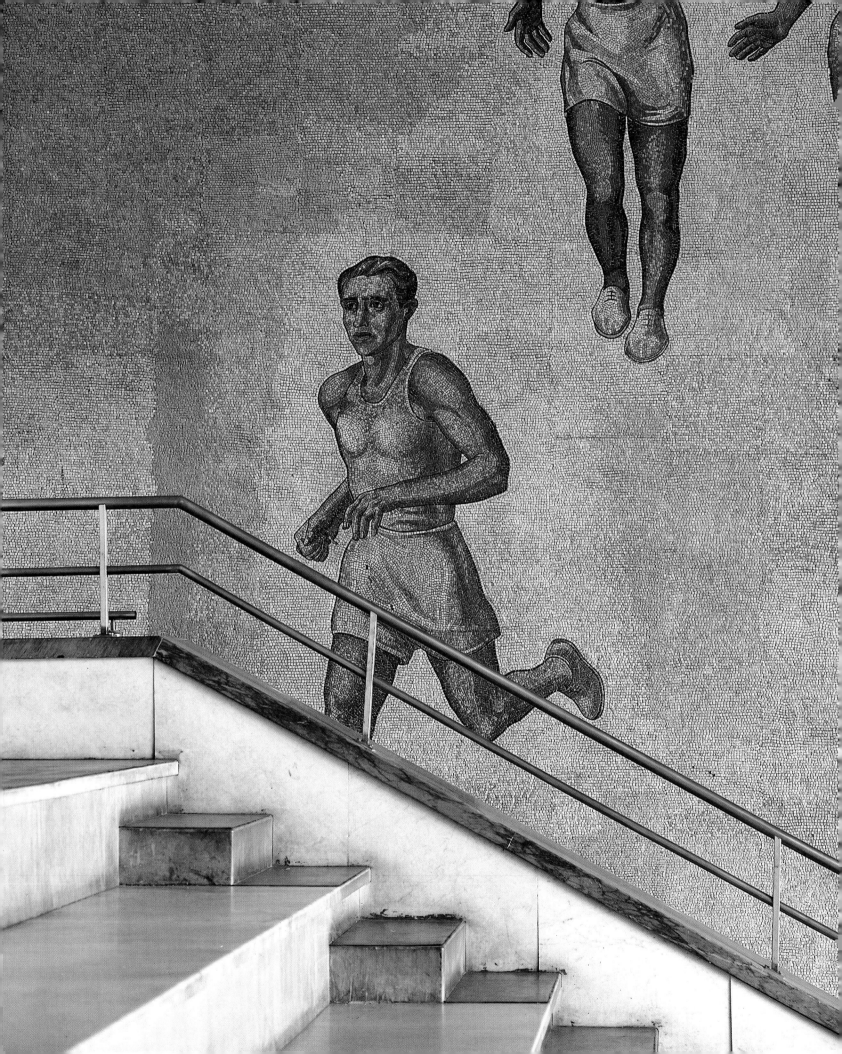

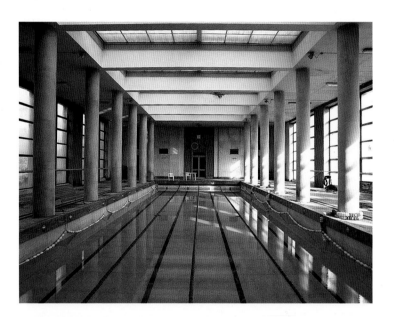

Foro Italico

continued

In a less exalted register are the mosaics in the *Piscina Pensile* (left), a shallow pool originally intended for the use of the Balilla, a Fascist youth movement for 6-12 year olds. Here the scenes are of circus animals and creatures of the sea. Surprisingly, Mussolini's personal gymnasium has survived, the so-called *Palestra del Duce* (right), which retains its original antique-style wall mosaics by Gino Severini, and the doors of a private lift bearing the dictator's monogram. The mosaic on the floor, also by Severini, clearly shows the influence of Cubism, a puzzling addition in view of Mussolini's professed contempt for avant-garde abstraction.

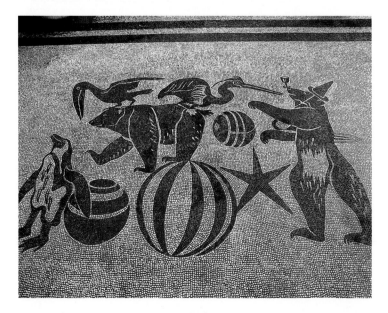

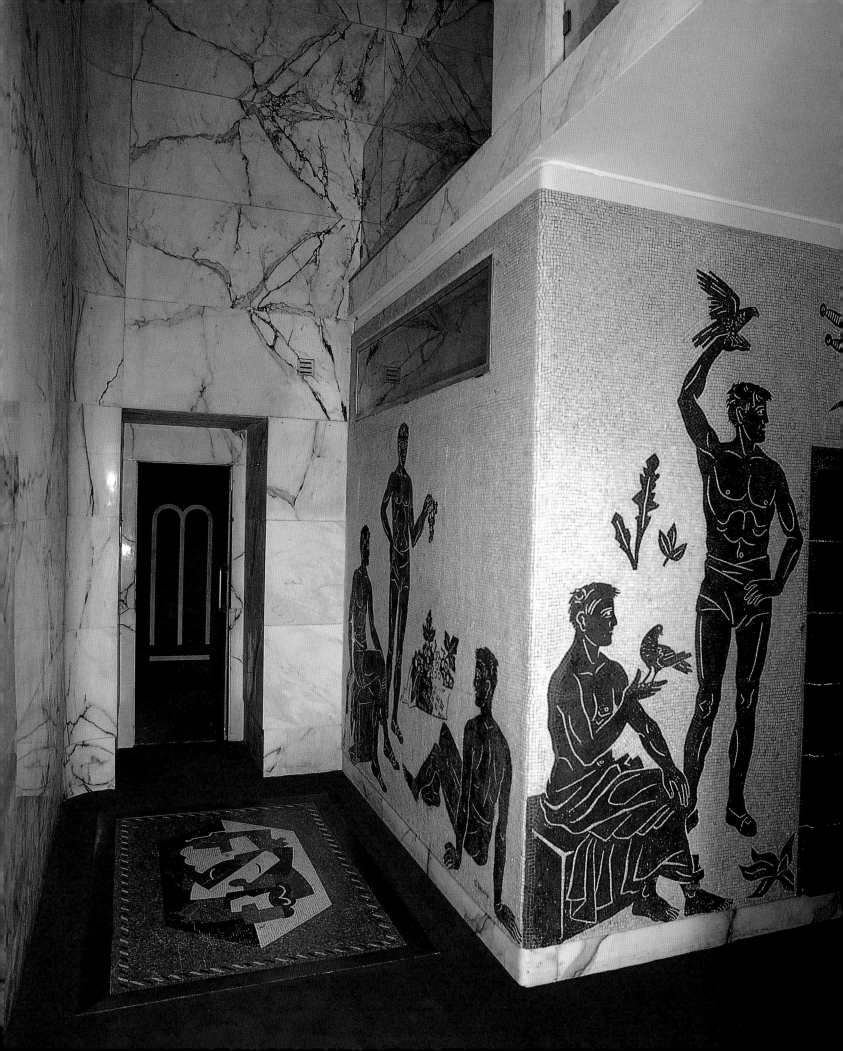

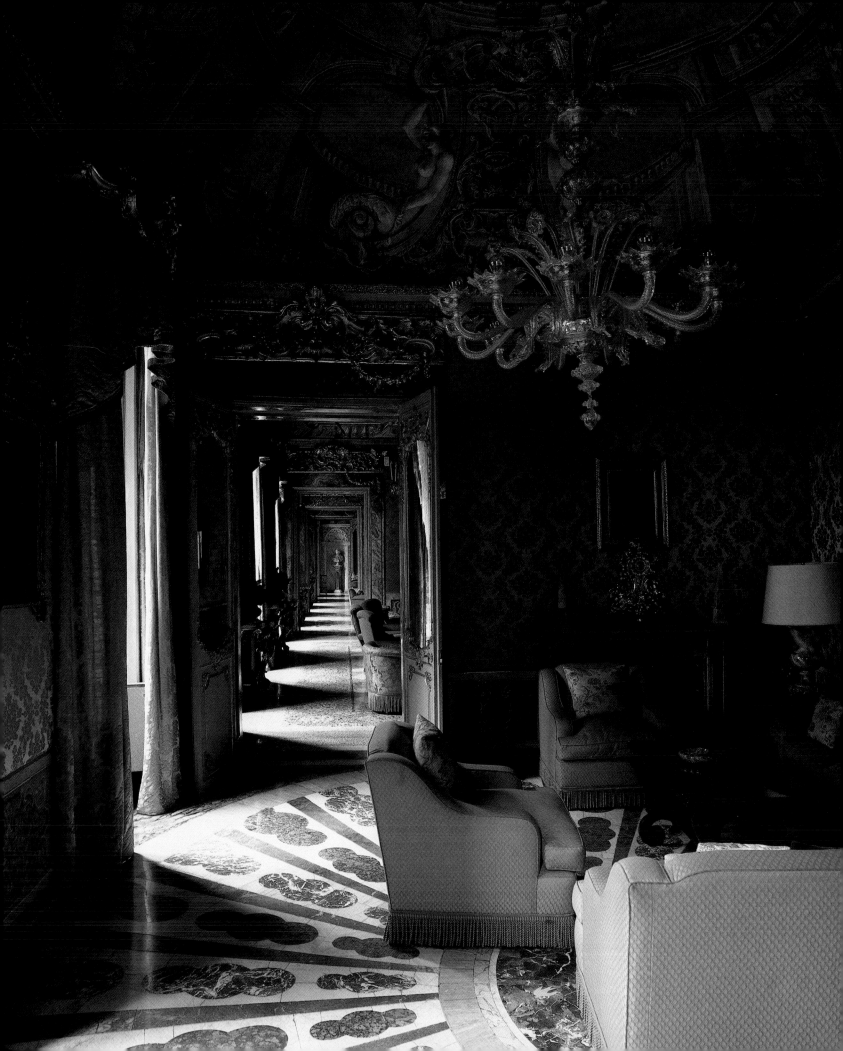

Palazzo Rondinini
Circolo degli Scacchi

The *Circolo degli Scacchi* (Chess Club) has its headquarters at the old Palazzo Rondinini, an early seventeenth-century palace on the Corso, which was acquired in 1744 by the marchesa Margherita Ambra Rondinini and substantially remodelled under her direction by the architect Alessandro Dori. The plan is typical of the eighteenth century, with rooms arranged on axis, creating dramatic perspectives which greatly increase the building's apparent size. The staircase hall (right) is painted in the cool tones of the neo-classical period, the sculpture providing a reminder that the palace once contained a celebrated collection of statues assembled by the marchese Giuseppe Rondinini. The floors are especially remarkable, inlaid after the Roman fashion with precious coloured marbles representing in one case the *rondini* (swallows) of the former owners' coat of arms (above).

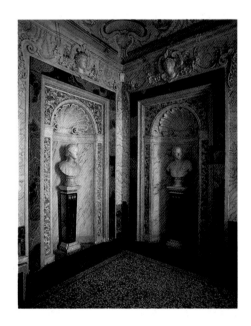

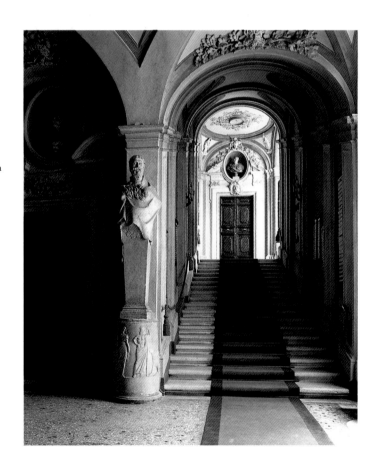

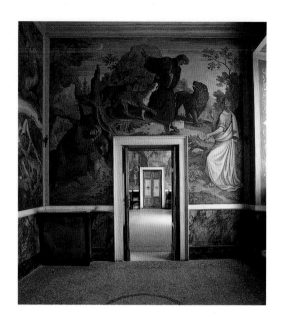

Villa Massimo
Delegazione dei
Francescani in Terra Santa

Occupied today by
Franciscan monks, this
delightful seventeenth-
century villa was originally
built for the Giustiniani
family and contains the
finest surviving murals in
Rome by the Nazarenes, a
group of German painters
formed in the early
nineteenth century, who
sought to revive religious
art through the imitation
of Dürer, Perugino and the
young Raphael. The murals,
commissioned by Carlo
Massimo following his
acquisition of the villa in
1803, are based on the epic
poems of Ariosto, Tasso,
and Dante, whose *Divina
Commedia* inspired the
decoration of the *Sala di
Dante* (above and right).

Palazzo Borghese
Circolo della Caccia

The *Circolo della Caccia*
(Hunt Club) occupies a
wing of the old Palazzo
Borghese, a building dating
back to the early seventeenth
century. The *Sala dei Ritratti*
(right) is decorated with
portraits of members of the
Borghese family encased
within the panelling. Equally
well preserved is the *Sala dei
Cuoi* (above), a rare example
of the use of leather wall
hangings.

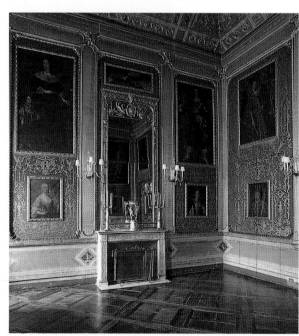

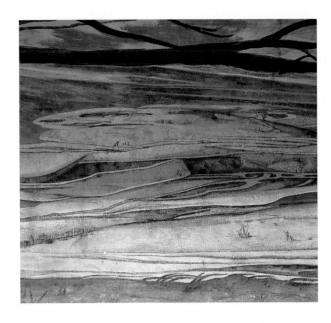

Convento di S. Trinità dei Monti

Situated above the Spanish Steps, the convent of S. Trinità dei Monti was originally established as a monastery for the Order of Minims, whose founder, S. Francesco di Paola, is represented in an extraordinary anamorphic fresco on the wall of a passageway (right). The fresco is painted in steep perspective. Viewed from either end, the saint is clearly visible, but when the spectator faces the fresco directly, the saint vanishes from sight and is replaced by a mountainous landscape dotted with miniature figures (above). The landscape is that of St Francis's native Calabria, while the figures enact scenes from his life. The fresco dates from the first half of the seventeenth century and was painted by a resident monk, Jean-François Nicéron.

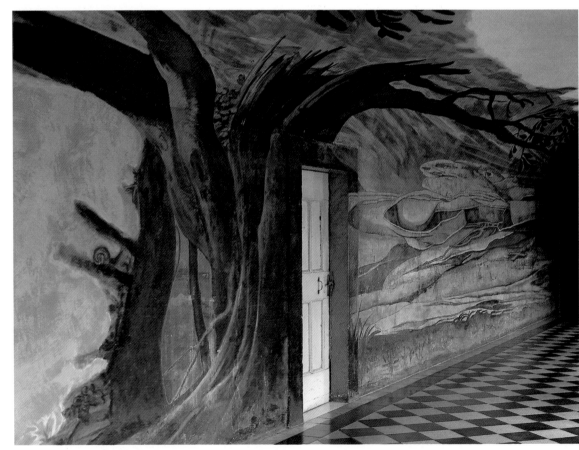

Convento di S. Trinità dei Monti

continued

Another French artist, Charles-Louis Clérisseau, was responsible for the equally remarkable frescoes in the *Stanza delle Rovine* (left and above), which date from around 1767. Clérisseau was an associate of Piranesi and Robert Adam, and the decoration of the room reflects the fascination of the period with antique ruins. The interior is conceived as the crumbling shell of an ancient Roman chamber, with exposed timbers, disintegrating masonry, and gaps in the walls and ceiling providing views of the sky and an imaginary landscape. The interior originally served as a bedchamber, commissioned from Clérisseau by its then occupant, a scientist-monk, and contained a suite of specially designed furniture, sadly dispersed, in the form of broken columns and other architectural fragments.

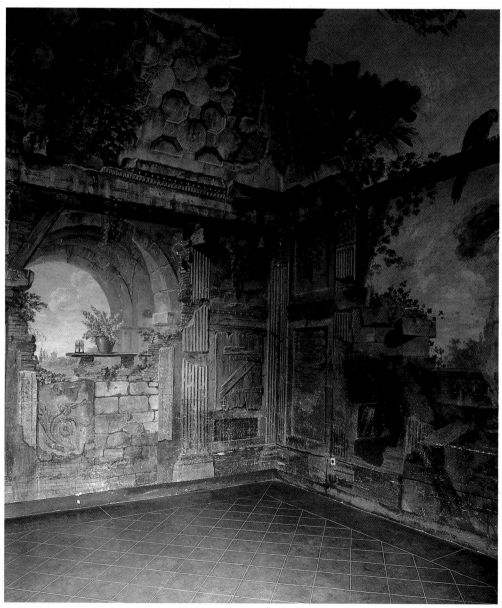

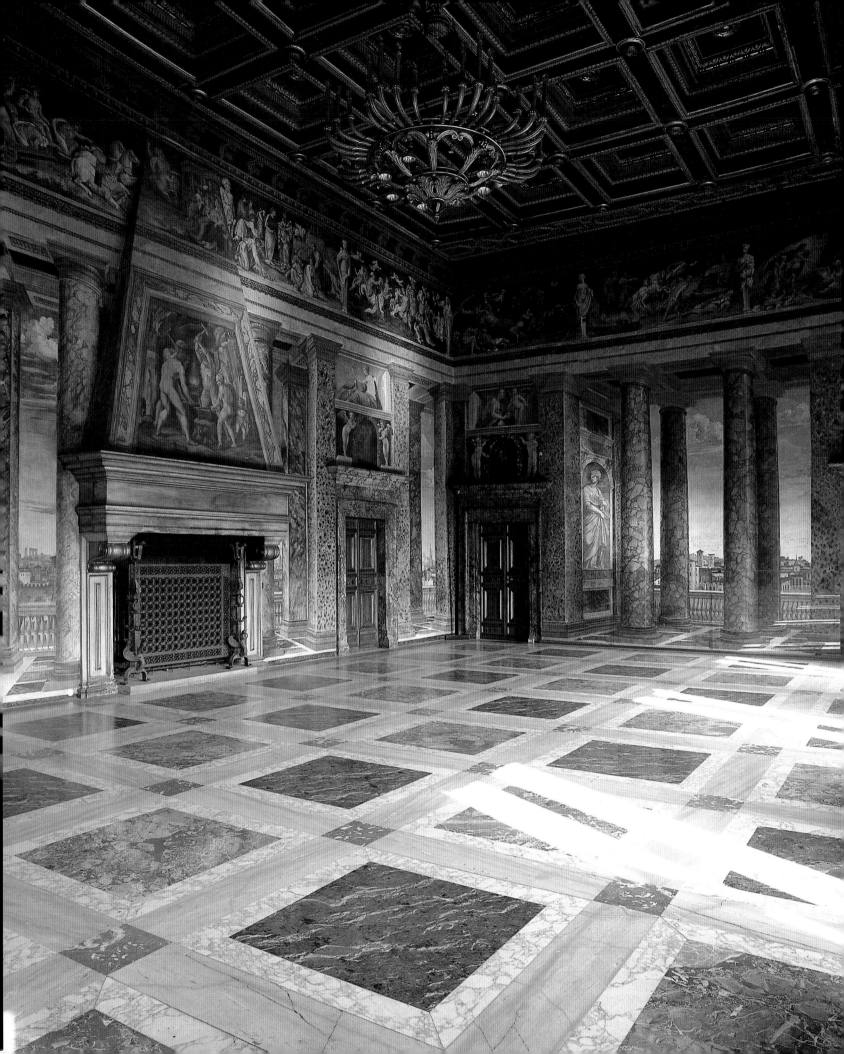

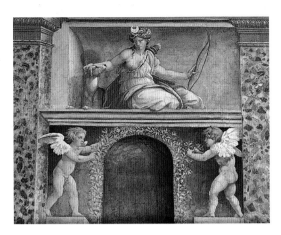

Villa Farnesina
Accademia dei Lincei

The Villa Farnesina was
built as a retreat from Rome,
yet the walls of the first
floor *salone* (left) were
frescoed with illusionistic
views of the Roman skyline.
Designed by Baldassare
Peruzzi, the building dates
from the early years of the
sixteenth century and was
originally occupied by the
Sienese banker Agostino
Chigi. Among its many
treasures is a bedchamber
(right) frescoed by Sodoma
with scenes representing the
nuptials of Alexander the
Great and Roxana.

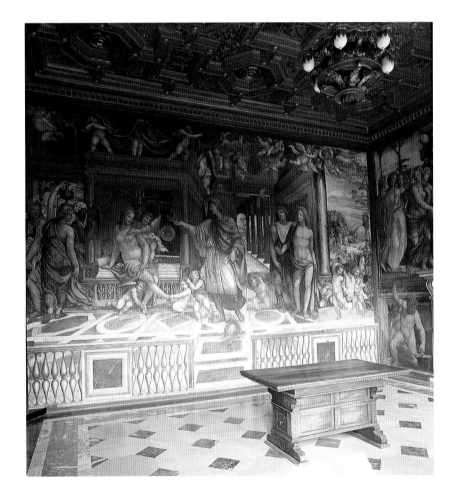

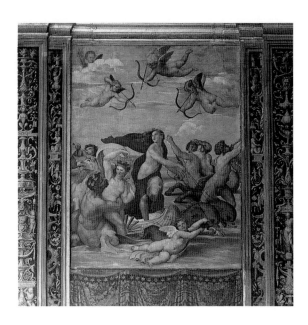

Villa Farnesina
Accademia dei Lincei
continued

A vaulted chamber on the ground floor (right) contains a celebrated fresco by Raphael of Galatea driving a marine chariot drawn by dolphins (above). The *Loggia di Psiche* (opposite) has ceiling paintings by Raphael's pupil, Giulio Romano, with bulbous fruit and vegetables suggestive of sex and fertility.

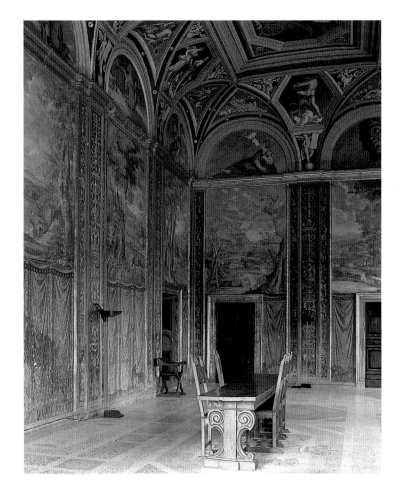

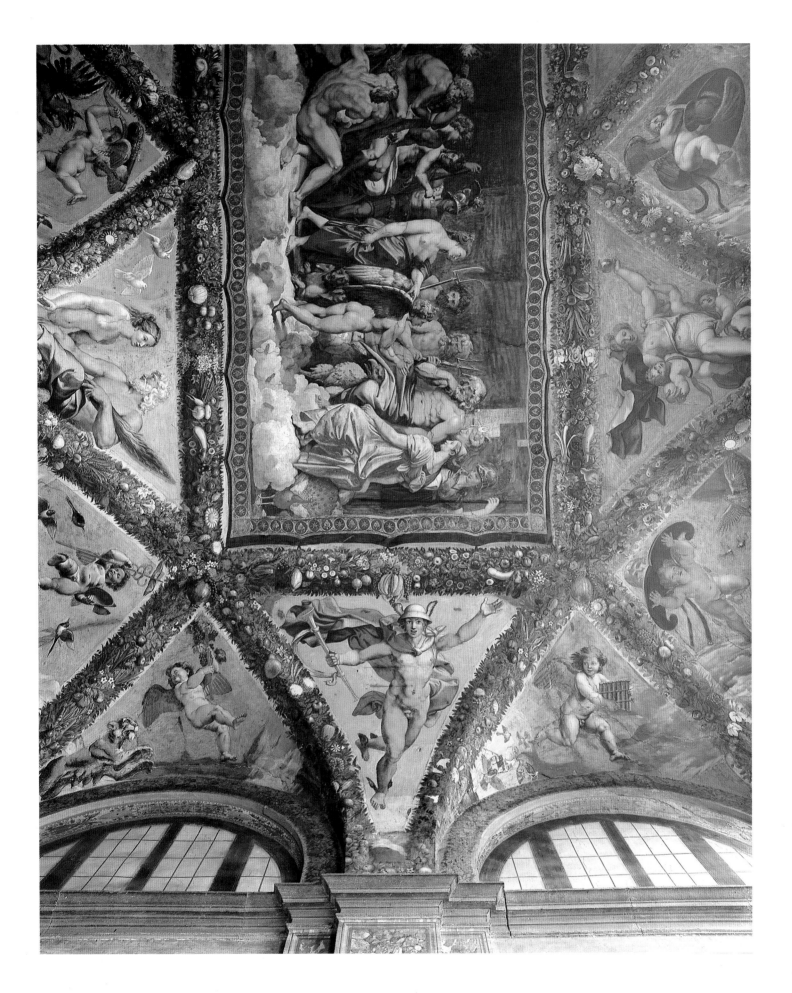

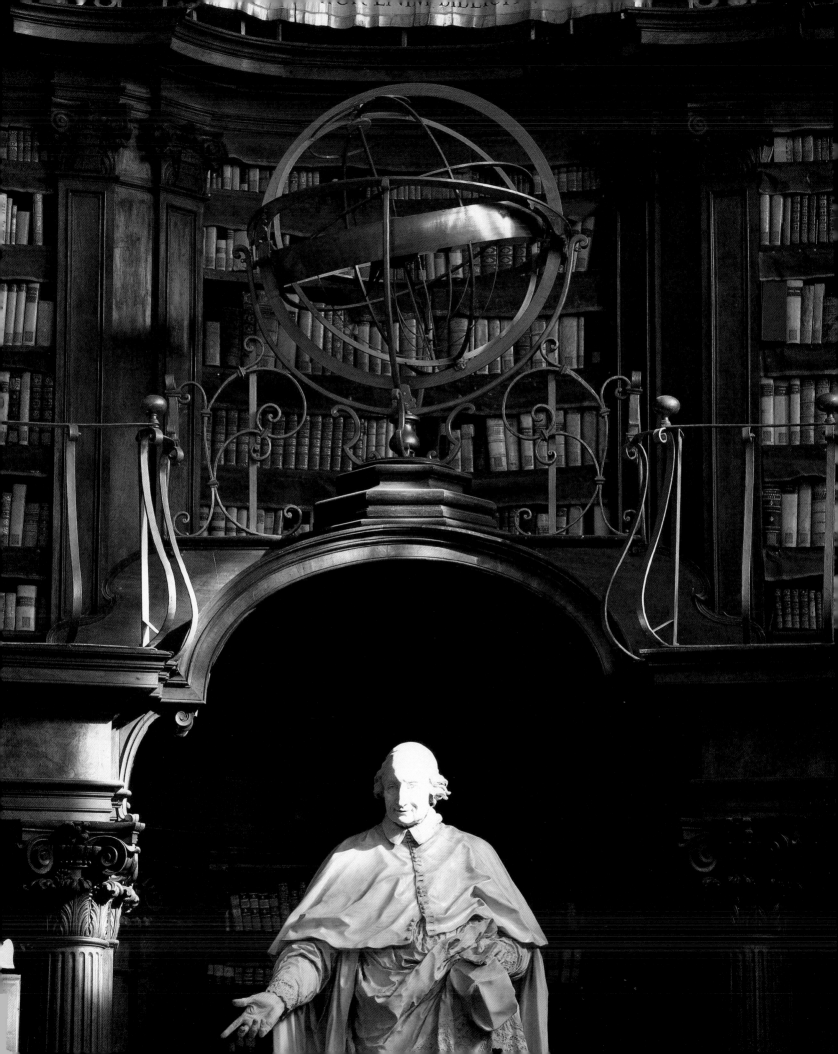

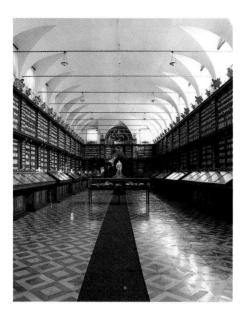

Biblioteca Casanatense

A statue of Cardinal
Casanate still presides over
the hangar-like reading
room of the library he
helped to establish
(left and above).
The interior dates from
the turn of the eighteenth
century and was designed
by the leading architect
Carlo Fontana. Despite
its vast proportions the
decoration is restrained,
almost hushed, as befits
a place of study
and reflection.

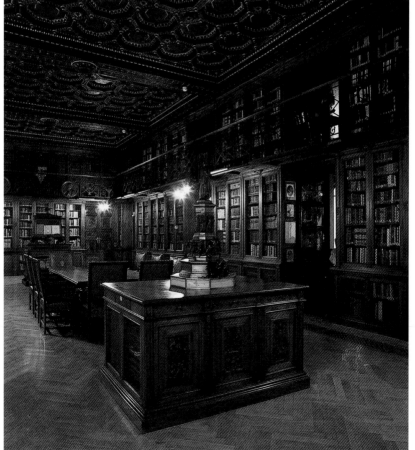

**La Fondazione Marco
Besso**

In 1905 insurance magnate
Marco Besso acquired a
sixteenth-century palace,
once belonging to the
Strozzi family, and
proceeded to build a library
(left) administered today by
the foundation which bears
his name. Alongside his
business activities Besso
pursued a life-long interest
in Dante; the library was
conceived as a shrine to the
poet, whose portrait appears
on the back of the chairs
embossed in gilt (above).

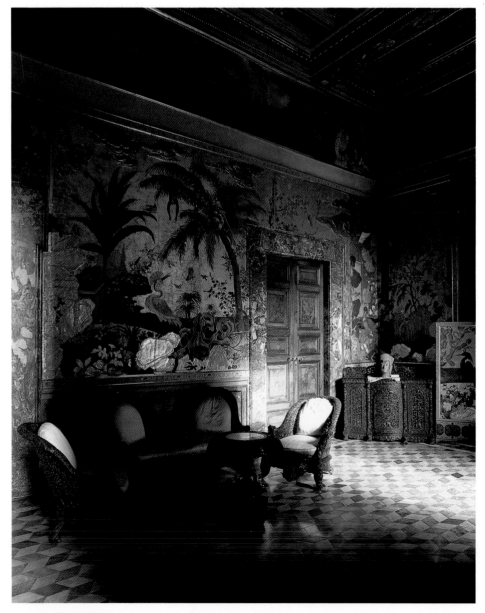

La Fondazione Marco Besso

conitnued

Another fascinating interior is the Chinese Room (left), an eclectic amalgam of diverse styles and periods. The walls are decorated with eighteenth-century chinoiserie panels representing wild animals and luxuriant vegetation on a brilliant gold ground (above). The furniture too is of Oriental inspiration, dating from the late nineteenth century. Most impressive of all is the ceiling with painted compartments illustrating a celebrated collection of shells formed in the sixteenth century by the Strozzi family (right).

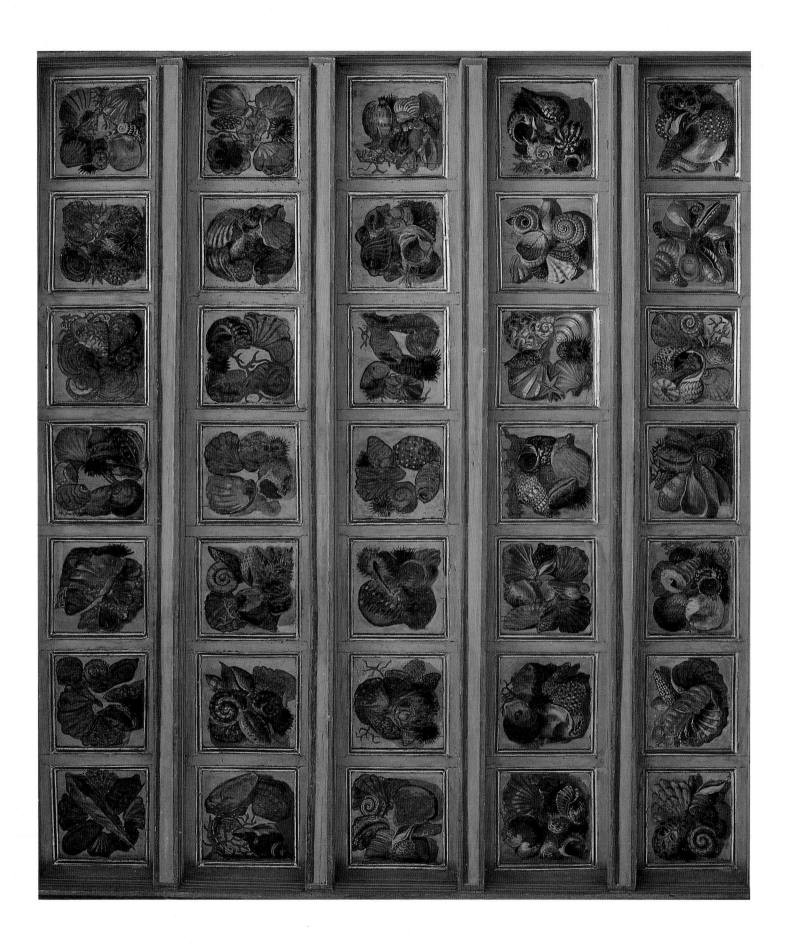

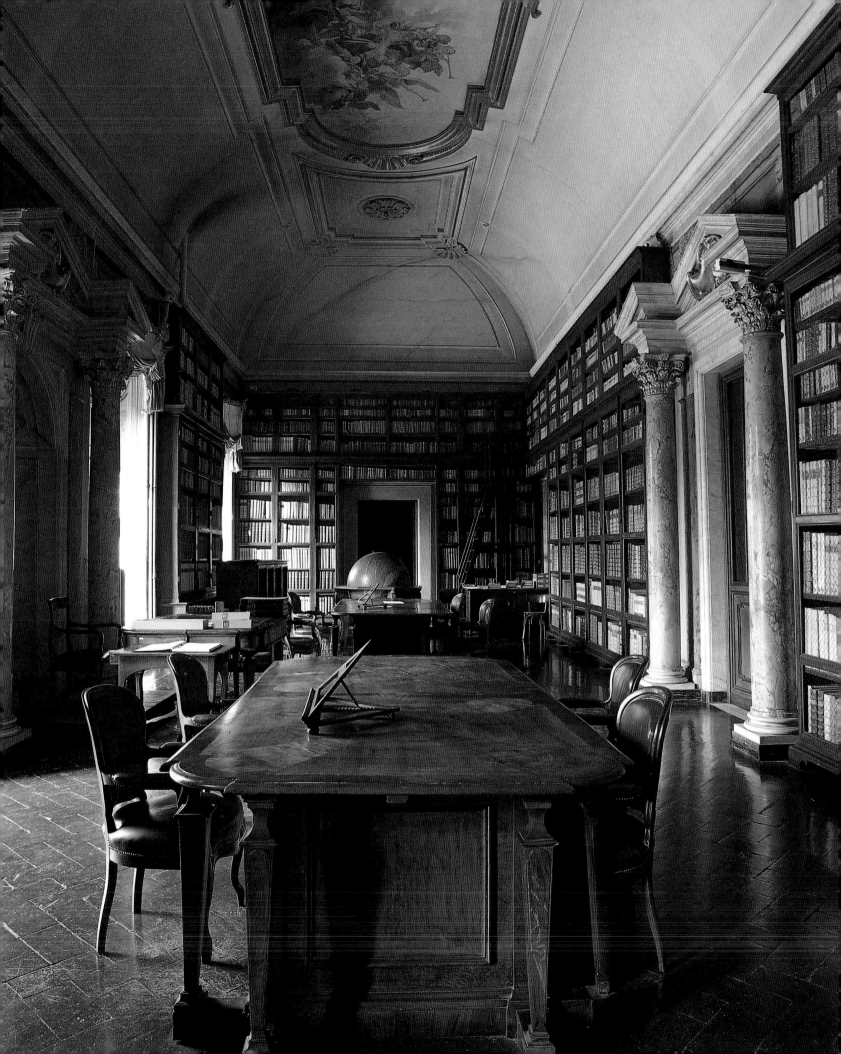

Palazzo Corsini
Biblioteca Corsiniana

Situated on the second floor
of the old Palazzo Corsini,
the book-lined reading
rooms of the Biblioteca
Corsiniana (left) still
preserve the atmosphere
of a private library, little
changed since the eighteenth
century, when they were
built to house the book
collection of Cardinal
Lorenzo Corsini.

Biblioteca Vallicelliana

Begun around 1642,
the reading room of the
Biblioteca Vallicelliana is
a little-known masterpiece
by the great Baroque
architect Borromini.
Among the contents are
books bequeathed by
S. Filippo Neri, specially
housed in an ornate cabinet
carved by the sculptor
Taddeo Landini around
1660 (right).

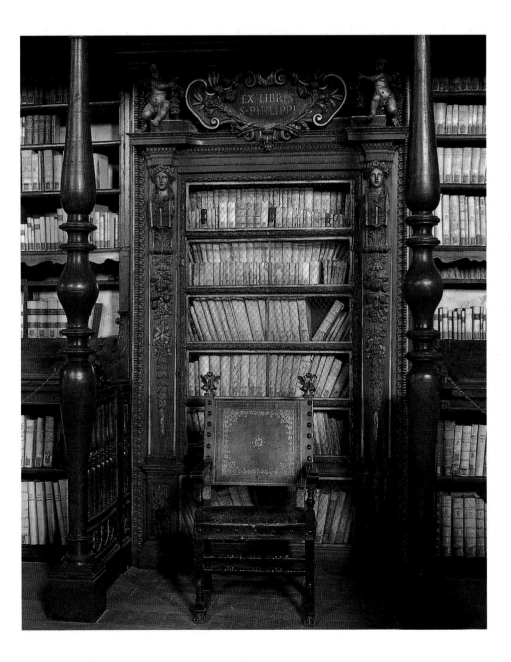

Places of Worship

The church of S. Costanza (right) stands on the threshold between antiquity and the Christian world. The building was erected around AD 320 as the burial place of Princesses Costantina and Helena, daughters of the Emperor Constantine. Although Christian in its purpose, the structure follows the traditional circular plan of a pagan mausoleum, with twelve pairs of coupled granite columns supporting a central dome ringed by a barrel-vaulted ambulatory. The latter retains its original decoration of brightly coloured mosaics representing human figures, animals, fruit, flowers and the harvesting of grapes. The mosaics are the most outstanding examples of their kind in Rome still *in situ*.

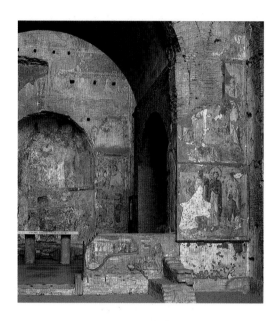

S. Maria Antiqua

The church of S. Maria Antiqua stands within the walls of a building in the Forum dating back to Roman times. The interior contains a rare series of eighth-century frescoes, executed by artists from Constantinople who had fled to Rome during a period of iconoclasm in their native city. The frescoes pay tribute to the Byzantine tradition and represent an assembly of oriental saints together with scenes from the scriptures (above and right).

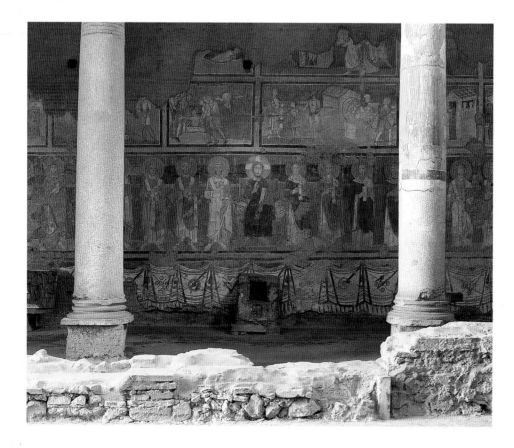

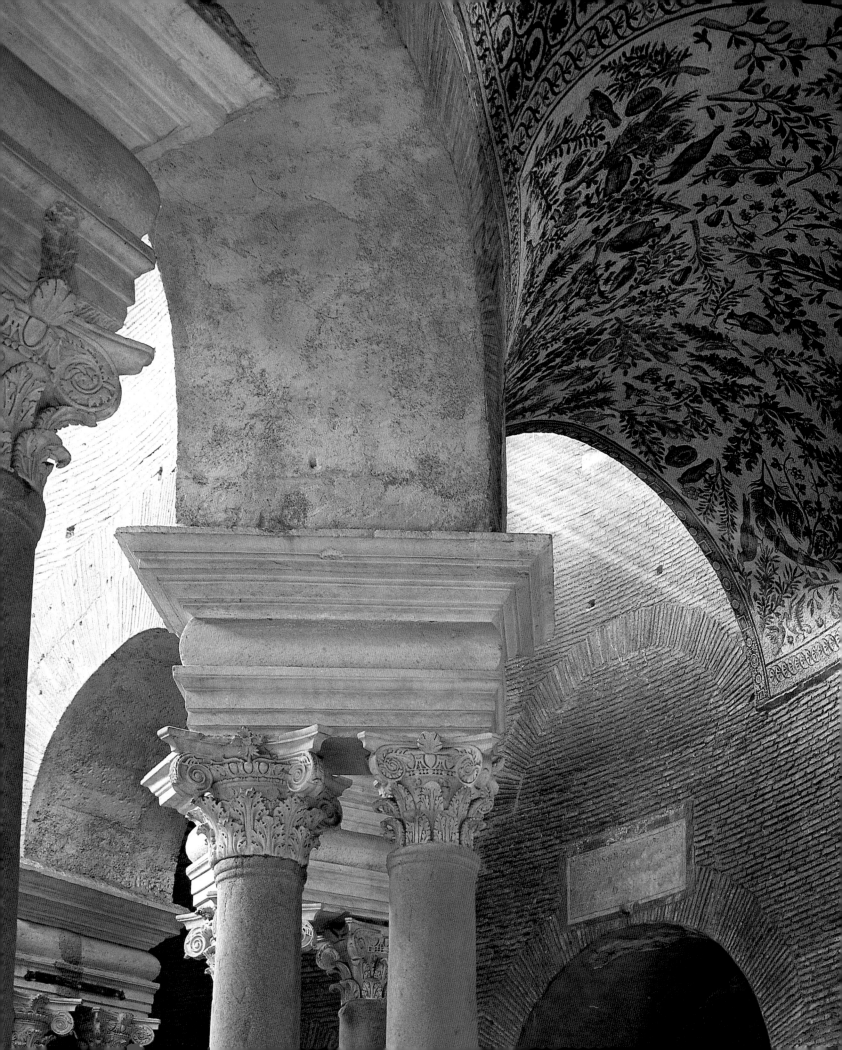

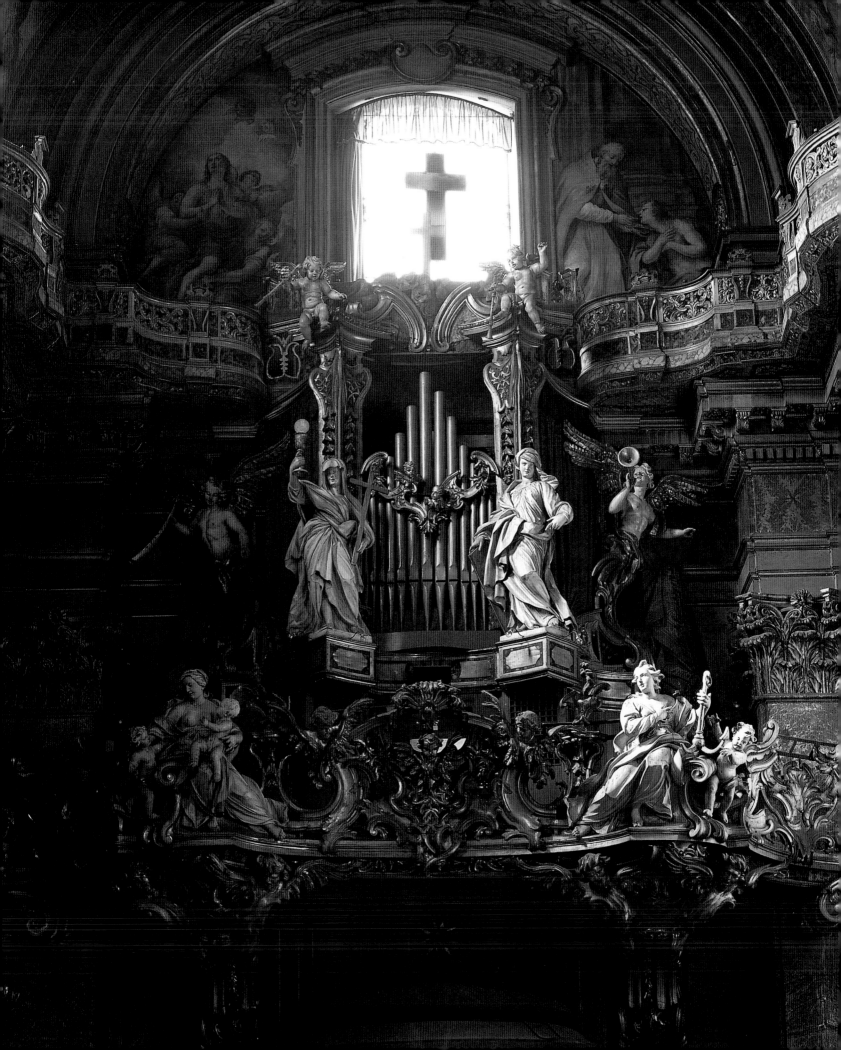

S. Maria Maddalena in Campomarzio

The church of S. Maria Maddalena was begun in the 1670s but completed almost a century later. The interior, which largely dates from the 1730s, is one of the best examples in Rome of the *barocchetto*, a variant of the Rococo style. Especially impressive is the organ above the entrance (left), with tier upon tier of carved and gilded woodwork forming multiple galleries surmounted by animated statues possessed by the spirit of music. The holy water basins (above) take the form of giant seashells protected by hovering angels.

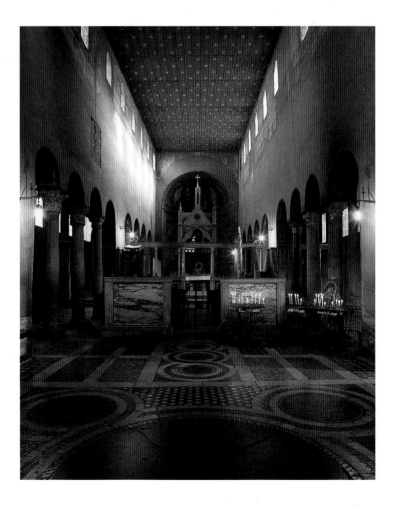

S. Maria in Cosmedin

The sixth-century church of S. Maria in Cosmedin is one of the finest examples of early Christian architecture in Rome. Its name is thought to derive from the Greek word 'Kosmeidon', meaning ornament, since in the eighth century the church was donated by Pope Adrian I to the Greek community of Rome. The Cosmatesque floor dates back to the twelfth century, as does the marble choir, while the Gothic baldaquin was added towards the end of the thirteenth century.

S. Maria del Popolo

S. Maria del Popolo is
both church and museum,
containing some of the finest
works of art anywhere on
public display in the city. At
one end of the church stands
a monument to Princess
Maria Flaminia Odescalchi
(above), a *tour de force* of neo-
classical design dating from
the 1770s. The Princess died
in childbirth at the age of 20,
and all the grief of her heart-
broken husband seems
concentrated in this
remarkable memorial to a
young and beautiful wife.

SS. Biagio e Carlo ai Catinari

Dedicated to S. Cecilia, the
patron saint of music, this
beautiful side chapel (right)
rises to a central dome
encircled by angels playing
musical instruments. The
interior was designed
around the turn of the
eighteenth century by
Antonio Gherardi, architect
of the Cappella Avila at
S. Maria in Trastevere
(page 117). The use of back-
lighting and the animation
of the figures are typical
of the Baroque, while the
sweetness and grace of
expression look forward
to the Rococo.

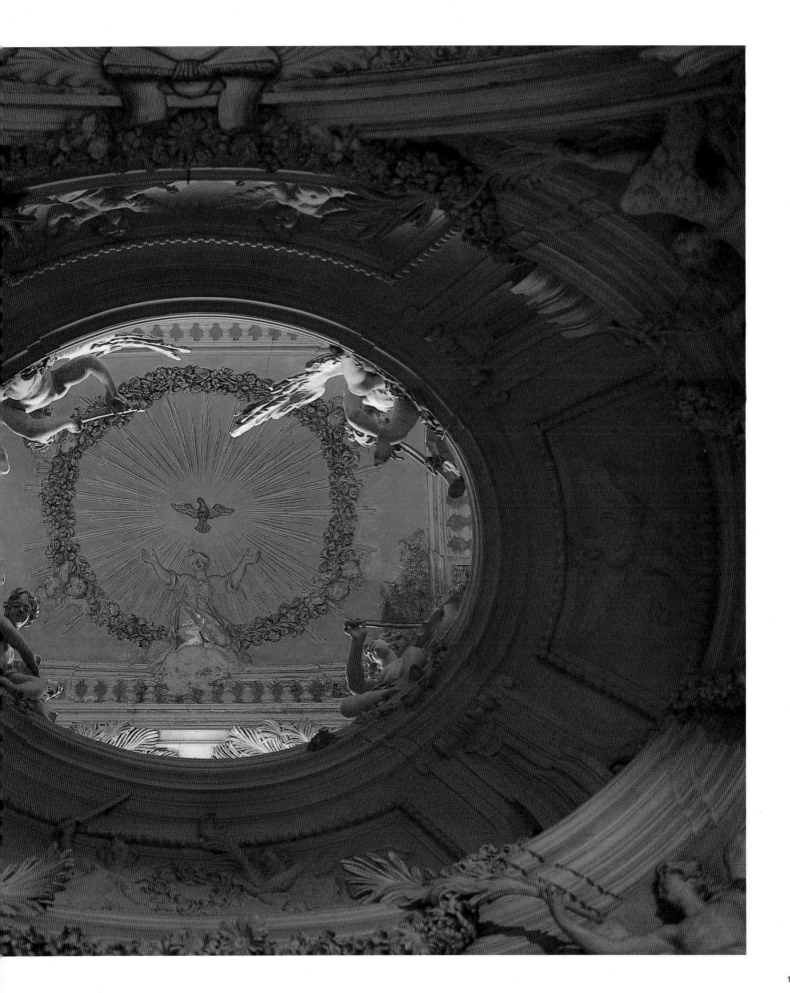

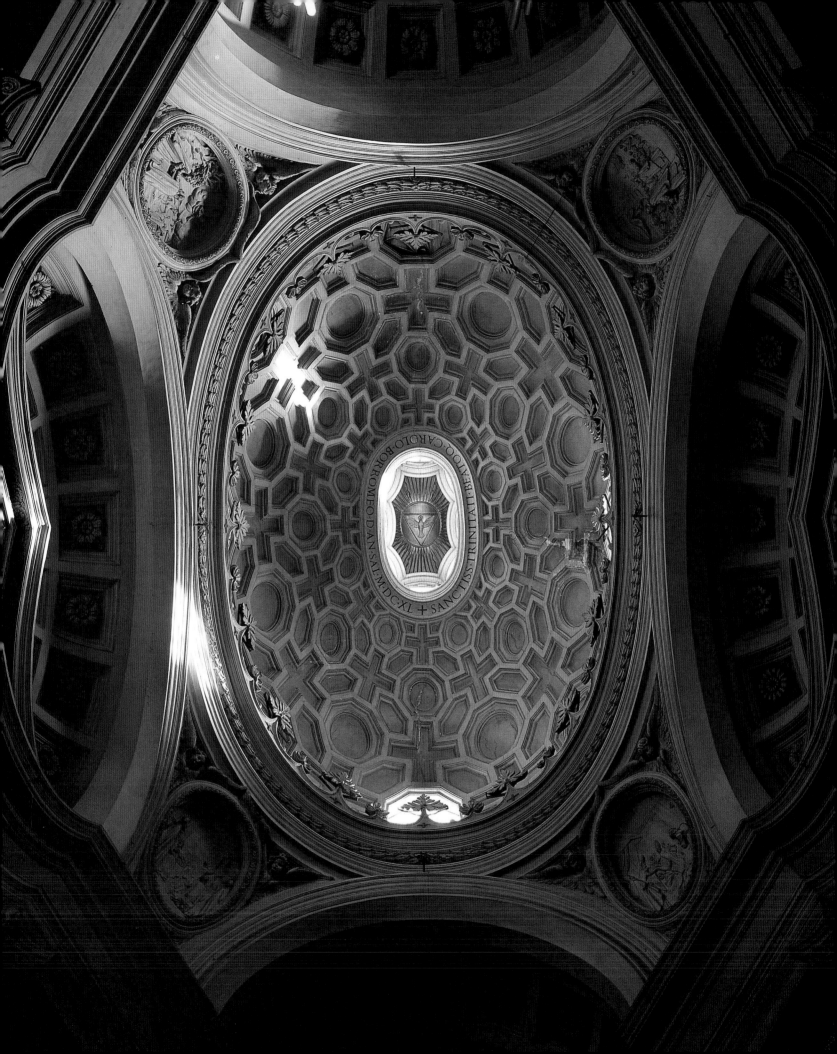

S. Carlo alle Quattro Fontane

A masterpiece of Baroque design, the church of S. Carlo alle Quattro Fontane (left) is the work of Francesco Borromini and was built in the 1630s for the Discalced Spanish Trinitarians, a religious order whose primary purpose was to raise money to buy back the freedom of Christians enslaved by the Moors. Within the narrow confines of a tiny structure, Borromini contrived the most powerful spatial effects. The plan is that of a circle intersected by an oval, but the static simplicity of the geometry is offset by a complex, dynamic play of projection and recession, curve and counter-curve, intersecting arcs and planes, the drama increased rather than diminished by a near-total absence of colour and gilding.

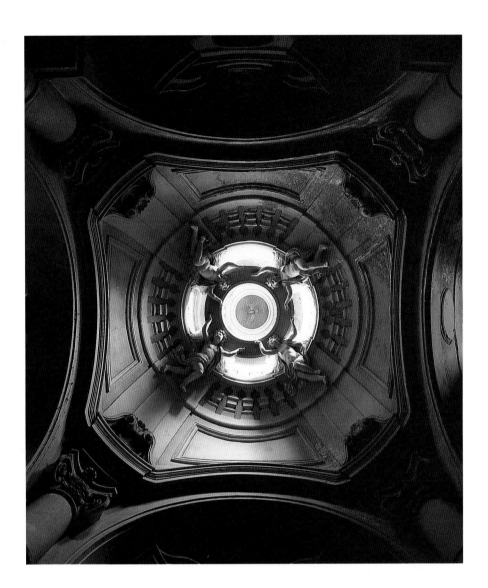

S. Maria in Trastevere

The church of S. Maria in Trastevere is rightly famous for its thirteenth-century mosaics, its antique granite columns and its carved and gilded ceiling by Domenichino. Less well known is the Avila Chapel (right), by Antonio Gherardi, a brilliant but neglected architect, who was likewise responsible for the chapel of S. Cecilia in the church of SS. Biagio e Carlo ai Catinari (pages 114–15). Suspended from the centre of the dome (above), as if ascending to heaven, are four angels carrying between them a *tempietto*, or miniature temple, intended perhaps as a metaphor for the offering up of prayer through the medium of the Church.

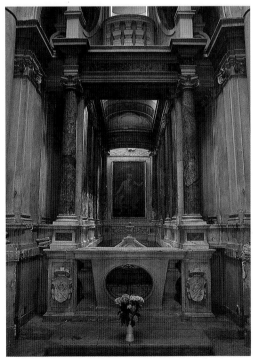

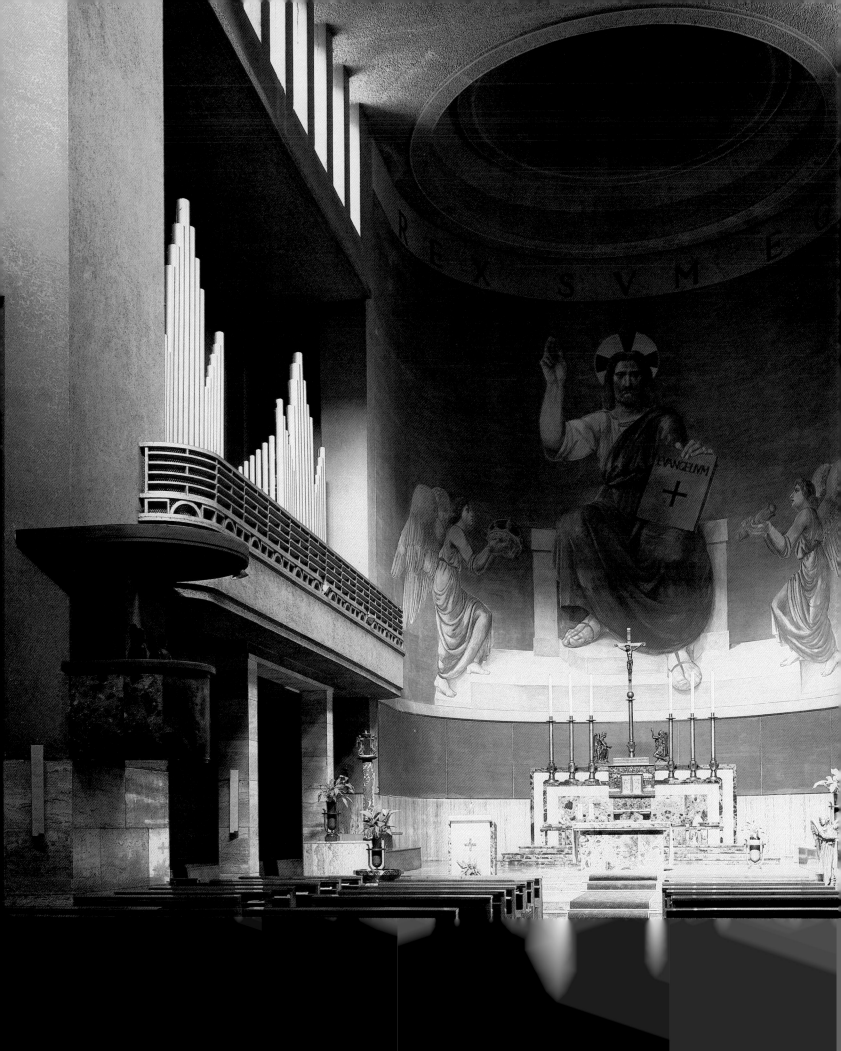

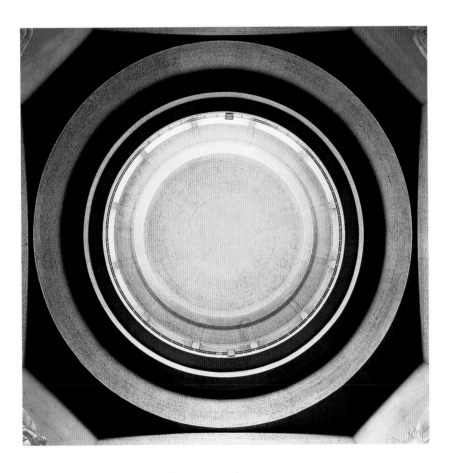

Tempio di Cristo Re

Of all the churches built
in Rome this century, the
most dramatic is surely the
Tempio di Cristo Re, a
monumental structure of the
1930s built by the leading
architect of the interwar
period, Marcello Piacentini.
The stark interior, with
its elemental geometry and
minimal use of colour and
ornament, was intended by
Piacentini to convey a sense
of awe, while demonstrating
in the most triumphant way
that the new rationalist
aesthetic in architecture
could be as successfully
applied to religious as
to secular buildings.

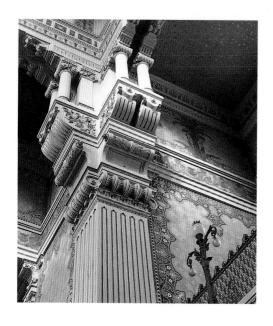

The Synagogue

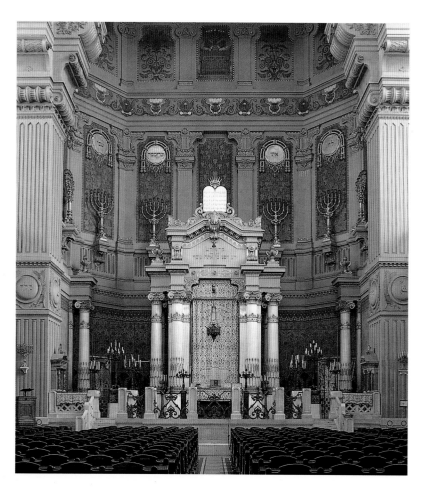

Situated on the fringes of
the old Jewish ghetto, the
Synagogue of Rome serves
a vital function as a place
of worship for one of the
oldest religious communities
in the world. The building
is equally important as
a symbol of Jewish
emancipation, having
been erected in the years
following the Risorgimento,
when the Roman ghetto was
abolished. In architectural
terms the Synagogue
represents a rare surviving
example of the so-called
'neo-Babylonian' style, the
interior decorated with
ornate metal work and
frescoed palm trees evoking
the landscape of the Bible.

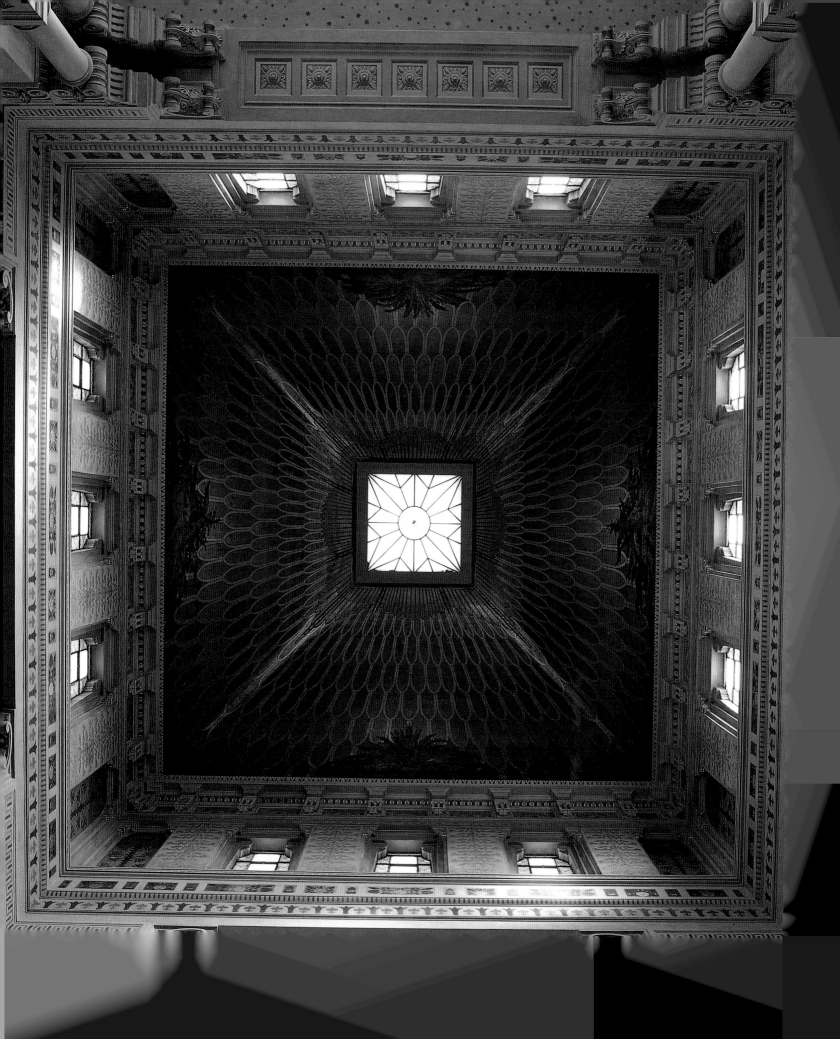

Acknowledgements

In the first place we must thank all those, too many
to name individually, who have made our work possible
by allowing us to visit and photograph the interiors
which appear in this book. We are grateful also for the
assistance we received from friends and colleagues, who
gave so generously of their time and knowledge, especially
Anna Maria Amadio, Count Giacomo Antonelli, Marco
Fabio Apolloni, S.E. Monsignor Arrighi, Maria Teresa
Avogadro, Rosanna Barbiellini Amidei, Francesca Boesch,
Alberto Bruno, Marchesa Antonella Bugnano, Lorenzo
Buldo, Maria Alberta Campitelli, Nicolo Carandini,
Guido Cornini, Angelo Curci, Angelo Delfini, Maria
Grazia Di Branco, Mario and Sandro D'Urso, Federico
Forquet, Milton Gendel, Monica Incisa Gendel,
Alessandra Ghidoli, Raniero Gnoli, Sergio Guarino,
Irene Iacopi, Giovanni Luciani, Antonio Martini,
Gianluigi Melega, Ugo Rossi Merighi, Lorenza Mochi
Onori, Gian Pietro Nattino, Ambassador Paolo Pansa
Cedronio, Emanuele Papi, Count Niccolò Pasolini, Anna
Maria Sommella, Claudio Strinati, Maria Elisa Tittoni,
Fabrizio Tomada, Rossella Vodret, Francesco Zurli.
For their kind hospitality and support we are likewise
indebted to Judy Caracciolo, and Cecilia, Domitilla
and Amparo Calamai. Thanks are also due to Filippo
del Drago, who did such sterling work as assistant
photographer. Finally we wish to thank our partner in
this venture, Francesco Venturi, whose photographs
so brilliantly fulfil the book's main purpose of recording
the beauty and diversity of Rome's historic interiors.

Bibliography

The bibliography on Rome is enormous, running to
well over 2000 titles in English alone, and there is scope
to list only a fraction of the books we have consulted
in the preparation of the present study. The most
dependable overall survey of the architecture of Rome
are the volumes of the *Guide Rionali di Roma*. An excellent
introduction to the buildings of the period *c.* 1600–1750
is Anthony Blunt's *Guide to Baroque Rome* (1979). There
are in addition numerous monographs on individual
buildings, many of them published in recent years by
Editalia. Although something of a period piece, having
first been published in the mid-1960s, Georgina
Masson's *Companion Guide to Rome* still provides a good,
brisk introduction, and the history of the city is neatly
summarized in Christopher Hibbert's *Rome, The
Biography of a City* (1985).

Gazetteer

To provide a complete architectural history for each of the buildings listed below, including all alterations subsequent to their construction, and the names of the architects and artists responsible, would in itself fill the pages of a book this size. To add the names of even the principal owners and occupants, present and past, would fill another. We have decided therefore to limit ourselves to a few brief lines relating in the main to the original construction of buildings and the creation of interiors specifically mentioned in the main text. A more extensive account can always be found in the *Guide Rionali di Roma*.

Private Houses and Apartments

Palazzo Sacchetti
Via Giulia 66
00186
Closed to visitors

Begun 1542 by architect Antonio da Sangallo; sold, unfinished, to Cardinal Giovanni Ricci 1552 and completed under direction of Nanni di Baccio Bigio; acquired by Sacchetti family 1649; *Sala dei Mappamondi* frescoed 1553–54 by Francesco Salviati; *Sala da Pranzo* (formerly Gallery) decorated by Giacomo Rocca.

Palazzo Massimo alle Colonne
Corso Vittorio Emanuele 141
00186
Closed to visitors

Built for Massimo family by Baldassare Peruzzi 1532–36 on site of earlier family palace damaged in sack of Rome; interiors ranging in date from 16th to 18th centuries, including *Sala Egiziana c.*1760.

Casino di Pio IV
Vatican
Generally closed to visitors

Built 1558–61 by Pirro Ligorio for Pope Pius IV; interiors include original shell-work nymphaeum.

Palazzo Pallavicini-Rospigliosi
Via XXIV Maggio 43
00187
Closed to visitors

Begun *c.*1605 for Cardinal Scipione Borghese; variously ascribed to Giovanni Vasanzio and Flaminio Ponzio; acquired by Pallavicini-Rospigliosi family 1704; interiors ranging in date from 17th to 18th centuries.

Palazzo Ruspoli
Via della Fontanella di Borghese 36
00186
Generally closed to visitors except public exhibition area

Built *c.*1580 for Rucellai family by Bartolomeo Ammanati; Gallery decorated 1586–90 by Jacopo Zucchi; acquired in 18th century by Ruspoli family; since acquired by Fondazione Memmo.

Palazzo Ricci
Piazza de' Ricci 129
00186
Closed to visitors

16th-century palace bought by Giulio Ricci, nephew of celebrated Renaissance patron Cardinal Ricci; occupied from mid-1930s to mid-1960s by Mario Praz; subsequently restored by owners Marchesi Giuseppe Gustavo and Eleonora Ricci Parracciani Bergamini; exterior frescoes by Polidoro da Caravaggio; frescoes in *piano nobile* drawing room attributed to Giovanni Guerra, pupil of Salviati, depicting allegories of human virtues.

Palazzo Taverna
Via Monte Giordano 36
00186
Closed to visitors but rooms may be hired for receptions and conferences by written application to principessa Stefanina Aldobrandini at above address

Built by Orsini family on site of earlier palace dating from at least mid-12th century; complex of five principal buildings spanning period 15th to 19th centuries; neo-classical wing with Empire-style painted decoration executed by Liborio Coccetti 1810–16.

Quartiere Coppedè
Piazza Mincio and Via Dora
00198
Access to entrance halls every day during shopping hours except Sat afternoon and Sun

Residential quarter built by architect Gino Coppedè 1919–23; entrance halls richly decorated with frescoes, polished wood and wrought iron in neo-medieval idiom.

Embassies

Palazzo Caetani
Residence of Brazilian Ambassador to Holy See
Via delle Botteghe Oscure 32
00186
Closed to visitors

Built 1564 for Alessandro Mattei, probably to designs of architect Nanni di Baccio Bigio; acquired by Duke Francesco Caetani and redecorated 1776; today owned by Fondazione Camillo Caetani.

Palazzo Borghese
Chancery of Spanish Embassy to Italian Republic
Largo Fontanella Borghese 19
00186
Closed to visitors

Built on site of earlier palace dating from *c.*1560; begun 1604 by Flaminio Ponzio for Cardinal Camillo Borghese, afterwards Pope Paul V; continued for latter's nephew, Cardinal Scipione Borghese, by Carlo Maderno and Giovanni Vasanzio; further alterations in 1670s by Carlo Rainaldi for Prince Paolo Borghese.

Villa Bonaparte
Residence of French Ambassador to Holy See
Via Piave 23
00187
Closed to visitors

Built *c.*1748 for Cardinal Silvio Valenti Gonzaga, Secretary of State under Pope Benedict XIV; design ascribed to Paolo Posi; occupied 1816–24 by Princess Pauline Bonaparte-Borghese, for whom remodelled, possibly by Canina; interiors include *Salone* with neo-classical murals; *Sala Egiziana*, with Egyptian-style painted ceiling believed to date from *c.*1800 and matching murals by Balthus; gallery with vaulted ceiling painted in *trompe-l'oeil* trellis work

Palazzo Farnese
Residence of French Ambassador to Italian Republic
Piazza Farnese 67
00186
Closed to visitors

Begun 1516 by Antonio da Sangallo the younger for Cardinal Alessandro Farnese, afterwards Pope Paul III; continued after Sangallo's death (1546) by Michelangelo; completed after Michelangelo's death (1564) by Giacomo della Porta; occupied by French Embassy since 1870.

Palazzo Pamphili
Residence of Brazilian Ambassador to Italian Republic
Piazza Navona 14
00186
Closed to visitors

Built on site of earlier palace occupied by Pamphili family from early 16th century; begun 1647 by order of Giovanni Battista Pamphili following election as pope two years earlier; original architect, Girolamo Rainaldi, superseded 1647 by Francesco Borromini; acquired by Republic of Brazil 1961; interiors include *Galleria Cortona* with ceiling paintings by Pietro da Cortona *c.*1651–55.

Palazzo di Spagna
Residence of Spanish Ambassador to Holy See
Piazza di Spagna 57
00187
Closed to visitors

Built 1647 by Antonio Del Grande; seat of Spanish Embassy to Holy See since second half of 17th century; suite of First Empire interiors including *Sala Rotonda* by Felice Giani.

Villa Berlingieri
Residence of Saudi Arabian Ambassador to
Italian Republic
Viale Regina Margherita 260
00198
Closed to visitors

Begun 1912 for Baron Arturo Berlingieri by architects
Pio and Marcello Piacentini, assisted by painter Ettore
Tito; acquired by Saudi Arabia 1966.

Government and Civic Buildings

Palazzo della Cancelleria
Piazza della Cancelleria
00186
Generally closed to visitors

Originally private palace built *c.*1485–95 for Cardinal
Raffaele Riario, nephew of Pope Sixtus IV; design ascribed
to Andrea Bregno, with subsequent additions by Bramante
notably courtyard; interiors include *Sala dei Cento Giorni*
with frescoed decoration by Vasari of 1546.

Palazzo Madama
Senato della Repubblica
Corso Rinascimento
00186
Closed to visitors

16th-century palace built for Medici family and named
after Madama Margherita of Austria, wife of Alessandro
de' Medici; since 1871 seat of Italian Senate; *Salone d'Onore*
(Hall of Honour) with frescoes by Cesare Maccari 1882–88
depicting scenes from ancient Roman Senate and, on
ceiling, allegories of new-born Italian State.

Palazzo Spada
Consiglio di Stato
Piazza Capodiferro 3
00186
Tel. 6861158
Galleria Spada open daily 9am–2pm except Mon; Sun 9am–1pm

Begun 1549 for Cardinal Girolamo Capodiferro; design
ascribed to Giulio Merigi da Caravaggio; acquired late
16th century by Mignanelli family; sold 1632 to Cardinal
Bernardino Spada; altered and enlarged by Paolo
Maruscelli from 1633, and from 1649 by Francesco
Borromini; further alterations in 1665 and 1700–2;
acquired by Italian state 1927; interiors include *Galleria
degli Stucchi* by Giulio Mazzoni dating from mid-16th
century; *Sala Grande* with antique Roman statues and
illusionistic murals executed by Agostino Mitelli and
Angelo Michele Colonna 1633–35.

Palazzo Chigi
Presidenza del Consiglio di Stato
Piazza Colonna 370
00187
Closed to visitors

Begun *c.*1618 for Cardinal Pietro Aldobrandini, nephew
of Pope Clement VIII, by Carlo Maderno; acquired 1659
by Fabio Chigi, Pope Alexander VII, and enlarged under
direction of Felice della Greca; acquired by Italian state
1917; interiors include *Sala delle Marine*, decorated 1748
for Agostino II Chigi, and *Salone d'Oro*, designed *c.*1765
by Giovanni Stern.

Palazzo Aereonautica
Ministero dell'Aereonautica
Viale Pretoriano 18
00185
Closed to visitors

Commissioned by Minister of Aviation Italo Balbo;
built 1929–30 to designs of Roberto Marino; well-
preserved interiors including office of Italo Balbo with
frescoes depicting Balbo's transatlantic voyage of 1931;
Room of Chief Commander (once Mussolini's office)
with views of planets; Telecommunication Office with
frescoes by Marcello Dudovich representing 'The
Paradise of Aviators' *c.*1932.

Palazzo dell'Industria
Ministero dell'Industria, Commercio e Artigianato
Via Molise 2
00187
Closed to visitors

Built 1928–32 to designs of Marcello Piacentini and
Giuseppe Vaccaro; entrance hall with doors in green
marble by Carlo Pini 1932; stained-glass window above
staircase designed by Mario Sironi 1931; much original
decoration in Fascist style destroyed or covered over
after July 1943.

Palazzo del Quirinale
Presidential Palace
Piazza del Quirinale
00187
Closed to visitors

Originally papal residence begun *c.*1583 by Pope
Gregory XIII to designs of Ottaviano Mascherino;
subsequent additions and alterations by, among others,
Domenico Fontana, Flaminio Ponzio, Carlo Maderno,
Gianlorenzo Bernini, Ferdinando Fuga; occupied by
Italian royal family 1870–1944; since adapted as residence
of President of Italian Republic; interiors include
elliptical spiral staircase by Mascherino of *c.*1583–85,
created for Pope Gregory XIII; *Fontana dell'Organo* created
*c.*1596 for Pope Clement VIII under direction of Carlo
Lambardi and Bernardo Valperga; *Fulcine di Vulcano* built
for Pope Gregory XVI *c.*1831–46; *Biblioteca del Piffetti*,
originally created *c.*1738 by cabinet-maker Pietro Piffetti
for Carlo Emanuele II di Savoia and transferred here from
Castello di Moncalieri, Turin, 1888; *Sala degli Specchi* and *Sala
degli Arazzi Piemontesi* decorated following occupation of
palace by Vittorio Emanuele I.

Villa Madama
Ministero degli Affari Esteri
Via di Villa Madama
00194
Tel. 36911
Open to groups by special arrangement

Begun *c.*1515 to designs of Raphael for Cardinal Giuliano
de' Medici, afterwards Pope Clement VII; purchased by

Italian state 1940; interiors include *Loggia* with grotesque
decoration by Giovanni da Udine and adjoining apartment
frescoed by Giulio Romano.

Stazione di Porta San Paolo
Via Ostiense
00154
*Usually open during weekdays; when closed may be seen at all hours
through iron gates*

Built 1919–22; unique etched cement wall panels
representing sea gods and marine animals; designed
by architect Pio Piacentini.

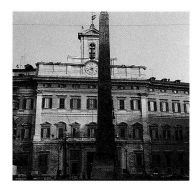

Palazzo di Montecitorio
Camera dei Deputati
Piazza di Montecitorio
00186
Closed to visitors

16th-century palace bought by Prince Nicolò Ludovisi 1653,
restructured by Gianlorenzo Bernini; completed by Carlo
Fontana for Pope Innocent XII 1697; seat of Italian
Parliament since 1871; Fontana's semi-circular courtyard
covered over to house debating chamber, built 1903–25 by
Sicilian architect Ernesto Basile.

Palazzo dell'Agricoltura
Ministero dell'Agricoltura e Foreste
Via XX Settembre 20
00187
Closed to visitors

Built 1914–19 to designs of Odoardo Cavagnari;
Parlamentino (Reunion Hall) decorated 1914–18 by
painter Andrea Petroni; mosaic floors attributed to
G. M. Mataloni.

Museums and Monuments

Palazzo Venezia
Via del Plebiscito
00186
Tel. 6798865
Museum open daily 9am–2pm except Mon; Sun and holidays 9am–1pm

Built 1455–71 for Venetian Cardinal Pietro Barbo, elected
Pope Paul II 1464; original construction involved Giuliano
da Sangallo; Loggia ascribed to Leon Battista Alberti;
interiors include *Sala del Mappamondo* with remains of late
15th-century frescoes and mosaic floor of *c.*1929 by Pietro
d'Achiardi; Zodiac room decorated *c.*1924–29 under
direction of Federico Hermanin.

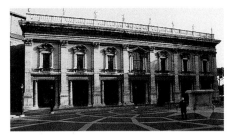

Museo Capitolino
Piazza del Campidoglio
Open daily 9.30am-1.30pm except Mon;
Tue 5pm-8pm; Sat 8pm-11pm

Built by order of Pope Innocent X *c.*1644–55 to designs of Girolamo Rainaldi; interiors include *Sala degli Imperatori* containing 66 busts of Roman emperors arranged in chronological order.

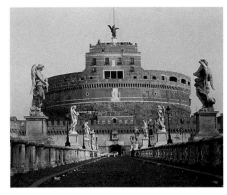

Castel S. Angelo
Lungotevere Castello 1
Tel. 6875063
Open Tue-Sat 9am-6.30pm; Sun and holidays 9am-12pm;
Mon 2pm-sunset

Originally Mausoleum of Emperor Hadrian, erected AD 130–139; subsequently converted into fortress; interiors include *Bagno di Clemente VII* with painted decoration of *c.*1525 ascribed to Giovanni da Udine.

Casa di Livia e di Augusto
Palatine
Entrance from Via dei Fori Imperiali
House of Livia open 9am-6pm; Tue and Sun 9am-1pm.
House of Augustus closed for restoration

Remains of *Domus Augusti,* palace erected *c.*36 BC for Augustus (later Emperor) and Livia; several surviving interiors with murals and mosaics.

Palazzo Barberini
Via delle Quattro Fontane 13
00184
Tel. 4814184
Museum open daily 9am-2pm except Mon; Sun and holidays 9am-1pm;
visits to 18th-century apartment generally every 30 minutes

Begun 1628 to designs of Carlo Maderno for Taddeo Barberini, nephew of Urban VIII; continued after Maderno's death by Gianlorenzo Bernini, assisted by Francesco Barberini; structure completed *c.*1635; interiors ranging in date from 17th to 18th centuries, including apartment on second floor decorated following marriage of Barberini heiress, Cornelia Costanza, and Giulio Cesare Colonna di Sciarra, principe di Carbognano (1728).

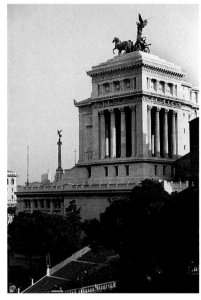

Vittoriano
Piazza Venezia
00184
Tel. 6991718
Monument houses Museo Sacrario delle Bandiere, open daily
9am-1.30pm except Mon; Biblioteca del Risorgimento open 9am-12pm
Tue-Sat; colonnade generally closed to visitors

Memorial to King Victor Emmanuel II, intended to celebrate unification of Italy; begun 1885 to designs of Giuseppe Sacconi and inaugurated 1911; mosaics by Giulio Bargellini and Antonio Rizzi; since 1921 Tomb of Unknown Soldier.

Palazzo Colonna
Galleria Colonna
Via della Pilotta 17
00187
Tel. 6784350
Open Sat 9am-1pm

Built 15th century for Pope Martin V Colonna; Gallery begun 1654 for Cardinal Girolamo Colonna by architects Antonio Del Grande and, after 1671, Girolamo Fontana; completed 1702 and inaugurated 1703 by Filippo Colonna.

Hotels, Shops and Restaurants

Grand Hotel Plaza
Via del Corso 126
00186
Tel. 672101

Originally opened 1860; lion staircase and principal salon with painted and stucco decoration, Liberty-style, stained-glass sky-light and turn-of-century furniture.

Le Grand Hotel de Rome
Via Emanuele Orlando 3
00185
Tel. 4709

Built by César Ritz, to designs of architect Podesti; inaugurated 1894; staircase with stucco decorations and allegorical ceiling painting; dining hall with painted ceiling depicting pastoral scenes in Symbolist style.

Albergo degli Ambasciatori
Via Veneto 70
00187
Tel. 47493

Built to designs of Marcello Piacentini and inaugurated 1927; ground-floor salon decorated with frescoes by Venetian painter Guido Cadorin 1926, depicting leading figures from Roman and international high society.

Galleria Sciarra
Via Minghetti 10
00187
Open daily during shopping hours

Shopping arcade adjoining Palazzo Sciarra; built by publisher Maffeo Sciarra to house offices of *La Tribuna* newspaper *c.*1883; architect Giulio De Angelis; first example in Rome of metal-frame architecture; frescoes by Giuseppe Cellini depicting scenes from contemporary life and allegories of Christian female virtues, 1886; acquired and restored by Cassa di Risparmio di Roma 1970.

Farmacia S. Maria della Scala
Piazza S. Maria della Scala
00153
Open to customers daily 9am-11am; donations from visitors appreciated

18th-century apothecary's on first floor of late 16th-century Carmelite monastery built to designs of Matteo da Castello and Mascherino; herbal cures supplied to popes and papal families since late 17th century; furniture, painted decoration and frescoes mostly 18th-century; some 19th-century additions; expropriated by state 1875; put up for auction and bought back by Carmelite monks; digestive liquors on sale.

Farmacia Capranica
Piazza Capranica 96
00186
Tel. 6794680
Open daily during shopping hours

Founded 1912; surviving original fittings include marble fountain with etched-glass mirror decorated with alchemical symbols.

Caffè Greco
Via dei Condotti 86
00187
Tel. 6782554-6791700
Open daily 8am-8.30pm except Sun

Founded *c.*1740 by Greek owner Nicola della Maddalena from late 18th-century meeting-place for German and Anglo-American expatriate writers and artists; Omnibus Room *c.*1860, with stucco medallions, portraits and series of landscape paintings by Dresden artist Edmund Hottenroth; officially recognized as monument of historical and national interest 1953.

Antica Macelleria Annibale
Via di Ripetta 236
00186
Tel. 3612269
Open Mon-Wed 6am-4pm; Thur 6am-2pm; Fri-Sat 6am-7.30pm

Founded *c.*1895 by butcher Alessandro Talacca; floor and walls retain original Ginori ceramics; doors and worktable in Carrara marble; original brass bull masks; acquired by present owner Annibale Mastrodda 1970.

Macelleria Angelo Feroci
Via della Maddalena 15
00186
Tel. 68307030
Open daily during shopping hours; closed Thur afternoon

Butcher's shop founded at turn of century; completely redecorated in early 1920s; worktable and cash desk in Carrara marble; cement and sawdust relief of tussling bulls; shop now owned by Polzella family, heirs of founder.

Da Alfredo all'Augusteo
Piazza Augusto Imperatore 30
00186
Tel. 6878734
Open daily for lunch and dinner except Sun

Inaugurated 1948; redecorated in early 1950s; original stucco reliefs representing founder of the restaurant on Roman chariot.

Ditta Radiconcini
Via del Corso 139
00193
Tel. 6791807
Open daily during shopping hours

Hat shop opened 1932 by Radiconcini family; original Liberty-style interior transformed in present Art Deco style in late 1930s; shop fittings intact, including etched glass panels depicting five phases of hat-making.

Banks and Offices

Villa Chigi
Via di Villa Chigi 24
00199
Currently under restoration; scheduled to open autumn 1993

Built mid-18th century for Cardinal Flavio Chigi by architect Tommaso Bianchi and, after 1766, by Camporesi; ornate interiors with mirrored doors, gilt-stucco reliefs and frescoes by Paolo Anese, Paolo Monaldi and Antonio Bicchierari; acquired by present owners 1991 for use as private cultural foundation.

Palazzo Altieri
Associazione Bancaria Italiana
Piazza del Gesù
Closed to visitors

Built by Altieri family on site of earlier palace dating from before 16th century; begun for Giambattista Altieri, brother of Pope Clement X c.1670, by architect Giovanni Antonio de' Rossi; interiors include Rococo *Gabinetto da Toeletta* c.1730; *Sala del Mosaico*, created c.1780–90 for Prince Paluzzo Altieri by Giuseppe Barberi.

Palazzo Sciarra
Banca di Roma
Via Minghetti 17
00187
Closed to visitors

Begun c.1590 for Francesco Colonna di Sciarra, duca di Palestrina; design variously ascribed to Martino Longhi the Elder, Flaminio Ponzio, and Orazio Torriani; *Libreria* and *Sala degli Specchi* created c.1750 by Luigi Vanvitelli for Cardinal Prospero Colonna.

Clubs and Institutions

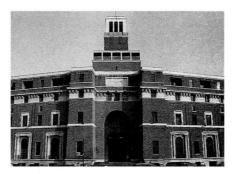

Casa Madre dei Mutilati
Piazza Adriana 3
00193
Tel. 6875352/3/4
Generally closed to visitors except by written application to Comitato Centrale dell'Associazione Mutilati e Invalidi di Guerra

Rome headquarters of private association founded 1917 to protect rights of war veterans; commissioned by Mussolini and designed by Marcello Piacentini; inaugurated 1928; original architectural decoration and furniture preserved; notable interiors include semi-circular *Parlamentino* (conference room) decorated with inlaid panelling by Eduardo Del Neri; oval room with frescoes by Mario Sironi depicting Mussolini and King Victor Emmanuel III facing each other on horseback; after fall of Fascism Sironi's frescoes covered over to protect against vandalism; rediscovered and restored c.1989.

Foro Italico
Largo Lauro de Bosi 3
00194
Tel. 36851
Principal swimming pool visible from street; visits to Palestra del Duce and children's pool by prior arrangement

Sports complex commissioned by Mussolini 1930s; designed by architect Enrico Del Debbio; principal buildings by Costantino Costantini; mosaics by Giulio Rosso, Angelo Canevari and Gino Severini.

Palazzo Rondinini
Circolo degli Scacchi
Via del Corso 518
00186
Closed to visitors

Begun c.1600 for painter Giuseppe Cesari, known as Cavaliere d'Arpino, to designs of Flaminio Ponzio; acquired 1744 by marchesa Margherita Ambra Rondinini and remodelled and enlarged under direction of Alessandro Dori; largely complete by 1754 but partly redecorated in 1760s; architectural decoration largely intact.

Villa Massimo
Delegazione dei Francescani in Terra Santa
Via M. Boiardo 16
00185
Tel. 70495651
Open Tue and Thur 9am-12pm; otherwise by prior arrangement

Built early 17th century as *casino* (summer lodge) for Vincenzo Giustiniani, probably to designs of Carlo Lombardi, although sometimes attributed to Borromini; bought by marchese Carlo Massimo 1803, under whose direction three ground-floor interiors frescoed by German Nazarenes including Peter Cornelius, Philip Veit and Joseph Anton Koch, with scenes from epic poems of Dante, Ariosto and Tasso; building sold to Lancellotti family 1847; acquired by present owners 1947.

Palazzo Borghese
Circolo della Caccia
Largo Fontanella Borghese 19
00186
Closed to visitors

See EMBASSIES: Chancery of Spanish Embassy to Italian Republic

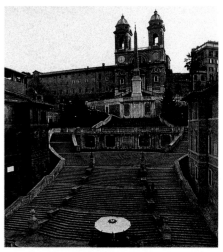

Convento di S. Trinità dei Monti
Piazza S. Trinità dei Monti
00187
Clérisseau room and anamorphic frescoes; visits Thur mornings around 11am

Originally monastery established by Charles VIII of France for Order of Minims founded by S. Francesco di Paola; building begun c.1502; transferred to Order of Sacré Cœur for use as convent 1828; interiors include passageway with anamorphic frescoes by J.-F. Nicéron dating from first half of 17th century; *Stanza delle Rovine* decorated by Charles-Louis Clérisseau c.1767.

Schools and Libraries

Villa Farnesina
Accademia dei Lincei
Via della Lungara 230
00165
Tel. 6838832
Open to readers daily 9am-1pm except Sun

Built 1508–11 by Baldassare Peruzzi for Agostino Chigi; acquired by Farnese family 1590; interiors include *Sala delle Prospettive* with illusionistic murals by Peruzzi; *Loggia di Psiche* conceived by Raphael and executed by his pupils notably Giulio Romano; bedchamber with frescoes by Sodoma depicting nuptials of Alexander the Great and Roxana.

Biblioteca Casanatense
Via S. Ignazio 52
00186
Tel. 6798855
Open to readers Mon, Wed, Sat 8.30am-1.20pm; Tue, Thur, Fri 8.30-7pm

Founded in honour of benefactor Cardinal Domenico Casanate 1698; built to designs of Antonio Maria Borioni; central hall designed by Carlo Fontana; statue of Cardinal Casanate by Pierre II Le Gros; library open to public since 1725; especially strong on theology and religious studies.

Fondazione Marco Besso
Largo di Torre Argentina 11
00186
Tel. 68802870
Not generally open to public, except for occasional exhibitions and seminars

Private foundation inaugurated c.1920; library specializing in Roman and Dante studies; situated on *piano nobile* of 16th-century palace formerly owned by Florentine banking family Strozzi; acquired and remodelled by General Insurance President Marco Besso 1905; Dante Library built c.1907; Chinese Room with painted shell decorations and chinoiserie panels dating from late 18th to early 19th century.

Palazzo Corsini
Biblioteca Corsiniana
Via della Lungara 10
00165
Tel. 6838832
Open to readers Mon-Sat 9am-1pm; Wed 3pm-6.30pm

18th-century library situated on second floor of 15th-century palace built for Cardinal Domenico Riario or possibly Cardinal Girolamo; acquired by Corsini family 1736 as home for library and art collection formed by Cardinal Lorenzo Corsini; subsequently enlarged and remodelled by Ferdinando Fuga; bought by Italian State 1883 to house Accademia dei Lincei, originally founded 1603 by Federico Cesi.

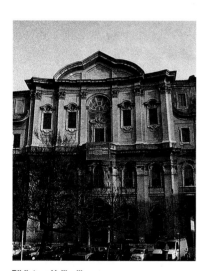

Biblioteca Vallicelliana
Piazza della Chiesa Nuova 18
00186
Tel. 68802671
Open to readers Mon, Fri, Sat 8.30am-1pm; Tue, Wed, Thur 8.30am-6.30pm; closed Sun

Built 1642–44 with bequest to Philippine monks by Portuguese humanist Achille Stazio; designed by Borromini; library of S. Filippo Neri added 1662; allegorical ceiling painting of *La Sapienza* (Knowledge) by Giovanni Francesco Romanelli; enlarged and altered following structural failure 1666; cotto floor added 1667.

Places of Worship

S. Maria Antiqua
Foro Romano
Closed for restoration

Early Christian church created within walls of Roman building of Imperial period; interior frescoed by Byzantine painters in 8th century; building largely destroyed in earthquake of 847; rebuilt in 13th century; remodelled 1617 by Onorio Longhi for Cardinal Marcello Lante; restored to 8th-century character 1902.

S. Costanza
Via Nomentana 349
00162
Tel. 8319140
Open daily 9am-12pm, 4pm-6pm; Sun 4pm-6pm

Originally built c. AD 320 as mausoleum of Costantina and Helena, daughters of Emperor Constantine; consecrated as church 1254; interior retaining original 4th-century mosaics.

S. Maria Maddalena in Campomarzio
Piazza della Maddalena 53
00186
Tel. 6797796
Open daily 8.30am-12pm, 5pm-7pm

Built on site of earlier church dating from 15th century; begun 1673 to designs of Carlo Fontana for Ministri degli Infermi; continued from 1690s by Giovanni Antonio De' Rossi; structure completed after latter's death (1695) by Carlo Quadri; decoration of façade and interior principally carried out by Giuseppe Sardi c.1735.

S. Maria in Cosmedin
Piazza della Bocca della Verità 18
00186
Tel. 6781419
Open daily 9am-12pm, 3pm-5pm

Built on archaeological site adjoining Teatro di Marcello, in 6th century; enlarged by Adrian I c.782 and donated to Greek community; enlarged by Nicholas I, 858–867; Cosmatesque floors, choir and portico dating from 12th century; Gothic baldaquin added 13th century; restored 1890s.

S. Maria del Popolo
Piazza del Popolo 12
00187
Tel. 3610836
Open daily 9am-12.30pm, 4pm-6pm

Begun c.1226, when consecrated by Pope Gregory IX; built at expense of Roman people (hence name) on site of earlier church dating from late 11th century; rebuilt 1472–80 by order of Pope Sixtus IV, possibly under direction of Andrea Bregno and Baccio Pontelli; subsequent alterations and additions by, among others, Bramante, Raphael and Bernini.

SS. Biagio e Carlo ai Catinari
Piazza Benedetto Cairoli 117
00186
Tel. 68803554
Open 8am-12pm, 5pm-7pm; Sun 10am-12pm, 5pm-7pm

Begun 1611 to designs of Rosato Rosati; built by Barnabite Order and dedicated to recently canonized S. Carlo

Borromeo; nave completed 1620; transepts and choir built c.1627–46; façade begun 1636 to designs of Giovanni Battista Soria; chapel of S. Cecilia added 1695–1700 by Antonio Gherardi.

S. Carlo alle Quattro Fontane
Via del Quirinale 23
00187
Tel. 4883261
Open 9am-12.30pm, 4pm-6pm; Sat 9am-12.30pm; Sun 12-1pm

Built by Discalced Spanish Trinitarians; church begun 1637 to designs of Francesco Borromini; façade begun 1665.

S. Maria in Trastevere
Piazza Santa Maria in Trastevere
00153
Tel. 5814802
Open daily 7am-1pm, 3pm-6.45pm

Founded in 3rd century by Pope Calixtus I; rebuilt in 12th century by order of Pope Innocent II; portico added by Carlo Fontana for Pope Clement XI 1701–2; restored 1870; Avila Chapel added c.1680 by Antonio Gherardi.

Tempio di Cristo Re
Viale Mazzini 32
00195
Tel. 3223383
Open daily 7.30am-12pm; Sat and Sun 5.30pm-7.30pm

Built to designs of Marcello Piacentini 1924–34; frescoes by Achille Funi.

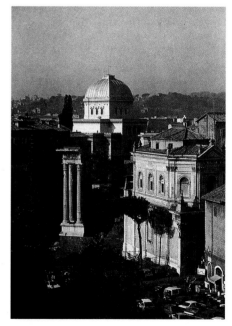

The Synagogue
Lungotevere de' Cenci
00186
Tel. 6877371
Temple and Museum of History of Jewish Community in Rome, open Mon-Thur 9.30am-2pm, 3pm-5pm; Fri morning only; Sun 9.30am-12.30pm; closed Sat

Built to designs of O. Armanni and L. Costa 1889; inaugurated 1904; Synagogue interior unchanged since construction.

Index

Page numbers in **bold** refer to the illustrations